How to Do
Nothing

How to Do Nothing

Resisting
the Attention
Economy

Jenny Odell

🏠 MELVILLE HOUSE
BROOKLYN · LONDON

How to Do Nothing

Copyright © 2019 by Jenny Odell
First Melville House Printing: April 2019

Melville House Publishing Suite 2000
 46 John Street and 16/18 Woodford Rd.
 Brooklyn, NY 11201 London E7 0HA

mhpbooks.com
@melvillehouse
ISBN: 978-1-61219-749-4
ISBN: 978-1-61219-750-0 (eBook)

Designed by Fritz Metsch

Printed in the United States of America

1 3 5 7 9 10 8 6 4 2

A catalog record for this book is available from the Library of Congress

to my students

Contents

Introduction

Surviving Usefulness

Redemption preserves itself in a small crack
in the continuum of catastrophe.
—WALTER BENJAMIN[1]

Nothing is harder to do than nothing. In a world where our value is determined by our productivity, many of us find our every last minute captured, optimized, or appropriated as a financial resource by the technologies we use daily. We submit our free time to numerical evaluation, interact with algorithmic versions of each other, and build and maintain personal brands. For some, there may be a kind of engineer's satisfaction in the streamlining and networking of our entire lived experience. And yet a certain nervous feeling, of being overstimulated and unable to sustain a train of thought, lingers. Though it can be hard to grasp before it disappears behind the screen of distraction, this feeling is in fact urgent. We still recognize that much of what gives one's life meaning stems from accidents, interruptions, and serendipitous encounters: the "off time" that a mechanistic view of experience seeks to eliminate.

Already in 1877, Robert Louis Stevenson called busyness a "symptom of deficient vitality," and observed "a sort of dead-alive, hackneyed people about, who are scarcely conscious of living except in the exercise of some conventional occupation."[2] And, after all, we only go around once. Seneca, in "On the Shortness of Life," describes the horror of looking back to see that life has slipped be-

tween our fingers. It sounds all too much like someone waking from the stupor of an hour on Facebook:

> Look back in memory and consider . . . how many have robbed you of life when you were not aware of what you were losing, how much was taken up in useless sorrow, in foolish joy, in greedy desire, in the allurements of society, how little of yourself was left to you; you will perceive that you are dying before your season![3]

On a collective level, the stakes are higher. We know that we live in complex times that demand complex thoughts and conversations—and those, in turn, demand the very time and space that is nowhere to be found. The convenience of limitless connectivity has neatly paved over the nuances of in-person conversation, cutting away so much information and context in the process. In an endless cycle where communication is stunted and time is money, there are few moments to slip away and fewer ways to find each other.

Given how poorly art survives in a system that only values the bottom line, the stakes are cultural as well. What the tastes of neoliberal techno manifest–destiny and the culture of Trump have in common is impatience with anything nuanced, poetic, or less-than-obvious. Such "nothings" cannot be tolerated because they cannot be used or appropriated, and provide no deliverables. (Seen in this context, Trump's desire to defund the National Endowment for the Arts comes as no surprise.) In the early twentieth century, the surrealist painter Giorgio de Chirico foresaw a narrowing horizon for activities as "unproductive" as observation. He wrote:

> In the face of the increasingly materialist and pragmatic orientation of our age . . . it would not be eccentric in the future to contemplate a society in which those who live for the pleasures of the mind will no longer have the right to demand their place in the sun. The writer, the thinker, the dreamer,

the poet, the metaphysician, the observer . . . he who tries to solve a riddle or to pass judgement will become an anachronistic figure, destined to disappear from the face of the earth like the ichthyosaur and the mammoth.[4]

This book is about how to hold open that place in the sun. It is a field guide to doing nothing as an act of political resistance to the attention economy, with all the stubbornness of a Chinese "nail house" blocking a major highway. I want this not only for artists and writers, but for any person who perceives life to be *more than an instrument* and therefore something that cannot be optimized. A simple refusal motivates my argument: refusal to believe that the present time and place, and the people who are here with us, are somehow not enough. Platforms such as Facebook and Instagram act like dams that capitalize on our natural interest in others and an ageless need for community, hijacking and frustrating our most innate desires, and profiting from them. Solitude, observation, and simple conviviality should be recognized not only as ends in and of themselves, but inalienable rights belonging to anyone lucky enough to be alive.

THE FACT THAT the "nothing" that I propose is only nothing from the point of view of capitalist productivity explains the irony that a book called *How to Do Nothing* is in some ways also a plan of action. I want to trace a series of movements: 1) a dropping out, not dissimilar from the "dropping out" of the 1960s; 2) a lateral movement outward to things and people that are around us; and 3) a movement downward into place. Unless we are vigilant, the current design of much of our technology will block us every step of the way, deliberately creating false targets for self-reflection, curiosity, and a desire to belong to a community. When people long for some kind of escape, it's worth asking: What would "back to the land" mean if we understood the land to be where we are right now? Could "aug-

mented reality" simply mean putting your phone down? And what (or who) is that sitting in front of you when you finally do?

It is within a blasted landscape of neoliberal determinism that this book seeks hidden springs of ambiguity and inefficiency. This is a four-course meal in the age of Soylent. But while I hope you find some relief in the invitation to simply stop or slow down, I don't mean this to be a weekend retreat or a mere treatise on creativity. The point of doing nothing, as I define it, isn't to return to work refreshed and ready to be more productive, but rather to question what we currently perceive as productive. My argument is obviously anticapitalist, especially concerning technologies that encourage a capitalist perception of time, place, self, and community. It is also environmental and historical: I propose that rerouting and deepening one's attention to place will likely lead to awareness of one's participation in history and in a more-than-human community. From either a social or ecological perspective, the ultimate goal of "doing nothing" is to wrest our focus from the attention economy and replant it in the public, physical realm.

I am not anti-technology. After all, there are forms of technology—from tools that let us observe the natural world to decentralized, noncommercial social networks—that might situate us more fully in the present. Rather, I am opposed to the way that corporate platforms buy and sell our attention, as well as to designs and uses of technology that enshrine a narrow definition of productivity and ignore the local, the carnal, and the poetic. I am concerned about the effects of current social media on expression—including the right not to express oneself—and its deliberately addictive features. But the villain here is not necessarily the Internet, or even the idea of social media; it is the invasive logic of *commercial* social media and its financial incentive to keep us in a profitable state of anxiety, envy, and distraction. It is furthermore the cult of individuality and personal branding that grow out of such platforms and affect the way we think about our offline selves and the places where we actually live.

———

GIVEN MY INSISTENCE on attending to the local and present, it's important that this book is rooted in the San Francisco Bay Area, where I grew up and where I currently live. This place is known for two things: technology companies and natural splendor. Here, you can drive directly west from venture-capitalist offices on Sand Hill Road to a redwood forest overlooking the sea, or walk out of the Facebook campus into a salt marsh full of shorebirds. When I was growing up in Cupertino, my mom would sometimes take me to her office at Hewlett-Packard, where I once tried on a very early version of a VR headset. To be sure, I spent a lot of time inside on the computer. But on other days my family would go for long hikes among the oak trees and redwoods in Big Basin, or along the cliffs at San Gregorio State Beach. In the summer, I was often away at camp in the Santa Cruz Mountains, forever learning the name *Sequoia sempervirens*.

I am an artist as well as a writer. In the early 2010s, because I used computers to make my art and maybe because I lived in San Francisco, I got shunted into the catch-all "art-and-technology" category. But my only real interest in technology was how it could give us more access to physical reality, which is where my real loyalties were. This put me in sort of an odd position, as someone who gets invited to tech conferences but who would rather be out bird-watching. It's just one of the strangely "in-between" aspects of my experience, first of all as a biracial person, and secondly as one who makes digital art about the physical world. I have been an artist in residence at such strange places as Recology SF (otherwise known as "the dump"), the San Francisco Planning Department, and the Internet Archive. All along, I've had a love-hate relationship with Silicon Valley as the source of my childhood nostalgia and the technology that created the attention economy.

Sometimes it's good to be stuck in the in-between, even if it's

uncomfortable. Many of the ideas for this book formed over years of teaching studio art and arguing its importance to design and engineering majors at Stanford, some of whom didn't see the point. The sole field trip in my digital design class is simply a hike, and sometimes I have my students sit outside and do nothing for fifteen minutes. I'm realizing that these are my ways of insisting on something. Living between the mountains and this hyper accelerated, entrepreneurial culture, I can't help but ask the question: What does it mean to construct digital worlds while the actual world is crumbling before our eyes?

The odd activities of my class also come from a place of concern. Among my students and in many of the people I know, I see so much energy, so much intensity, and so much anxiety. I see people caught up not just in notifications but in a mythology of productivity and progress, unable not only to rest but simply to see where they are. And during the summer that I wrote this, I saw a catastrophic wildfire without end. This place, just as much as the place where you are now, is calling out to be heard. I think we should listen.

LET'S START IN the hills overlooking Oakland, the city where I currently live. Oakland has two famous trees: first is the Jack London Tree, a gigantic coast live oak in front of City Hall, from which the city gets its tree-shaped logo. The other, which is hidden among the hills, is not as well known. Nicknamed the "Grandfather" or "Old Survivor," it's Oakland's only old-growth redwood left standing, a miraculous five-hundred-year-old holdover from the time before all of the ancient redwoods were logged following the Gold Rush. Though much of the East Bay Hills are covered in redwoods, they are all second growth, sprouted from the stumps of ancestors that at one point were some of the largest on the entire coast. Before 1969, people in Oakland assumed that all of the old-growth trees were gone, until a naturalist happened upon Old Survivor towering over the other trees. Since then, the ancient tree has figured in the

collective imagination, prompting articles, group hikes, and even a documentary.

Before they were logged, the old-growth redwoods of the East Bay Hills also included the Navigation Trees, redwoods that were so tall that sailors in the San Francisco Bay used them to steer clear of the submerged and dangerous Blossom Rock. (When the trees were logged, the Army Corp of Engineers had to literally blow up Blossom Rock.) Though it wasn't one of those trees, I like to think of Old Survivor as its own kind of navigational aid. This wizened tree has a few lessons to teach us that correspond to the course I will try to chart throughout this book.

The first lesson is about resistance. Old Survivor's somewhat legendary status has to do not only with its age and unlikely survival, but its mysterious location. Even those who grew up hiking in the East Bay Hills can have a hard time finding it. When you do spot Old Survivor, you still can't get that close, because it sits on a steep rocky slope whose ascent would require a serious scramble. That's one reason it survived logging; the other reason has to do with its twisted shape and its height: ninety-three feet, a runt compared to other old-growth redwoods. In other words, Old Survivor survived largely by appearing useless to loggers as a timber tree.

To me, this sounds like a real-life version of a story—the title of which is often translated as "The Useless Tree"—from the *Zhuangzi*, a collection of writings attributed Zhuang Zhou, a fourth-century Chinese philosopher. The story is about a carpenter who sees a tree (in one version, a serrate oak, a similar-looking relative to our coast live oak) of impressive size and age. But the carpenter passes it right by, declaring it a "worthless tree" that has only gotten to be this old because its gnarled branches would not be good for timber. Soon afterward, the tree appears to him in a dream and asks, "Are you comparing me with those useful trees?" The tree points out to him that fruit trees and timber trees are regularly ravaged. Meanwhile, uselessness has been this tree's strategy: "This is of great use to me. If I had been of some use, would I ever have grown this large?"

The tree balks at the distinction between usefulness and worth, made by a man who only sees trees as potential timber: "What's the point of this—things condemning things? You a worthless man about to die—how do you know I'm a worthless tree?"[5] It's easy for me to imagine these words being spoken by Old Survivor to the nineteenth-century loggers who casually passed it over, less than a century before we began realizing what we'd lost.

This formulation—the usefulness of uselessness—is typical of Zhuang Zhou, who often spoke in apparent contradictions and non sequiturs. But like his other statements, it's not a paradox for the sake of being a paradox: rather, it's merely an observation of a social world that is itself a paradox, defined by hypocrisy, ignorance, and illogic. In a society like that, a man attempting a humble and ethical life would certainly appear "backward": for him, good would be bad, up would be down, productivity would be destruction, and indeed, uselessness would be useful.

If you'll allow me to stretch this metaphor, we could say that Old Survivor was *too weird* or *too difficult* to proceed easily toward the sawmill. In that way, the tree provides me with an image of "resistance-in-place." To resist in place is to make oneself into a shape that cannot so easily be appropriated by a capitalist value system. To do this means refusing the frame of reference: in this case, a frame of reference in which value is determined by productivity, the strength of one's career, and individual entrepreneurship. It means embracing and trying to inhabit somewhat fuzzier or blobbier ideas: of maintenance as productivity, of the importance of nonverbal communication, and of the mere experience of life as the highest goal. It means recognizing and celebrating a form of the self that changes over time, exceeds algorithmic description, and whose identity doesn't always stop at the boundary of the individual.

In an environment completely geared toward capitalist appropriation of even our smallest thoughts, doing this isn't any less uncomfortable than wearing the wrong outfit to a place with a

dress code. As I'll show in various examples of past refusals-in-place, to remain in this state takes commitment, discipline, and will. Doing nothing is *hard*.

THE OTHER LESSON that Old Survivor offers us has to do with its function as witness and memorial. Even the most stalwart materialist must admit that Old Survivor is different from a man-made monument because it is, after all, *alive*. In a 2011 issue of a community newspaper called *MacArthur Metro*, the late Gordon Laverty, then a retired East Bay Municipal Utility District worker, and his son Larry, wrote a paean to Old Survivor: "There's a fella who lives high up on a slope in nearby Leona Park who's been a witness to our madness here for as long as people have been in Oakland. His name is Old Survivor. He's a redwood tree and he's old." They frame the tree as a witness to history, from the hunting and gathering of the Ohlone people, to the arrival of the Spanish and the Mexicans, to the white profiteers. The tree's viewpoint—unchanging vis-à-vis the many successive follies of newcomers—ultimately makes it a moral symbol for the Lavertys: "Old Survivor still stands . . . as a sentinel to remind us to make our choices wisely."[6]

I see him the same way. Old Survivor is above all a physical fact, a wordless testament to a very real past, both natural and cultural. To look at the tree is to look at something that began growing in the midst of a very different, even unrecognizable world: one where human inhabitants preserved the local balance of life rather than destroying it, where the shape of the coastline was not yet changed, where there were grizzly bears, California condors, and Coho salmon (all of which disappeared from the East Bay in the nineteenth century). This is not the stuff of fable. Indeed, it wasn't even that long ago. Just as surely as the needles that grow from Old Survivor are connected to its ancient roots, the present grows out of the past. This rootedness is something we desperately need when

we find ourselves awash in an amnesiac present and the chain-store aesthetic of the virtual.

These two lessons should give you a sense of where I'm headed in this book. The first half of "doing nothing" is about disengaging from the attention economy; the other half is about reengaging with something else. That "something else" is nothing less than time and space, a possibility only once we meet each other there on the level of attention. Ultimately, against the placelessness of an optimized life spent online, I want to argue for a new "placefulness" that yields sensitivity and responsibility to the historical (what happened here) and the ecological (who and what lives, or lived, here).

In this book, I hold up bioregionalism as a model for how we might begin to think again about place. Bioregionalism, whose tenets were articulated by the environmentalist Peter Berg in the 1970s, and which is widely visible in indigenous land practices, has to do with an awareness not only of the many life-forms of each place, but how they are interrelated, including with humans. Bioregionalist thought encompasses practices like habitat restoration and permaculture farming, but has a cultural element as well, since it asks us to identify as citizens of the bioregion as much as (if not more than) the state. Our "citizenship" in a bioregion means not only familiarity with the local ecology but a commitment to stewarding it together.

It's important for me to link my critique of the attention economy to the promise of bioregional awareness because I believe that capitalism, colonialist thinking, loneliness, and an abusive stance toward the environment all coproduce one another. It's also important because of the parallels between what the economy does to an ecological system and what the attention economy does to our attention. In both cases, there's a tendency toward an aggressive monoculture, where those components that are seen as "not useful" and which cannot be appropriated (by loggers or by Facebook) are the first to go. Because it proceeds from a false understanding of life as atomized and optimizable, this view of usefulness fails to

recognize the ecosystem as a living whole that in fact needs all of its parts to function. Just as practices like logging and large-scale farming decimate the land, an overemphasis on performance turns what was once a dense and thriving landscape of individual and communal thought into a Monsanto farm whose "production" slowly destroys the soil until nothing more can grow. As it extinguishes one species of thought after another, it hastens the erosion of attention.

Why is it that the modern idea of productivity is so often a frame for what is actually the *destruction* of the natural productivity of an ecosystem? This sounds a lot like the paradox in Zhuang Zhou's story, which more than anything is a joke about how narrow the concept of "usefulness" is. When the tree appears to the carpenter in his dream, it's essentially asking him: Useful for what? Indeed, this is the same question I have when I give myself enough time to step back from the capitalist logic of how we currently understand productivity and success. Productivity that produces what? Successful in what way, and for whom? The happiest, most fulfilled moments of my life have been when I was completely aware of being alive, with all the hope, pain, and sorrow that that entails for any mortal being. In those moments, the idea of success as a teleological goal would have made no sense; the moments were ends in themselves, not steps on a ladder. I think people in Zhuang Zhou's time knew the same feeling.

There's an important detail at the beginning of the useless tree story. Multiple versions of it mention that the gnarled oak tree was so large and wide that it should shade "several thousand oxen" or even "thousands of teams of horses." The shape of the useless tree does more than just protect it from the carpenter; it is also the shape of care, of branching out over the thousands of animals who seek shelter, thus providing the grounds for life itself. I want to imagine a whole forest of useless trees, branches densely interwoven, providing an impenetrable habitat for birds, snakes, lizards, squirrels, insects, fungi, and lichen. And eventually,

through this generous, shaded, and useless environment might come a weary traveler from the land of usefulness, a carpenter who has laid down his tools. Maybe after a bit of dazed wandering, he might take a cue from the animals and have a seat beneath an oak tree. Maybe, for the first time ever, he'd take a nap.

LIKE OLD SURVIVOR, you'll find that this book is a bit oddly shaped. The arguments and observations I'll make here are not neat, interlocking parts in a logical whole. Rather, I saw and experienced many things during the course of writing it—things that changed my mind and then changed it again, and which I folded in as I went. I came out of this book different than I went in. So, consider this not a closed transmission of information, but instead an open and extended essay, in the original sense of the word (a journey, an essaying forth). It's less a lecture than an invitation to take a walk.

The first chapter of this book is a version of an essay I wrote in the spring following the 2016 election, about a personal state of crisis that led me to the necessity of doing nothing. In that chapter I begin to identify some of my most serious grievances with the attention economy, namely its reliance on fear and anxiety, and its concomitant logic that "disruption" is more productive than the work of maintenance—of keeping ourselves and others alive and well. Written in the midst of an online environment in which I could no longer make sense of anything, the essay was a plea on behalf of the spatially and temporally embedded human animal; like the technology writer Jaron Lanier, I sought to "double down on being human."

One reaction to all of this is to head for the hills—permanently. In the second chapter, I look at a few different people and groups who took this approach. The countercultural communes of the 1960s in particular have much to teach us about the challenges inherent in trying to extricate oneself completely from the fabric of a capitalist reality, as well as what was sometimes an ill-fated attempt

to escape politics altogether. This is the beginning of an ongoing distinction I'll make between 1) escaping "the world" (or even just other people) entirely and 2) remaining in place while escaping the framework of the attention economy and an over-reliance on a filtered public opinion.

This distinction also forms the basis for the idea of refusal-in-place, the subject of my third chapter. Taking a cue from Herman Melville's "Bartleby, the Scrivener," who answers not "I will not" but "I would prefer not to," I look to the history of refusal for responses that protest the terms of the question itself. And I try to show how that creative space of refusal is threatened in a time of widespread economic precarity, when everyone from Amazon workers to college students see their margin of refusal shrinking, and the stakes for playing along growing. Thinking about what it takes to *afford* refusal, I suggest that learning to redirect and enlarge our attention may be the place to pry open the endless cycle between frightened, captive attention and economic insecurity.

Chapter 4 comes mainly from my experience as an artist and art educator long interested in how art can teach us new scales and tones of attention. I look both to art history and to vision studies to think about the relationship between attention and volition—how we might not only disentangle ourselves from the attention economy but learn to wield attention in a more intentional way. This chapter is also based on my personal experience learning about my bioregion for the first time, a new pattern of attention applied to the place I've lived in my entire life.

If we can use attention to inhabit a new plane of reality, it follows that we might meet each other there by paying attention to the same things and to each other. In Chapter 5, I examine and try to dissolve the limits that the "filter bubble" has placed on how we view the people around us. Then I'll ask you to stretch it even further, extending the same attention to the more-than-human world. Ultimately, I argue for a view of the self and of identity that is the opposite of the personal brand: an unstable, shapeshifting thing deter-

mined by interactions with others and with different kinds of places.

In the last chapter, I try to imagine a utopian social network that could somehow hold all of this. I use the lens of the human bodily need for spatial and temporal context to understand the violence of "context collapse" online and propose a kind of "context collection" in its place. Understanding that meaningful ideas require incubation time and space, I look both to noncommercial decentralized networks and the continued importance of private communication and in-person meetings. I suggest that we withdraw our attention and use it instead to restore the biological and cultural ecosystems where we forge meaningful identities, both individual and collective.

DURING THE SUMMER that I spent nearly every day writing this book, some friends joked about how I was working so hard on something called *How to Do Nothing*. But the real irony is that in writing something by this title, I inadvertently radicalized myself by learning the importance of *doing something*. In my capacity as an artist, I have always thought about attention, but it's only now that I fully understand where a life of sustained attention leads. In short, it leads to awareness, not only of how lucky I am to be alive, but to ongoing patterns of cultural and ecological devastation around me—and the inescapable part that I play in it, should I choose to recognize it or not. In other words, simple awareness is the seed of responsibility.

At some point, I began to think of this as an activist book disguised as a self-help book. I'm not sure that it's fully either. But as much as I hope this book has something to offer you, I also hope it has something to contribute to activism, mostly by providing a rest stop for those on the their way to fight the good fight. I hope that the figure of "doing nothing" in opposition to a productivity-obsessed environment can help restore individuals who can then help restore communities, human and beyond. And most of all, I hope it can help people find ways of connecting that are substan-

tive, sustaining, and absolutely unprofitable to corporations, whose metrics and algorithms have never belonged in the conversations we have about our thoughts, our feelings, and our survival.

One thing I have learned about attention is that certain forms of it are contagious. When you spend enough time with someone who pays close attention to something (if you were hanging out with me, it would be birds), you inevitably start to pay attention to some of the same things. I've also learned that patterns of attention— what we choose to notice and what we do not—are how we render reality for ourselves, and thus have a direct bearing on what we feel is possible at any given time. These aspects, taken together, suggest to me the revolutionary potential of taking back our attention. To capitalist logic, which thrives on myopia and dissatisfaction, there may indeed be something dangerous about something as pedestrian as doing nothing: escaping laterally toward each other, we might just find that everything we wanted is already here.

How to Do
Nothing

Chapter 1

The Case for Nothing

wakes up and looks at phone
ah let's see what fresh horrors await me on the fresh horrors device
— @MISSOKISTIC IN A TWEET ON NOVEMBER 10, 2016

In early 2017, not long after Trump's inauguration, I was asked to give a keynote talk at EYEO, an art and technology conference in Minneapolis. I was still reeling from the election and, like many other artists I knew, found it difficult to continue making anything at all. On top of that, Oakland was in a state of mourning following the 2016 Ghost Ship fire, which took the lives of many artists and community-minded people. Staring at the blank field in which I was supposed to enter my talk title, I thought about what I could possibly say that would be meaningful in a moment like this. Without yet knowing what the talk would actually be, I just typed in "How to Do Nothing."

After that, I decided to ground the talk in a specific place: the Morcom Amphitheatre of Roses in Oakland, California, otherwise known simply as the Rose Garden. I did that partly because it was in the Rose Garden that I began brainstorming my talk. But I had also realized that the garden encompassed everything I wanted to cover: the practice of doing nothing, the architecture of nothing, the importance of public space, and an ethics of care and maintenance.

I live five minutes away from the Rose Garden, and ever since I've lived in Oakland, it's been my default place to go to get away from my computer, where I do much of my work, art and other-

wise. But after the election, I started going to the Rose Garden almost every day. This wasn't exactly a conscious decision; it was more of an innate movement, like a deer going to a salt lick or a goat going to the top of a hill. What I would do there is nothing. I'd just sit there. And although I felt a bit guilty about how incongruous it seemed—beautiful garden versus terrifying world—it really did feel like a necessary survival tactic. I recognized the feeling in a passage from Gilles Deleuze in *Negotiations*:

> We're riddled with pointless talk, insane quantities of words and images. Stupidity's never blind or mute. So it's not a problem of getting people to express themselves but of providing little gaps of solitude and silence in which they might eventually find something to say. Repressive forces don't stop people expressing themselves but rather force them to express themselves; what a relief to have nothing to say, the right to say nothing, because only then is there a chance of framing the rare, and ever rarer, thing that might be worth saying.[1]

He wrote that in 1985, but I could identify with the sentiment in 2016, almost to a painful degree. The function of nothing here—of saying nothing—is that it's a precursor to having something to say. "Nothing" is neither a luxury nor a waste of time, but rather a necessary part of meaningful thought and speech.

Of course, as a visual artist, I've long had an appreciation of doing nothing—or, more properly, making nothing. I had been known to do things like collect hundreds of screenshots of farms or chemical-waste ponds from Google Earth, cutting them out and arranging them in mandala-like compositions. In *The Bureau of Suspended Objects*, a project I did while in residence at Recology SF, I spent three months photographing, cataloging, and researching the origins of two hundred discarded objects. I presented them as a browsable archive in which people could scan a handmade tag next to each object and learn about its manufacturing, material, and cor-

porate history. At the opening, a confused and somewhat indignant woman turned to me and said, "Wait . . . so did you actually make anything? Or did you just put things on shelves?" I often say that my medium is context, so the answer was yes to both.

Part of the reason I work this way is because I find existing things infinitely more interesting than anything I could possibly make. *The Bureau of Suspended Objects* was really just an excuse for me to stare at the amazing things in the dump—a Nintendo Power Glove, a jumble of bicentennial-edition 7UP cans, a bank ledger from 1906—and to give each object the attention it was due. This near-paralyzing fascination with one's subject is something I've termed the "observational eros." There's something like it in the introduction of Steinbeck's *Cannery Row*, where he describes the patience and care involved in close observation of one's specimens:

> When you collect marine animals there are certain flat worms so delicate that they are almost impossible to capture whole, for they break and tatter under the touch. You must let them ooze and crawl of their own will onto a knife blade and then lift them gently into your bottle of sea water. And perhaps that might be the way to write this book—to open the page and let the stories crawl in by themselves.[2]

Given this context, it's perhaps unsurprising that one of my favorite public art pieces was done by a documentary filmmaker. In 1973, Eleanor Coppola carried out a public art project called *Windows*, which materially speaking consisted only of a map with a date and a list of locations in San Francisco. Following Steinbeck's formula, the windows at each location were the bottle, and whatever happened behind them were the stories that "crawled in." Coppola's map reads:

> Eleanor Coppola has designated a number of windows in all parts of San Francisco as visual landmarks. Her purpose in

this project is to bring to the attention of the whole community, art that exists in its own context, where it is found, without being altered or removed to a gallery situation.[3]

I like to consider this piece in contrast with how we normally experience public art, which is some giant steel thing that looks like it landed in a corporate plaza from outer space. Coppola instead casts a subtle frame over the whole of the city itself, a light but meaningful touch that recognizes art that exists where it already is.

A more recent project that acts in a similar spirit is Scott Polach's *Applause Encouraged*, which happened at Cabrillo National Monument in San Diego in 2015. On a cliff overlooking the sea, forty-five minutes before the sunset, a greeter checked guests in to an area of foldout seats formally cordoned off with red rope. They were ushered to their seats and reminded not to take photos. They watched the sunset, and when it finished, they applauded. Refreshments were served afterward.

THESE LAST FEW projects have something important in common. In each, the artist creates a structure—whether that's a map or a cordoned-off area (or even a lowly set of shelves!)—that holds open a contemplative space against the pressures of habit, familiarity, and distraction that constantly threaten to close it. This attention-holding architecture is something I frequently think about at the Rose Garden. Far from your typical flat square garden with simple rows of roses, it sits into a hill, with an endlessly branching system of paths and stairways through and around the roses, trellises, and oak trees. I've observed that everyone moves very slowly, and yes, people do quite literally stop and smell the roses. There are probably a hundred possible ways to wind your way through the garden, and just as many places to sit. Architecturally, the Rose Garden wants you to stay awhile.

You can see this effect at work in the circular labyrinths that

are designed for nothing other than contemplative walking. Labyrinths function similarly to how they appear, enabling a sort of dense infolding of attention; through two-dimensional design alone, they make it possible not to walk straight through a space, nor to stand still, but something very well in between. I find myself gravitating toward these kinds of spaces—libraries, small museums, gardens, columbaria—because of the way they unfold secret and multifarious perspectives even within a fairly small area.

But of course, this infolding of attention doesn't need to be spatialized or visual. For an auditory example, I look to *Deep Listening*, the legacy of the musician and composer Pauline Oliveros. Classically trained in composition, Oliveros was teaching experimental music at UC San Diego in the 1970s. She began developing participatory group techniques—such as performances where people listened to and improvised responses to each other and the ambient sound environment—as a way of working with sound that could bring some inner peace amid the violence and unrest of the Vietnam War.

Deep Listening was one of those techniques. Oliveros defines the practice as "listening in every possible way to every thing possible to hear no matter what you are doing. Such intense listening includes the sounds of daily life, of nature, of one's own thoughts as well as musical sounds."[4] She distinguished between listening and hearing: "To hear is the physical means that enables perception. To listen is to give attention to what is perceived both acoustically and psychologically."[5] The goal and the reward of Deep Listening was a heightened sense of receptivity and a reversal of our usual cultural training, which teaches us to quickly analyze and judge more than to simply observe.

When I learned about Deep Listening, I realized I had unwittingly been practicing it for a while—only in the context of bird-watching. In fact, I've always found it funny that it's called bird-watching, because half if not more of bird-watching is actually bird-listening. (I personally think they should just rename it "bird-noticing.") However you refer to it, what this practice has

in common with Deep Listening is that observing birds requires you quite literally to do nothing. Bird-watching is the opposite of looking something up online. You can't really look *for* birds; you can't make a bird come out and identify itself to you. The most you can do is walk quietly and wait until you hear something, and then stand motionless under a tree, using your animal senses to figure out where and what it is.

What amazed and humbled me about bird-watching was the way it changed the granularity of my perception, which had been pretty "low-res." At first, I just noticed birdsong more. Of course it had been there all along, but now that I was paying attention to it, I realized that it was almost everywhere, all day, all the time. And then, one by one, I started learning each song and associating it with a bird, so that now when I walk into the Rose Garden, I inadvertently acknowledge them in my head as though they were people: "Hi, raven, robin, song sparrow, chickadee, goldfinch, towhee, hawk, nuthatch . . ." and so on. The sounds have become so familiar to me that I no longer strain to identify them; they register instead like speech. This might sound familiar to anyone who has ever learned another (human) language as an adult. Indeed, the diversification of what was previously "bird sounds"—into discrete sounds that mean something to me—is something I can only compare to the moment that I realized that my mom spoke three languages, not two.

My mom has only ever spoken English to me, and for a very long time, I assumed that whenever my mom was speaking to another Filipino person, she was speaking Tagalog. I didn't really have a good reason for thinking this other than that I knew she did speak Tagalog and it sort of all sounded like Tagalog to me. But my mom was only sometimes speaking Tagalog. Other times she was speaking Ilonggo, which is a completely different language that is specific to where she's from in the Philippines. The languages are not the same, i.e., one is not simply a dialect of the other; in fact, the Philippines is full of language groups that, according to my mom,

have so little in common that speakers would not be able to understand each other, and Tagalog is only one.

This type of embarrassing discovery, in which something you thought was one thing is actually two things, and each of those two things is actually ten things, seems like a simple function of the duration and quality of one's attention. With effort, we can become attuned to things, able to pick up and then hopefully differentiate finer and finer frequencies each time.

THERE'S SOMETHING IMPORTANT that the moment of stopping to listen has in common with the labyrinthine quality of attention-holding architecture: in their own ways, each enacts some kind of interruption, a removal from the sphere of familiarity. Every time I see or hear an unusual bird, time stops, and later I wonder where I was, just as wandering some unexpected secret passageway can feel like dropping out of linear time. Even if brief or momentary, these places and moments are retreats, and like longer retreats, they affect the way we see everyday life when we do come back to it.

The location of the Rose Garden—when it was built in the 1930s—was specifically chosen because of the natural bowl shape of the land. The space feels physically and acoustically enclosed, remarkably separate from everything around it. When you sit in the Rose Garden, you truly sit *in* it. Likewise, labyrinths of any kind, by virtue of their shape, collect our attention into these small circular spaces. When Rebecca Solnit, in her book *Wanderlust*, wrote about walking in the labyrinth inside the Grace Cathedral in San Francisco, she found herself barely in the city at all: "The circuit was so absorbing I lost sight of the people nearby and hardly heard the sound of the traffic and the bells for six o'clock."[6]

This isn't a new idea, and it also applies over longer periods of time. Most people have, or have known someone who has, gone through some period of "removal" that fundamentally changed their attitude to the world they returned to. Sometimes that's occa-

sioned by something terrible, like illness or loss, and sometimes it's voluntary, but regardless, that pause in time is often the only thing that can precipitate change on a certain scale.

One of our most famous observers, John Muir, had just such an experience. Before becoming the naturalist that we know him as, he worked as a supervisor and sometimes-inventor in a wagon wheel factory. (I suspect that he was a man concerned with productivity, since one of his inventions was a study desk that was also an alarm clock and timer, which would open up books for an allotted amount of time, close them, and then open the next book.) Muir had already developed a love of botany, but it was being temporarily blinded by an eye accident that made him reevaluate his priorities. The accident confined him to a darkened room for six weeks, during which he was unsure whether he would ever see again.

The 1916 edition of *The Writings of John Muir* is divided into two parts, one before the accident and one after, each with its own introduction by William Frederic Badè. In the second introduction, Badè writes that this period of reflection convinced Muir that "life was too brief and uncertain, and time too precious, to waste upon belts and saws; that while he was pottering in a wagon factory, God was making a world; and he determined that, if his eyesight was spared, he would devote the remainder of his life to a study of the process."[7] Muir himself said, "This affliction has driven me to the sweet fields."[8]

As it turns out, my dad went through his own period of removal when he was my age and working as a technician in the Bay Area. He'd gotten fed up with his job and figured he had enough saved up to quit and live extremely cheaply for a while. That ended up being two years. When I asked him how he spent those years, he said he read a lot, rode his bike, studied math and electronics, went fishing, had long chats with his friend and roommate, and sat in the hills, where he taught himself the flute. After a while, he says, he realized that a lot of his anger about his job and out-

side circumstances had more to do with him than he realized. As he put it, "It's just you with yourself and your own crap, so you have to deal with it." But that time also taught my dad about creativity, and the state of openness, and maybe even the boredom or nothingness, that it requires. I'm reminded of a 1991 lecture by John Cleese (of Monty Python) on creativity, in which two of the five required factors he lists are time:

1. Space
2. Time
3. Time
4. Confidence
5. ~~A 22-inch waist~~ Humor[9]

And so at the end of this stretch of open time, my dad looked around for another job and realized that the one he'd had was actually pretty good. Luckily for him, they welcomed him back ~~without hesitation~~ open arms. But also, because he'd discovered what was necessary for his own creativity, things weren't exactly the same the second time around. With renewed energy and a different perspective on his job, he went from technician to engineer, and has filed around twelve patents so far. To this day, he insists that he comes up with all of his best ideas on the top of a hill after a long bike ride.

This got me thinking that perhaps the granularity of attention we achieve outward also extends inward, so that as the perceptual details of our environment unfold in surprising ways, so too do our own intricacies and contradictions. My dad said that leaving the confined context of a job made him understand himself not in relation to that world, but just to the world, and forever after that, things that happened at work only seemed like one small part of something much larger. It reminds me of how John Muir described himself not as a naturalist but as a "poetico-trampo-geologist-botanist and ornithologist-naturalist etc. etc.," or of how Pauline Oliveros described herself in 1974:

Pauline Oliveros is a two legged human being, female, les-
bian, musician, and composer among other things which
contribute to her identity. She is herself and lives with her
partner . . . along with assorted poultry, dogs, cats, rabbits
and tropical hermit crabs.[10]

Of course, there's an obvious critique of all of this, and that's that
it comes from a place of privilege. I can go to the Rose Garden, stare
into trees, and sit on hills all the time because I have a teaching
job that only requires me to be on campus two days a week, not
to mention a whole set of other privileges. Part of the reason my
dad could take that time off was that on some level, he had cause
to think he could get another job. It's very possible to understand
the practice of doing nothing solely as a self-indulgent luxury, the
equivalent of taking a mental health day, if you're lucky enough to
work at a place that has those.

But here I come back to Deleuze's "right to say nothing," and
just because this right is denied to many people doesn't make it
any less of a right or any less important. As far back as 1886, de-
cades before it would finally be guaranteed, workers in the United
States pushed for an eight-hour workday: "eight hours of work,
eight hours of rest, and eight hours of what we will." The famous
graphic by the Federation of Organized Trades and Labor Unions
shows this motto corresponding to three sections of the day: a
textile worker at her station, a sleeping person's feet sticking out
of a blanket, and a couple sitting in a boat on a lake, reading a
union newspaper.

The movement also had its own song:

We mean to make things over;
we're tired of toil for naught
but bare enough to live on:
never an hour for thought.

We want to feel the sunshine;
we want to smell the flowers;
We're sure that God has willed it,
and we mean to have eight hours.

We're summoning our forces
from shipyard, shop and mill:
Eight hours for work, eight hours for rest,
eight hours for what we will![11]

Here, I'm struck by the types of things associated with the category "what we will": rest, thought, flowers, sunshine. These are bodily, human things, and this bodily-ness is something I will come back to. When Samuel Gompers, who led the labor group that organized this particular iteration of the eight-hour movement, gave an address titled "What Does Labor Want?" the answer he arrived at was, "It wants the earth and the fullness thereof."[12] And to me it seems significant that it's not eight hours of, say, "leisure" or "education," but "eight hours of what we will." Although leisure or education might be involved, the most humane way to describe that period is to refuse to define it.

That campaign was about a demarcation of time. So it's interesting, and certainly troubling, to understand the decline in labor unions in the last several decades alongside a similar decline in the demarcation of public space. True public spaces, the most obvious examples being parks and libraries, are places for—and thus the spatial underpinnings of—"what we will." A public, noncommercial space demands nothing from you in order for you to enter, nor for you to stay; the most obvious difference between public space and other spaces is that you don't have to buy anything, or pretend to want to buy something, to be there.

Consider an actual city park in contrast to a faux public space like Universal CityWalk, which one passes through upon leaving the Universal Studios theme park. Because it interfaces between

the theme park and the actual city, CityWalk exists somewhere in between, almost like a movie set, where visitors can consume the supposed diversity of an urban environment while enjoying a feeling of safety that results from its actual homogeneity. In an essay about such spaces, Eric Holding and Sarah Chaplin call CityWalk "a 'scripted space' par excellence, that is, a space which excludes, directs, supervises, constructs, and orchestrates use."[3] Anyone who has ever tried any funny business in a faux public space knows that such spaces do not just script actions, they police them. In a public space, ideally, you are a citizen with agency; in a faux public space, you are either a consumer or a threat to the design of the place.

The Rose Garden is a public space. It is a Works Progress Administration (WPA) project from the 1930s, and like all WPA projects, was built by people put to work by the federal government during the Depression. I'm reminded of its beginnings every time I see its dignified architecture: that this rose garden, an incredible public good, came out of a program that itself was also a public good. Still, it wasn't surprising to me to find out recently that the Rose Garden is in an area that almost got turned into condos in the seventies. I'm appalled, but not surprised. I'm also not surprised that it took a concerted effort by local residents to have the area rezoned to prevent that from happening. That's because this kind of thing always seems to be happening: those spaces deemed commercially unproductive are always under threat, since what they "produce" can't be measured or exploited or even easily identified—despite the fact that anyone in the neighborhood can tell you what an immense value the garden provides.

Currently, I see a similar battle playing out for our time, a colonization of the self by capitalist ideas of productivity and efficiency. One might say the parks and libraries of the self are always about to be turned into condos. In *After the Future*, the Marxist theorist Franco "Bifo" Berardi ties the defeat of labor movements in the eighties to rise of the idea that we should all be entrepreneurs. In the past, he notes, economic risk was the business of the capitalist,

the investor. Today, though, "'we are all capitalists' . . . and there-
fore, we all have to take risks . . . The essential idea is that we should
all consider life as an economic venture, as a race where there are
winners and losers."[14]

The way that Berardi describes labor will sound as familiar to
anyone concerned with their personal brand as it will to any Uber
driver, content moderator, hard-up freelancer, aspiring YouTube
star, or adjunct professor who drives to three campuses in one
week:

> In the global digital network, labor is transformed into small
> parcels of nervous energy picked up by the recombining ma-
> chine . . . The workers are deprived of every individual con-
> sistency. Strictly speaking, the workers no longer exist. **Their
> time exists, their time is there, permanently available to
> connect**, to produce in exchange for a temporary salary.[15]
> (emphasis mine)

The removal of economic security for working people dissolves
those boundaries—eight hours for work, eight hours for rest, eight
hours for what we will—so that we are left with twenty-four poten-
tially monetizable hours that are sometimes not even restricted to
our time zones or our sleep cycles.

In a situation where every waking moment has become the time
in which we make our living, and when we submit even our lei-
sure for numerical evaluation via likes on Facebook and Instagram,
constantly checking on its performance like one checks a stock,
monitoring the ongoing development of our personal brand, time
becomes an economic resource that we can no longer justify spend-
ing on "nothing." It provides no return on investment; it is simply
too expensive. This is a cruel confluence of time and space: just
as we lose noncommercial spaces, we also see all of our own time
and our actions as potentially commercial. Just as public space gives
way to faux public retail spaces or weird corporate privatized parks,

so we are sold the idea of compromised leisure, a freemium leisure that is a very far cry from "what we will."

In 2017, while I was an artist in residence at the Internet Archive in San Francisco, I spent a lot of time going through the ads in old issues of *BYTE*, a 1980s-era hobbyist computing magazine. Among unintentionally surreal images—a hard drive plugged into an apple, a man arm wrestling with his desktop computer, or a California gold miner holding up a pan of computer chips and saying, "Eureka!"—I came across a lot of ads about computers whose main point was that they were going to save you time working. My favorite was an ad by NEC, whose motto was "Taking it to the limit." The ad, titled "Power Lunch," shows a man at home, typing on a computer whose screen shows a bar graph of increasing values. He drinks a small carton of milk, but his sandwich is untouched. Taking it to the limit indeed.

Part of what's so painful about this image is that we know how this story ends; yes, it did get easier to work. From anywhere. All the time! For an extreme example, look no further than Fiverr, a microtasking site where users sell various tasks—basically, units of their time—for five dollars each. Those tasks could be anything: copyediting, filming a video of themselves doing something of your choice, or pretending to be your girlfriend on Facebook. To me, Fiverr is the ultimate expression of Franco Berardi's "fractals of time and pulsating cells of labor."[16]

In 2017, Fiverr ran a similar ad to NEC's "Power Lunch," but missing the lunch. In this one, a gaunt twenty-something stares dead-eyed into the camera, accompanied by the following text: "You eat a coffee for lunch. You follow through on your follow-through. Sleep deprivation is your drug of choice. You might be a doer." Here, the idea that you would even withhold some of that time to sustain yourself with food is essentially ridiculed. In a *New Yorker* article aptly titled "The Gig Economy Celebrates Working Yourself to Death," Jia Tolentino concludes after reading a Fiverr press release: "This is the jargon through which the essentially cannibalistic na-

ture of the gig economy is dressed up as an aesthetic. No one wants to eat coffee for lunch or go on a bender of sleep deprivation—or answer a call from a client while having sex, as recommended in [Fiverr's promotional] video."[7] When every moment is a moment you could be working, power lunch becomes power lifestyle.

Though it finds its baldest expression in things like the Fiverr ads, this phenomenon—of work metastasizing throughout the rest of life—isn't constrained to the gig economy. I learned this during the few years that I worked in the marketing department of a large clothing brand. The office had instituted something called the Results Only Work Environment, or ROWE, which meant to abolish the eight-hour workday by letting you work whenever from wherever, as long as you got your work done. It sounded noble enough, but there was something in the name that bothered me. After all, what is the *E* in ROWE? If you could be getting results at the office, in your car, at the store, at home after dinner—aren't those all then "work environments"? At that time, in 2011, I'd managed not to get a phone with email yet, and with the introduction of this new workday, I put off getting one even longer. I knew exactly what would happen the minute I did: that every minute of every day I would in fact be answerable to someone, even if my leash was a lot longer.

Our required reading, *Why Work Sucks and How to Fix It: The Results-Only Revolution*, by the creators of ROWE, seemed well intended, as the authors attempted to describe a merciful slackening of the "be in your chair from nine to five" model. But I was nonetheless troubled by how the work and non-work selves are completely conflated throughout the text. They write:

> If you can have your time and work and live and be a person, then the question you're faced with every day isn't, Do I really have to go to work today? but, How do I contribute to this thing called life? What can I do today to benefit my family, my company, myself?[8]

To me, "company" doesn't belong in that sentence. Even if you love your job! Unless there's something specifically about you or your job that requires it, there is nothing to be admired about being constantly connected, constantly potentially productive the second you open your eyes in the morning—and in my opinion, no one should accept this, not now, not ever. In the words of Othello: "Leave me but a little to myself."

This constant connection—and the difficulty of maintaining any kind of silence or interiority—is already a problem, but after the 2016 election it seemed to take on new dimensions. I was seeing that the means by which we give over our hours and days are the same with which we assault ourselves with information and misinformation, at a frankly inhumane rate. Obviously the solution is not to stop reading the news, or even what other people have to say about that news, but we could use a moment to examine the relationship between attention span and the speed of information exchange.

Berardi, contrasting modern-day Italy with the political agitations of the 1970s, says the regime he inhabits "is not founded on the repression of dissent; nor does it rest on the enforcement of silence. On the contrary, it relies on the proliferation of chatter, the irrelevance of opinion and discourse, and on making thought, dissent, and critique banal and ridiculous." Instances of censorship, he says, "are rather marginal when compared to what is essentially an immense informational overload and an actual siege of attention, combined with the occupation of the sources of information by the head of the company."[19]

It is this *financially incentivized* proliferation of chatter, and the utter speed at which waves of hysteria now happen online, that has so deeply horrified me and offended my senses and cognition as a human who dwells in human, bodily time. The connection between the completely virtual and the utterly real, as evidenced by something like Pizzagate, or the doxing and swatting of online journalists, is deeply, fundamentally disturbing on a human

phenomenological level. I know that in the months after the election, a lot of people found themselves searching for this thing called "truth," but what I also felt to be missing was just reality, something I could point to after all of this and say, *This is really real.*

IN THE MIDDLE of this postelection heartbreak and anxiety, I was still looking at birds. Not just any birds, and not even a species, but a few specific individuals. First, it was a couple of black-crowned night herons that reliably perch outside of a KFC in my neighborhood, almost all day and night. If you've never seen one, night herons are stocky compared to other herons. My boyfriend once described them as a cross between a penguin and Paul Giamatti. They have a grumpy stoicism about them, sitting hunched over with their long neck completely hidden away. I sometimes affectionately refer to these birds as "the colonels" (because of their location) or "my precious footballs" (because of their shape).

Without really thinking about it, I modified my path home from the bus to pass by the night herons whenever I could, just to be reassured by their presence. I remember specifically feeling comforted by the presence of these strange birds, like I could look up from the horrifying maelstrom of that day's Twitter and they'd probably be there, unmoving with their formidable beaks and their laser-red eyes. (In fact, I even found them sitting in the same place on 2011 Google Street View, and I have no doubt they were there earlier, but Street View doesn't go back any further.) The KFC is near Lake Merritt, a man-made lake in a completely developed area that, like much of the East Bay and the Peninsula, used to be the type of wetlands that herons and other shorebirds love. Night herons have existed here since before Oakland was a city, holdovers from that marshier time. Knowing this made the KFC night herons begin to seem like ghosts to me, especially at night when the streetlights would make their white bellies glow from below.

One of the reasons the night herons are still here is that, like

crows, they don't mind humans, traffic, or the occasional piece of trash for dinner. And indeed, crows were the other birds I had started paying more attention to. I had just finished reading Jennifer Ackerman's *The Genius of Birds* and had learned that crows are incredibly intelligent (in the way that humans measure intelligence, anyway) and can recognize and remember human faces. They have been documented making and using tools in the wild. They can also teach their children who are the "good" and "bad" humans—good being ones who feed them and bad being ones who try to catch them or otherwise displease them. They can hold grudges for years. I'd seen crows all my life, but now I became curious about the ones in my neighborhood.

My apartment has a balcony, so I started leaving a few peanuts out on it for the crows. For a long time the peanuts just stayed there and I felt like a crazy person. And then once in a while I'd notice that one was gone, but I couldn't be sure who took it. Then a couple times I saw a crow come by and swipe one, but it wouldn't stay. And this went on for a while until finally they began hanging out on a telephone wire nearby. One started coming every day around the time that I eat breakfast, sitting exactly where I could see it from the kitchen table, and it would caw to make me come out on the balcony with a peanut. Then one day it brought its kid, which I knew was its kid because the big one would groom the smaller one and because the smaller one had an undeveloped, chicken-like squawk. I named them Crow and Crowson.

I soon discovered that Crow and Crowson preferred it when I threw peanuts off the balcony so they could do fancy dives off the telephone line. They'd do twists, barrel rolls, and loops, which I made slow-motion videos of with the obsessiveness of a proud parent. Sometimes they wouldn't want any more peanuts and would just sit there and stare at me. One time Crowson followed me halfway down the street. And frankly, I spent a lot of time staring back at them, to the point that I wondered what the neighbors might think. But again, like the night herons, I found their company com-

THE CASE FOR NOTHING

forting, somehow extremely so given the circumstances. It was comforting that these essentially wild animals recognized me, that I had some place in their universe, and that even though I had no idea what they did the rest of the day, that they would (and still do) stop by my place every day—that sometimes I can even wave them over from a faraway tree.

Inevitably, I began to wonder what these birds see when they look at me. I assume they just see a human who for some reason pays attention to them. They don't know what my work is, they don't see progress—they just see recurrence, day after day, week after week. And through them, I am able to inhabit that perspective, to see myself as the human animal that I am, and when they fly off, to some extent, I can inhabit that perspective too, noticing the shape of the hill that I live on and where all of the tall trees and good landing spots are. I noticed that some ravens live half in and half out of the Rose Garden, until I realized that there is no "rose garden" to them. These alien animal perspectives on me and our shared world have provided me not only with an escape hatch from contemporary anxiety but also a reminder of my own animality and the animateness of the world I live in. Their flights enable my own literal flights of fancy, recalling a question that one of my favorite authors, David Abram, asks in *Becoming Animal: An Earthly Cosmology*: "Do we really believe that the human imagination can sustain itself without being startled by other shapes of sentience?"[20]

Strange as it sounds, this explained my need to go to the Rose Garden after the election. What was missing from that surreal and terrifying torrent of information and virtuality was any regard, any place, for the human animal, situated as she is in time and in a physical environment with other human and nonhuman entities. It turns out that groundedness requires *actual ground*. "Direct sensuous reality," writes Abram, "in all its more-than-human mystery, remains the sole solid touchstone for an experiential world now inundated with electronically generated vistas and engineered pleasures; only in regular contact with the tangible ground and sky can

we learn how to orient and to navigate in the multiple dimensions that now claim us."[21]

When I realized this, I grabbed on to it like a life raft, and I haven't let go. *This* is real. Your eyes reading this text, your hands, your breath, the time of day, the place where you are reading this— these things are real. I'm real too. I am not an avatar, a set of prefer- ences, or some smooth cognitive force; I'm lumpy and porous, I'm an animal, I hurt sometimes, and I'm different one day to the next. I hear, see, and smell things in a world where others also hear, see, and smell me. And it takes a break to remember that: a break to do nothing, to just listen, to remember in the deepest sense *what*, *when*, and *where* we are.

I WANT TO be clear that I'm not actually encouraging anyone to stop doing things completely. In fact, I think that "doing nothing"—in the sense of refusing productivity and stopping to listen—entails an active process of listening that seeks out the effects of racial, environ- mental, and economic injustice and brings about real change. I con- sider "doing nothing" both as a kind of deprogramming device and as sustenance for those feeling too disassembled to act meaningfully. On this level, the practice of doing nothing has several tools to offer us when it comes to resisting the attention economy.

The first tool has to do with repair. In such times as these, having recourse to periods of and spaces for "doing nothing" is of utmost importance, because without them we have no way to think, reflect, heal, and sustain ourselves—individually or collectively. There is a kind of nothing that's necessary for, at the end of the day, doing some- thing. When overstimulation has become a fact of life, I suggest that we reimagine #FOMO as #NOMO, the necessity of missing out, or if that bothers you, #NOSMO, the necessity of sometimes missing out.

That's a strategic function of nothing, and in that sense, you could file what I've said so far under the heading of self-care. But if you do, make it "self-care" in the activist sense that Audre Lorde

meant it in the 1980s, when she said that "[c]aring for myself is not self-indulgence, it is self preservation, and that is an act of political warfare." This is an important distinction to make these days, when the phrase "self-care" is appropriated for commercial ends and risks becoming a cliché. As Gabrielle Moss, author of *Glop: Nontoxic, Expensive Ideas That Will Make You Look Ridiculous and Feel Pretentious* (a book parodying goop, Gwyneth Paltrow's high-priced wellness empire), put it: self-care "is poised to be wrenched away from activists and turned into an excuse to buy an expensive bath oil."[22]

The second tool that doing nothing offers us is a sharpened ability to listen. I've already mentioned Deep Listening, but this time I mean it in the broader sense of understanding one another. To do nothing is to hold yourself still so that you can perceive what is actually there. As Gordon Hempton, an acoustic ecologist who records natural soundscapes, put it: "Silence is not the absence of something but the presence of everything."[23] Unfortunately, our constant engagement with the attention economy means that this is something many of us (myself included) may have to relearn. Even with the problem of the filter bubble aside, the platforms that we use to communicate with each other do not encourage listening. Instead they reward shouting and oversimple reaction: of having a "take" after having read a single headline.

I alluded earlier to the problem of speed, but this is also a problem both of listening and of bodies. There is in fact a connection between 1) listening in the Deep Listening, bodily sense, and 2) listening, as in me understanding your perspective. Writing about the circulation of information, Berardi makes a distinction that's especially helpful here, between what he calls connectivity and sensitivity. Connectivity is the rapid circulation of information among compatible units—an example would be an article racking up a bunch of shares very quickly and unthinkingly by like-minded people on Facebook. With connectivity, you either are or are not compatible. Red or blue: check the box. In this transmission of information, the units don't change, nor does the information.

Sensitivity, in contrast, involves a difficult, awkward, ambiguous encounter between two differently shaped bodies that are themselves ambiguous—and this meeting, this sensing, requires and takes place in time. Not only that, due to the effort of sensing, the two entities might come away from the encounter a bit different than they went in. Thinking about sensitivity reminds me of a monthlong artist residency I once attended with two other artists in an extremely remote location in the Sierra Nevada. There wasn't much to do at night, so one of the artists and I would sometimes sit on the roof and watch the sunset. She was Catholic and from the Midwest; I'm sort of the quintessential California atheist. I have really fond memories of the languid, meandering conversations we had up there about science and religion. And what strikes me is that neither of us ever convinced the other—that wasn't the point—but we listened to each other, and we did each come away different, with a more nuanced understanding of the other person's position.

So connectivity is a share or, conversely, a trigger; sensitivity is an in-person conversation, whether pleasant or difficult, or both. Obviously, online platforms favor connectivity, not simply by virtue of being online, but also arguably for profit, since the difference between connectivity and sensitivity is time, and time is money. Again, too expensive.

As the body disappears, so does our ability to empathize. Berardi suggests a link between our senses and our ability to make sense, asking us to "hypothesize the connection between the expansion of the infosphere . . . and the crumbling of the sensory membrane that allows human beings to understand that which cannot be verbalized, that which cannot be reduced to codified signs."[24] In the environment of our online platforms, "that which cannot be verbalized" is figured as excess or incompatible, although every in-person encounter teaches us the importance of nonverbal expressions of the body, not to mention the very matter-of-fact presence of the body in front of me.

BUT BEYOND SELF-CARE and the ability to (really) listen, the practice of doing nothing has something broader to offer us: an antidote to the rhetoric of growth. In the context of health and ecology, things that grow unchecked are often considered parasitic or cancerous. Yet we inhabit a culture that privileges novelty and growth over the cyclical and the regenerative. Our very idea of productivity is premised on the idea of producing something new, whereas we do not tend to see maintenance and care as productive in the same way.

This is the place to mention a few regulars of the Rose Garden. Besides Rose the wild turkey and Grayson the cat (who will sit on your book if you're trying to read), you are always likely to see a few of the park's volunteers doing maintenance. Their presence is a reminder that the Rose Garden is beautiful in part because it is cared for, that effort must be put in, whether that's saving it from becoming condos or just making sure the roses come back next year. The volunteers do such a good job that I often see park visitors walk up to them and thank them for what they're doing.

When I see them pulling weeds and arranging hoses, I often think of the artist Mierle Laderman Ukeles. Her well-known pieces include *Washing/Tracks/Maintenance: Outside*, a performance in which she washed the steps of the Wadsworth Atheneum, and *Touch Sanitation Performance*, in which she spent eleven months shaking hands with and thanking New York City's 8,500 sanitation men, in addition to interviewing and shadowing them. She has in fact been a permanent artist in residence with the New York City Sanitation Department since 1977.

Ukeles's interest in maintenance was partly occasioned by her becoming a mother in the 1960s. In an interview, she explained, "Being a mother entails an enormous amount of repetitive tasks. I became a maintenance worker. I felt completely abandoned by my culture because it didn't have a way to incorporate sustaining

work." In 1969, she wrote the "Manifesto for Maintenance Art", an exhibition proposal in which she considers her own maintenance work as the art. She says, "I will live in the museum and do what I customarily do at home with my husband and my baby, for the duration of the exhibition . . . My working will be the work."[25] Her manifesto opens with a distinction between what she calls the death force and the life force:

I. IDEAS

A. The Death Instinct and the Life Instinct:

The Death Instinct: separation, individuality, Avant-Garde par excellence; to follow one's own path—do your own thing; dynamic change.

The Life Instinct: unification; the eternal return; the perpet-uation and MAINTENANCE of the species; survival systems and operations, equilibrium.[26]

The life force is concerned with cyclicality, care, and regenera-tion; the death force sounds to me a lot like "disrupt." Obviously, some amount of both is necessary, but one is routinely valorized, not to mention masculinized, while the other goes unrecognized because it has no part in "progress."

That brings me to one last surprising aspect of the Rose Garden, which I first noticed on the central promenade. Set into the concrete on either side are a series of numbers in the tens, each signifying a decade, and within each decade are ten plaques with the names of various women. As it turns out, the names are of women who were voted Mother of the Year by Oakland residents. To be Mother of the Year, you must have "contributed to improving the quality of life for the people of Oakland—through home, work, community service, volunteer efforts or combination thereof."[27] In an old in-dustry film about Oakland, I found footage of a Mother of the Year

ceremony from the 1950s. After a series of close-ups on different roses, someone hands a bouquet to an elderly woman and kisses her on the forehead. And for a few days this last May, I noticed an unusual number of volunteers in the garden, sprucing everything up, repainting things. It took me a while to realize they were preparing for Mother of the Year 2017, Malia Luisa Latu Saulala, a local church volunteer.

I'm mentioning this celebration of mothers in the context of work that sustains and maintains—but I don't think that one needs to be a mother to experience a maternal impulse. At the end of *Won't You Be My Neighbor?*, the stunning 2018 documentary on Fred Rogers (aka Mister Rogers), we learn that in his commencement speeches, Rogers would ask the audience to sit and think about someone who had helped them, believed in them, and wanted the best for them. The filmmakers then ask the interviewees to do this. For the first time, the voices we've been hearing for the past hour or so fall silent; the film cuts between different interviewees, each thinking, looking slightly off camera. Judging from the amount of sniffling in the theater where I saw this film, many in the audience were also thinking of their own mothers, fathers, siblings, friends. Rogers's point in the commencement speeches was made anew: we are all familiar with the phenomenon of selfless care from at least some part of our lives. This phenomenon is no exception; it is at the core of what defines the human experience.

Thinking about maintenance and care for one's kin also brings me back to a favorite book, *A Paradise Built in Hell: The Extraordinary Communities That Arise in Disaster*, in which Rebecca Solnit dispenses with the myth that people become desperate and selfish after disasters. From the 1906 San Franscisco earthquake to Hurricane Katrina, she gives detailed accounts of the surprising resourcefulness, empathy, and sometimes even humor that arise in dark circumstances. Several of her interviewees report feeling a strange nostalgia for the purposefulness and the connection they felt with their neighbors immediately following a disaster. Solnit

suggests that the real disaster is everyday life, which alienates us from each other and from the protective impulse that we harbor.

And as my familiarity with and love for the crows grows over the years, I'm reminded that we don't even need to limit this sense of kinship to the human realm. In her essay "Anthropocene, Capitalocene, Plantationocene, Chthulucene: Making Kin," Donna J. Haraway reminds us that *relatives* in British English meant "logical relations" until the seventeenth century, when they became "family members." Haraway is less interested in individuals and genealogical families than in symbiotic configurations of different kinds of beings maintained through the practice of care—asking us to "make kin, not babies!" Citing Shakespeare's punning between "kin" and "kind," she writes, "I think that the stretch and recomposition of kin are allowed by the fact that all earthlings are kin in the deepest sense, and it is past time to practice better care of kinds-as-assemblages (not species one at a time). Kin is an assembling sort of word."[28]

Gathering all this together, what I'm suggesting is that we take a protective stance toward ourselves, each other, and whatever is left of what makes us human—including the alliances that sustain and surprise us. I'm suggesting that we protect our *spaces* and our *time* for non-instrumental, noncommercial activity and thought, for maintenance, for care, for conviviality. And I'm suggesting that we fiercely protect our human animality against all technologies that actively ignore and disdain the body, the bodies of other beings, and the body of the landscape that we inhabit. In *Becoming Animal*, Abram writes that "all our technological utopias and dreams of machine-mediated immortality may fire our minds but they cannot feed our bodies. Indeed, most of this era's transcendent technological visions remain motivated by a fright of the body and its myriad susceptibilities, by a fear of our carnal embedment in a world ultimately beyond our control—by our terror of the very wildness that nourishes and sustains us."[29]

Certain people would like to use technology to live longer, or forever. Ironically, this desire perfectly illustrates the death drive at play in the "Manifesto of Maintenance Art" ("separation, individuality, Avant-Garde par excellence; to follow one's own path— do your own thing; dynamic change")[30]. To such people I humbly propose a far more parsimonious way to live forever: to exit the trajectory of productive time, so that a single moment might open almost to infinity. As John Muir once said, "Longest is the life that contains the largest amount of time-effacing enjoyment."

Of course, such a solution isn't good for business, nor can it be considered particularly innovative. But in the long meantime, as I sit in the deep bowl of the Rose Garden, surrounded by various human and nonhuman bodies, inhabiting a reality interwoven by myriad bodily sensitivities besides my own—indeed, the very boundaries of my own body overcome by the smell of jasmine and just-ripening blackberry—I look down at my phone and wonder if it isn't its own kind of sensory-deprivation chamber. That tiny, glowing world of metrics cannot compare to this one, which speaks to me instead in breezes, light and shadow, and the unruly, indescribable detail of the real.

Chapter 2

The Impossibility of Retreat

A lot of people withdraw from society, as an experiment . . . So I
thought I would withdraw and see how enlightening it would be.
But I found out that it's not enlightening. I think that what you're
supposed to do is stay in the midst of life.

—AGNES MARTIN[1]

If doing nothing requires space and time away from the unforgiv-
ing landscape of productivity, we might be tempted to conclude
that the answer is to turn our backs to the world, temporarily or
for good. But this response would be shortsighted. All too often,
things like digital detox retreats are marketed as a kind of "life
hack" for increasing productivity upon our return to work. And
the impulse to say goodbye to it all, *permanently*, doesn't just neglect
our responsibility to the world that we live in; it is largely unfeasi-
ble, and for good reason.

Last summer, I accidentally staged my own digital detox retreat. I
was on a solitary trip to the Sierra Nevada to work on a project about
the Mokelumne River, and the cabin I had booked had no cell re-
ception and no Wi-Fi. Because I hadn't expected this to be the case,
I was also unprepared: I hadn't told people I would be offline for
the next few days, hadn't answered important emails, hadn't down-
loaded music. Alone in the cabin, it took me about twenty minutes
to stop freaking out about how abruptly disconnected I felt.

But after that brief spell of panic, I was surprised to find how
quickly I stopped caring. Not only that, I was fascinated with how

inert my phone appeared as an object; it was no longer a portal to a thousand other places, a machine charged with dread and potentiality, or even a communication device. It was just a black metal rectangle, lying there as silently and matter-of-factly as a sweater or a book. Its only use was as a flashlight and a timer. With newfound peace of mind, I worked on my project unperturbed by the information and interruptions that would have otherwise lit up that tiny screen every few minutes. To be sure, it gave me a valuable new perspective on how I use technology. But as easy as it was to romanticize giving everything up and living like a hermit in this isolated cabin, I knew I eventually needed to return home, where the world waited and the real work remained to be done.

The experience made me think of Levi Felix, one of the early proponents of digital detox. Felix's narrative is an archetypal story not only of tech burnout but of a Westerner "finding himself" in the East. In 2008, at the age of twenty-three, Felix had been working seventy-hour weeks as the VP of a startup in Los Angeles when he was hospitalized for complications arising from stress. Taking this as a wake-up call, he traveled to Cambodia with Brooke Dean, his girlfriend and later wife; together, they unplugged and discovered mindfulness and meditation of a distinctly Buddhist flavor. On the way back from his travels, Felix and Dean noticed that "every restaurant, every bar, every cafe, every bus, every subway was filled with people looking at their screens."[2] Compelled to share the mindfulness they had discovered abroad, they opened Camp Grounded, a digital detox summer camp for adults in Mendocino, California.

Felix was particularly concerned with the addictive features of everyday technology. While he wouldn't disavow technology entirely, claiming to be a "geek, not a Luddite," he thought that people could at least learn a healthier relationship to it. "I'd like to see more people looking into people's faces instead of looking in their screens," he'd say.[3] Arriving at Camp Grounded, visitors passed through a "cultish tech-check tent run by the International Institute

of Digital Detoxification,"[4] where they recited a pledge, watched a five-minute video involving sock puppets, and handed their phones over to camp guides wearing hazmat suits, who sealed them in plastic bags labeled "biohazard." They agreed to a set of rules:

- No Digital Technology
- No Networking
- No Phones, Internet or Screens
- No Work-Talk
- No Clocks
- No Boss
- No Stress
- No Anxiety
- No FOMO (fear of missing out)[5]

Instead of these things, visitors chose from fifty decidedly analog activities like "superfood truffle-making, cuddle therapy, pickling, stilt-walking, laughter yoga, solar carving, Pajama Brunch choir, creative writing on typewriters, stand-up comedy, and archery." All of this required a lot of planning. In his tribute to Felix, who passed away in 2017 after a battle with brain cancer, Smiley Poswolsky writes that "Levi would spend hours (literally, hours) walking around with the production team at night, making sure each tree was perfectly lit and would make someone feel the magical power of being in nature."[6]

The camp's aesthetics, philosophy, and madcap humor suggest that the vibe that Felix was so meticulously designing for was specifically informed by Burning Man. And indeed, Felix was a Burning Man enthusiast. Poswolsky fondly recalls the time Felix was invited to speak alongside Dennis Kucinich at IDEATE, a camp at Burning Man. Felix took the opportunity to evangelize:

> Levi took a shot of tequila, made himself a Bloody Mary, and
> wearing a white dress and a pink wig, went over and spoke

for forty-five minutes on the importance of unplugging from technology, as our friend Ben Madden played a Casio synth in the background. I couldn't tell you exactly what Levi said that morning since I was delirious, but I do remember that everyone who was there said it was one of the most inspiring talks they had ever heard.

Much has been written lately about how Burning Man is not what it used to be. Indeed, it breaks most of the rules that Levi adopted for his own experiment. The festival, which started as an illegal bonfire on Baker Beach in San Francisco in 1986 before moving to Black Rock Desert, has become an attraction for the libertarian tech elite, something Sophie Morris sums up nicely in the title of her piece on the festival: "Burning Man: From far-out freak-fest to corporate schmoozing event." Mark Zuckerberg famously helicoptered into Burning Man in 2015 to serve grilled cheese sandwiches, while others from the upper echelon of Silicon Valley have enjoyed world-class chefs and air-conditioned yurts. Morris quotes the festival's director of business and communications, who unflinchingly describes Burning Man as "a little bit like a corporate retreat. The event is a crucible, a pressure cooker and, by design, a place to think of new ideas or make new connections."[7]

While Felix and Poswolsky may have been old-school Burners who disdained corporate yurts with AC, the direction Camp Grounded was headed in when Felix passed away was not without its similarities. Initially insisting that camp was *not* a networking event, the camp's parent company, Digital Detox, at some point began offering corporate retreats to the likes of Yelp, VMWare, and Airbnb. Digital Detox representatives would travel to the companies themselves, offering "recess," "playshops," and "daycare," capsule versions of the activities offered at camps. They offered a kind of perpetual embedment—representatives could come by quarterly, monthly, or even weekly—arguably relegating themselves to the status of a corporate amenity like a gym or a cafeteria. And

although the word *productive* appears nowhere on the Digital Detox website, one can infer what kinds of benefits a company might expect from its products:

> Our team retreat gives individuals the freedom and permission they need to truly decompress and unplug, leaving them with newfound creative inspiration, perspective and personal growth.
>
> We'll help your team develop tools and strategies that bring balance into their day-to-day with lifestyle techniques that focus on keeping them grounded and connected even in the most stressed or overwhelming times.[8]

What's especially ironic about this is the exploitation of the basic and profound kernel of truth that Felix had initially started with as a collapsed workaholic. The answer he'd found was not a weekend retreat to become a better employee, but rather a total and permanent reevaluation of one's priorities—presumably similar to what had happened to him on his travels. In other words, digital distraction was a bane not because it made people less productive but because it took them away from the one life they had to live. Poswolsky writes of their initial discovery: "I think we also found the answer to the universe, which was, quite simply: just spend more time with your friends."

This might explain why Felix eventually began to contemplate an escape from the one he had constructed, and a more permanent one at that. In his eulogy, Poswolsky says that Felix "dreamed of escaping the stress of running Camp and moving to a beautiful farm somewhere in the redwoods where he could just listen to records all day with Brooke." He also recalls that Felix sometimes talked of buying land in northern California. Even farther from the city than the old Camp Grounded, this new retreat would let them do whatever they wanted, including nothing: "we could just relax and look up at the trees."

FELIX'S DREAM OF a permanent retreat registers a familiar and age-old reaction to an untenable situation: leave and find a place to start over. Unlike the solitary mountain hermits of East Asia or the Desert Fathers who wandered into the sands of Egypt, this dream involves not only renouncing society but attempting to build another one with others, if only in miniature.

One very early example of this approach was the garden school of Epicurus in the fourth century BC. Epicurus, the son of a schoolteacher, was a philosopher who held happiness and leisurely contemplation to be the loftiest goals in life. He also hated the city, seeing in it only opportunism, corruption, political machinations, and military bravado—the kind of place where Demetrius Poliorcetes, dictator of Athens, could tax the citizens hundreds of thousands of dollars ostensibly because his mistress needed soap. More generally, Epicurus observed that people in modern society ran in circles, unaware of the source of their unhappiness:

> Everywhere you can find men who live for empty desires and have no interest in the good life. Stupid fools are those who are never satisfied with what they possess, but only lament what they cannot have.[9]

Epicurus decided to buy a garden on the rural outskirts of Athens and establish a school there. Like Felix, he wanted to create a space that functioned both as an escape and a curative for people who visited, although in Epicurus's case, the visitors were students who lived there permanently. Articulating a form of happiness called *ataraxia* (loosely, "absence of trouble"), Epicurus found that the "trouble" of a troubled mind came from unnecessary mental baggage in the form of runaway desires, ambitions, ego, and fear. What he proposed in their absence was simple: relaxed contempla-

tion in a community that was turned away from the city at large. "Live in anonymity," Epicurus enjoined his students, who rather than engage in civic affairs, grew their own food within The Garden, chatting and theorizing among the lettuces. In fact, so much did Epicurus live by his own teachings that for most of his life he and his school remained relatively unknown within Athens. That was fine, since he believed that "[t]he purest security is that which comes from a quiet life and withdrawal from the many."[10]

Quite contrary to the modern-day meaning of the word *epicurean*—often associated with decadent and plentiful food—what the school of Epicurus taught was that man actually needed very little to be happy, as long as he had recourse to reason and the ability to limit his desires. It's no accident that this sounds similar to ideas of non-attachment in eastern philosophy. Before founding the school, Epicurus had read Democritus and Pyrrho, both of whom are known to have had contact with the gymnosophists, or "naked wise men," of India. One can certainly hear echoes of Buddhism in Epicurus's prescription for the soul: "The disturbance of the soul cannot be ended nor true joy created either by the possession of the greatest wealth or by honour and respect in the eyes of the mob or by anything else that is associated with causes of unlimited desire."[11]

The school of Epicurus sought to free its students not only from their own desires but from the fear associated with superstitions and myths. Teachings incorporated empirical science for the express purpose of dispelling anxieties about mythical gods and monsters who were thought to control things like the weather—or, for that matter, one's fortune in life. In that sense, the school's purpose might have been similar not only to Camp Grounded but to any addiction recovery center. At the school of Epicurus, students were being "treated" for runaway desire, needless worry, and irrational beliefs.

Epicurus's garden was different from other schools in important ways. Since only an individual could decide whether he had been "cured," the atmosphere was noncompetitive, and students graded

themselves. And while shunning one type of community, the school of Epicurus actively constructed another one: The Garden was the only school to admit non-Greeks, slaves, and women (including *he-taera*, or professional courtesans). Admission was free. Noting that, for most of human history, schooling has been a privilege restricted by class, Richard W. Hibler writes:

> Nothing was traditional about the Garden in comparison with most schools of the time. For instance, anyone with the zeal for learning how to live the life of refined pleasure was welcomed. The brotherhood was open to all sexes, nationalities, and races; the wealthy and the poor sat side by side next to "barbarians" such as slaves and non-Greeks. Women, who openly flaunted the fact that they were once prostitutes, assembled and joined men of all ages in the quest for Epicurean happiness.[12]

This is even more significant given that students of the school were not merely pursuing their studies in parallel isolation. They might have been escaping the city, but they were not escaping other people—friendship itself was a subject of study, a requirement for the kind of happiness the school taught.

Epicurus was neither the first nor the last to seek a communal refuge in the countryside. Indeed, the Epicurean program—a group of people growing vegetables and focusing on chilling out, with vaguely Eastern influences—will sound familiar to a lot of us. Although similar experiments were repeated many times throughout history, the garden school reminds me the most of the commune movement of the 1960s, when thousands of people decided to drop out of modern life and try their hand at liberated country living. Of course, the flame of this movement burned brighter and shorter than the school of Epicurus. But in a time when I'm often seized by the urge to move to the Santa Cruz Mountains and throw my phone into the ocean at San Gregorio—without having really

thought that through—I find the varying fates of the 1960s communes to be especially instructive.

First, as relatively recent versions of this experiment, the communes exemplify the problems with any imagined escape from the media and effects of capitalist society, including the role of privilege. Second, they show how easily an imagined apolitical "blank slate" leads to a technocratic solution where design has replaced politics, ironically presaging the libertarian dreams of Silicon Valley's tech moguls. Lastly, their wish to break with society and the media— proceeding from feelings I can sympathize with—ultimately reminds me not only of the impossibility of such a break, but of my responsibility to that same society. This reminder paves the way for a form of political refusal that retreats not in space, but in the mind.

THINGS MAY SEEM bad now, but some would argue that the late 1960s were worse. Nixon was president, the Vietnam War was raging, Martin Luther King, Jr., and Robert Kennedy were assassinated, and unarmed student protestors were shot at Kent State. Signs of environmental devastation were accumulating, and large-scale urban redevelopment projects and freeways were destroying the fabric of "blighted" ethnic neighborhoods. All the while, successful adulthood was pictured as a two-car garage house in a white suburb. To young people, this looked like a sham, and they were ready to quit.

Between 1965 and 1970, more than a thousand communal groups formed across the country. The writer Robert Houriet, who visited fifty American "communal experiments" between 1968 and 1970, described this movement as "the gut reaction of a generation" who saw no other way to resist:

> To a country seemingly entrenched in self-interest, deaf to change and blind to its own danger, they said "Fuck it" and split. If the cities were uninhabitable and the suburbs plastic,

they would still have to live somewhere. If the spirit of hu-
mane community and culture were dead in urban Amerika,
they would have to create their own.[13]

Those who fled to the communes took a particularly ahistori-
cal view of time; according to Houriet, the communes were rela-
tively unaware of the history of utopian experiments—maybe even
Epicurus's garden school. But this is perhaps to be expected from
anyone desperately seeking a complete break from everything.
Houriet writes that those who fled "had no time to assess the his-
torical parallels or to make careful plans for the future . . . Their
flight was desperate." After all, this wasn't the 1960s; it was the Age
of Aquarius, an exit from time and a chance to start from scratch:

> Somewhere in the line of history, civilization had made a
> wrong turn, a detour that had led into a cul-de-sac. The only
> way, they felt, was to drop out and go all the way back to the
> beginning, to the primal source of consciousness, the true ba-
> sis of culture: the land.[14]

In his description of the Drop City commune in a book by the
same name, Drop City resident Peter Rabbit describes the general
outline: "put together some bread, buy a piece of land, make the
land free, and start rebuilding the economic, social, and spiritual
structures of man from the bottom up." He adds, however, that
"none of these people had any idea that that's what they were do-
ing . . . We just thought we were dropping out."[15]

Some of the communes Houriet visited on his tour became vi-
able for a few years or more; others he heard about were gone by
the time he arrived. At an old resort hotel in the Catskills, Houriet
found just two people left, and they were on their way out. Left
over in one of the bedrooms were a mattress, a crate, the stub of a
candle, and some roaches in an ashtray. "They had burned all their
furniture and smoked the last of their grass. On the wall, writ in

Magic Marker, was the self-epitaph of a community that never was: FOREVER CHANGE."[16]

What the communes did have in common was a search for "the good life," an experience of community opposed to the competitive and exploitative system they had rejected. At the outset, some were inspired by the articulation of modern anarchism in Paul Goodman's *Growing Up Absurd: Problems of Youth in the Organized System*. In that book, Goodman had suggested replacing capitalist structures with a decentralized network of individualized communities making judicious use of new technology and supporting themselves with cottage industries.

Understandably, this turned out to be much easier said than done in 1960s America, and most of the communes had vexed relationships with the capitalist world outside. After all, mortgages had to be paid, children had to be raised, and most communes couldn't grow all of their own food. Even if they were far from the city, they were still in America. To manage, many members had to continue working regular jobs and some communes relied on welfare. The eclectic menu at High Ridge Farm in Oregon illustrates this mixed bag of income. Among the many jars of homegrown produce, Houriet observed expensive store-bought organic food and commodities donated by the US Department of Agriculture ("commodities cheese" was a favorite). Along with "exotic salads with Brussels sprouts and kohlrabi," they had "a commodities hash or a curry made from turkeys donated last Thanksgiving by the Welfare Department."[17]

Much as they wanted to break with capitalist society, those who escaped from it sometimes carried its influences within themselves, like ineradicable contagions. Writing about a communal house in Philadelphia in 1971, Michael Weiss says that all eight members of the group were "more or less anti-capitalist" and hoped the commune would offer an alternative in the form of equal wealth distribution. But because some of the members made so much more than the others, they agreed to a compromise: each person would contribute half, not all, of their earnings to the house fund. Even so,

Weiss writes that any conversations about money were marked by "defensiveness, self-righteousness, inexperience with money sharing, and the fear of having to relinquish one's most cherished comforts and pleasures for the sake of group amity."[8] In his commune, the first "money crisis" ends up not being a shortage, but hurt feelings when one of the wealthier members comes home with a sixty-dollar coat. The coat sets off a long house meeting about class consciousness, which, like many of the other meetings chronicled in *Living Together*, is ultimately left unresolved.

Other ghosts of the "straight" world complicated the communes' dreams of radicality. Like the hippie movement they came from, commune members were mostly middle-class and college-educated—a far cry from Epicurus's radically reconstituted student body. They were overwhelmingly white; several times in *Getting Back Together*, Houriet mentions talking to "the only black" in a commune, and he describes a strangely tense scene between a Twin Oaks community member and a local black family. The rural setting sometimes created "a natural impetus to revert to traditional roles: Women stay inside, cook, and look after the children, while men plow, chop, and build roads."[19] In *What the Trees Said: Life on a New Age Farm*, Stephen Diamond states it outright: "None of the men ever washes dishes or hardly cooks."[20] A spatial move to the country, or into an isolated communal house, did not always equal a move out of ingrained ideologies.

Probably the biggest problem that the communes faced, though, was the idea of starting from scratch. In many ways, "going back to the beginning" meant rehashing timeworn struggles over governance and the rights of the individual, albeit in capsule form. There was, after all, a potential paradox at the heart of the whole endeavor. Retreat and refusal are the precise moments in which the individual distinguishes herself from the mob, declining to buy a house and a car and conform to a stodgy, oppressive society where, as Diamond puts it, "there was always some Total Death Corporation job with your name on it." But in order for these refuseniks to stay out

there and function as a commune, they needed to negotiate a new balance between the individual and the group. As Weiss recalled of the Philadelphia commune, "the slipperiest decisions always involved reconciling privacy and communality, the individual and the house"[21]—in other words, the very fundamentals of governance.

Politics inevitably surfaced, sometimes like an unwelcome guest at a house party. At Bryn Athyn, a short-lived commune near Stratford, Vermont, Houriet describes the general apathy of the members when one of them tries to figure out the legal details of buying the farm. And when conflicts arose, a political process was notably lacking:

> The long after-dinner meetings were discontinued when some members rejected them as artificial "mind-fucking sessions that brought people down." Everything would go smoothly if everyone made love, some argued. Others said vaguely that personal conflicts should be resolved through the natural and spontaneous interplay of feelings. And if that didn't work, then those who didn't get along should leave.[22]

In fact, leaving was a common solution. Faced with what a Twin Oaks member called "the tyranny of everyone doing their own thing," those who had escaped once were driven to escape again, this time from the commune. Houriet witnessed this especially in the early and unstable years of the communes: "Somebody was always splitting, rolling up his bag, packing his guitar and kissing good-bye—off again in search of the truly free, un-hungup community."[23]

OF COURSE, IT wasn't just internal politics that troubled the communes; they were also fleeing national politics and the media. The experience of Michael Weiss, from the commune that argued over the expensive coat, is especially telling. Weiss had been a journalist for the *Baltimore News-American*, where the task of covering politics

had given him an increasingly cynical view of politicians. In 1968, he'd flown around the country with Spiro Agnew during his campaign to be Nixon's vice president, watching with horror "how [Agnew] self-righteously pandered to the fright of decent people who were baffled by the complications of the world."[24] Although Weiss believed that Agnew was a truly dangerous man ("an unimaginative pedant with a lust for power"), he wrote a long analysis of the campaign in which he endeavored to remain objective. The piece ran one edition before being killed by the managing editor for the Hearst-owned paper, who called it biased.

Disillusioned beyond repair, Weiss quit. For months he and two friends hid away at a house his parents owned in the Catskills: "The snow fell four feet deep and at evening we would sit and watch the sun turn the sky purple and orange across the frozen lake." I'm reminded of my blissful media-less cabin stay in the Sierras when he adds: "For months I didn't read a newspaper, after years of reading four or five a day."[25]

Even at Stephen Diamond's New Age Farm, a commune that split off from the radical underground Liberation News Service (LNS) in New York with the express purpose of running their own news service, the world of politics began to feel distant from the farm. "[W]e were getting farther and farther away from it, away from the draft resistance news, birth control articles, Abbie Hoffman in Chicago, the poetry of the 'revolution'"[26] At one point Diamond fantasizes about burning down the barn in which they still prepare their LNS mailings:

> But would that stop it, though? Would that act of the flaming building help reduce those contrasts and tensions ("The ironies that kill") that were driving me mad: would it put an end to LNS, to that poorly balanced seesaw between starting new, from nothing, and still trying to stay "plugged in," carrying all the old death karma with us into the hills—and it bringing us down with it.[27]

The problem, Diamond says, was that they had chosen exit. "We simply didn't have anything more to say, other than perhaps get some land, get your people together, and see what happens."

For those of us too young to remember firsthand the intellectual and moral quagmire of the late 1960s, this attitude can easily sound irresponsible or escapist. In fact, fourth-century Greece passed much the same judgment on the school of Epicurus, whose students avoided public service and chose to live in obscurity. One of the school's harshest critics was Epictetus. Like other Stoics, he prized civic duty, and he thought the Epicureans needed to get real: "In the name of Zeus, I ask you, can you imagine an Epicurean state? . . . The doctrines are bad, subversive of the State, destructive to the family . . . Drop these doctrines, man. You live in an imperial State; it is your duty to hold office, to judge uprightly"[28]

The Epicureans' rebuttal might have been similar to Houriet's: They were changing themselves first. How could accusations of selfishness be leveled on a school that taught altruism to the degree that one was expected to die for a friend? More practically, in order to build the kind of world that Epicurus wanted, he needed to close it off from the world. But his critics didn't see it that way. Clearly the students of The Garden felt deep responsibility to one another, but responsibility to everyone else was left out of the question. They had forsaken the world.

IN *GETTING BACK TOGETHER*, Houriet distinguishes two "stages" in the evolution of communes of the time. Facing disorganization and frustration—unfinished geodesic domes, crops gone wrong, arguments over how to raise children, and "the phenomenon of the un-labeled jars"—the atmosphere of naive optimism eventually gave way in some places to a more rigid and less idealistic approach. This second stage was epitomized by the vision of a new society in the 1948 utopian novel *Walden Two*.

Originally published to little fanfare, *Walden Two* became hugely popular in the 1960s, enough that some were inspired to base their communes on it. It was written by B. F. Skinner, an American psychologist and behavioral scientist famous for the Skinner box, in which a test subject animal learns to press a lever in response to specific stimuli. *Walden Two* reads like exactly what it is: a novel written by a scientist. To Skinner, everyone was potentially a test subject, and utopia was an experiment—not a political one, but a scientific one.

In *Walden Two*, a psychology professor named Burris (B. F. Skinner's first name was Burrhus) visits an eerily harmonious community of one thousand people founded by a former colleague named Frazier. When he arrives, the scene is bucolic: People stroll about and have picnics, organize impromptu classical music performances, and sit contentedly in rocking chairs. Children are heavily conditioned from an early age, and the entire community is run as a behavioral engineering experiment. As a result, no one is unhappy with his lot in life; Frazier, the founder, has engineered it that way. "Our members are practically always doing what they want to do—what they 'choose' to do," says Frazier cheerfully, "but we see to it that they will want to do precisely the things which are best for themselves and the community. Their behavior is determined, yet they're free."[29] Members do not really vote; they live by "the Code," whose development is deliberately obscured from them for their own good. Planners and "experts," nearly anonymous and linguistically hidden in the passive voice, wield all of the power in Walden Two. In turn, they're beholden to Frazier's all-encompassing vision.

In the void left by politics, the emphasis in *Walden Two* lies on the aesthetic. Giving Burris a tour of the grounds, Frazier extols the advantages of their better designed and more efficient tea glasses. Even the members are reduced to elements of decor. At one point Burris observes that all of the women are beautiful, and one female passerby—with a hairstyle and outfit that he apparently finds pleasing—reminds him of "a piece of modern sculpture done in a shining dark wood."[30]

Burris is accompanied on his visit by a philosophy professor named Castle, a grumbling man who is supposed to represent old-guard academia. When Castle accuses Frazier of being a fascist despot, Frazier responds not with an actual argument but with a pastoral image:

> Frazier . . . drew us back along the Walk. We entered one of the lounges and went to the windows to look out over the landscape, which was dotted here and there with groups of people enjoying the fresh green countryside.
>
> Frazier allowed perhaps a minute to pass. Then he turned to Castle.
>
> "What were you saying about despotism, Mr. Castle?"
>
> Castle was taken by surprise, and he stared at Frazier as a deep flush crept over his face. He tried to say something. His lips parted but no words came.[31]

However, in order for this "image" to persist, every part must have a static, controllable function. Frazier addresses this first by conditioning all of the members of Walden Two so that, although they are not literally static, they exhibit predictable behavior. In that regard, the members are not too different from the artificially intelligent "hosts" of the TV series *Westworld*, who believe they are acting of their own volition but are actually running a series of scripts and loops designed by humans they do not know.

Furthermore, just as the hosts of *Westworld* are designed to be tame yet technologically superior to humans, Frazier looks forward to eugenic breeding and says in the meantime that the "unfit" of Walden Two are discouraged from having children. (Presumably, Frazier decides who is unfit, and for what.) The iPad-like devices that the engineers use in *Westworld*, with sliders for qualities like intelligence and aggression, come to mind when Frazier brags about his own behavioral technology:

Give me the specifications, and I'll give you the man! What do you say to the control of motivation, building the interests which will make men most productive and most successful? Does that seem to you fantastic? Yet some of the techniques are available, and more can be worked out experimentally. Think of the possibilities![32]

Frazier's example of a more productive man is no accident. Like someone running a corporate digital detox retreat, he is obsessed with productivity, claiming fantastically that mankind is only 1 percent as productive as it could be.

Memory and horizontal alliances are two hallmarks of individuality. In *Westworld*, humans maintain the hosts' docility by periodically wiping their memories, keeping them effectively trapped in the present. Indeed, the show's drama originates when aberrant hosts become able to access memories from past lives, allowing them not only to connect the dots about how they are being used, but to recognize old kinships with other hosts that exist outside of their given narratives. We should not be surprised, then, that Walden Two prohibits members from discussing the Code with each other, or that the study of history has been dispensed with entirely. Amazingly, Frazier tells Burris that "we can make no *real* use of history as a current guide," and spends an entire paragraph sneering at large academic libraries and the librarians who stock them with "trash . . . on the flimsy pretext that someday someone will want to study the 'history of a field.'"[33] Instead the library at Walden Two is small and for entertainment purposes only. Both implausibly and creepily, Burris is "amazed at the clairvoyance with which the Walden Two librarians had collected most of the books I had always wanted to read."[34]

IN A NEW preface from 1976, Skinner reflects on why his book drew so much attention in the 1960s. Like others, he detects that "[t]he

world was beginning to face problems of an entirely new order of magnitude." But the problems he lists are decidedly scientific: "exhaustion of resources, the pollution of the environment, over-population, and the possibility of a nuclear holocaust"—he mentions neither the Vietnam War nor the ongoing struggles over racial equality.[35] Even in 1976, the remaining question for Skinner was not how power could be redistributed, or injustice redressed, but how a technical problem might be solved with the very same methods as the Skinner box: "How were people to be induced to use new forms of energy, to eat grain rather than meat, and to limit the size of their families; and how were atomic stockpiles to be kept out of the hands of desperate leaders?" He proposed avoiding politics altogether and working instead on "the design of cultural practices."[36] To him, the late twentieth century was an exercise in R&D.

The kind of escape that Walden Two embodies reminds me of a more recent utopian proposal. In 2008, Wayne Gramlich and Patri Friedman founded the nonprofit the Seasteading Institute, which seeks to establish autonomous island communities in international waters. For Silicon Valley investor and libertarian Peter Thiel, who supported the project early on, the prospect of a brand-new floating colony in a place outside the law was interesting indeed. In his 2009 essay "The Education of a Libertarian," Thiel echoes Skinner's conclusion that the future requires a total escape from politics. Having decided that "democracy and freedom are incompatible," Thiel's gesture toward some other option that is somehow not totalitarian is either naive or disingenuous:

> Because there are no truly free places left in our world, I suspect that the mode for escape must involve some sort of new and hitherto untried process that leads us to some undiscovered country; and for this reason I have focused my efforts on new technologies that may create a new space for freedom.[37]

For Thiel, only the sea, outer space, and cyberspace can provide

this "new space." As in *Walden Two*, the locus of power is carefully hidden in Thiel's language, either disappearing into the passive voice or being associated with abstractions like design or technology. But it's not hard to infer that the result in this case would be a technocratic dictatorship under the Seasteading Institute. After all, the masses do not interest Thiel, for whom "[t]he fate of our world may depend on the effort of a single person who builds or propagates the machinery of freedom that makes the world safe for capitalism."

AS ARTICULATIONS OF retreat, both Thiel's essay and *Walden Two* seem almost to have been reverse-engineered by Hannah Arendt's classic 1958 work *The Human Condition*, in which she diagnoses the age-old temptation to substitute design for the political process. Throughout history, she observes, men have been driven by the desire to escape "the haphazardness and moral irresponsibility inherent in a plurality of agents." Unfortunately, she concludes, "the hallmark of all such escapes is rule, that is, the notion that men can lawfully and politically live together only when some are entitled to command and the others forced to obey."[38] Arendt traces this temptation specifically to Plato and the phenomenon of the philosopher-king, who, like Frazier, builds his city according to an image:

> In *The Republic*, the philosopher-king applies the ideas as the craftsman applies his rules and standards; he "makes" his City as the sculptor makes a statue; and in the final Platonic work these same ideas have even become laws which need only be executed.[39]

This substitution introduces a division between the expert/ designer and the layman/executor, or "between those who know and do not act and those who act and do not know." Such a division is evident in *Walden Two*: the workings of the Code are hidden from

the members, whose only job is to live out Frazier's dream. It's also their job not to interfere. Arendt writes that these escapes "always amount to seeking shelter from action's calamities in an activity where one man, isolated from all others, remains master of his doings from beginning to end."[40]

HOURIET'S DESCRIPTION OF what happened to Bryn Athyn, the commune that shunned house meetings, illustrates this development. Like many communes, Bryn Athyn got its start thanks to a wealthy person sympathetic to the cause. In this case, it was a man named Woody Ransom, "an heir to corporate wealth" who had recently gotten into anarchism and who had bought a farm as an artist's retreat for himself and his wife. When the marriage failed, he invited friends to move in and start a commune. Ransom was initially content to recede into the background: "Anarchically, he declared that the land and house belonged to the community."[41]

But Ransom had spent a large sum on equipment, taxes, and upkeep, and eventually became restless about the farm's lack of economic self-sufficiency. While the rest were exploring communal culture and practicing free love, Ransom monomaniacally pursued the idea of harvesting syrup from the farm's stand of maple trees, buying books and equipment and setting a three-hundred-gallon production quota. He wanted to recoup the money he'd invested not for personal reasons, but rather to prove that an economically self-sufficient community was possible. But when harvest time came, the other members were on another plane of existence:

> One morning, he hitched up the horses to collect the sap, which was rapidly dripping into buckets scattered over the property. However, that day the others were taking a trip. When he walked into the farmhouse to get help for the sap run, Woody found everyone rolling in a "love heap" on the floor. He left, furious, and collected the sap himself.[42]

Antagonism grew between Ransom and the rest of the commune, and he eventually left.

But he returned later that year with six people he'd met on the West Coast, determined to form a new work-oriented commune entirely under his command. Ransom had given up anarchism in favor of behavioral science, and wanted to create a technocratic *Walden Two* community whose rigidity was his vengeful answer to the "love heap." When Houriet visited a second time, he found an Arendt-ian tyrant running "the diametrical opposite of leaderless, ruleless Bryn Athyn." Now members lived in a modern house with regular appliances, worked eight hours a day six days a week, and kept strict visiting hours. The new emphasis was on "mechanized efficiency." Hoping to wipe the slate clean once again, Ransom changed the name from Bryn Athyn to Rock Bottom Farm.[43]

IT TURNS OUT, though, that no slate can be thus cleaned—even in the sea. In 2018, two years after the Seasteading Institute signed an informal agreement with French Polynesian officials to allow offshore development there, the government backed out, citing concerns about "tech colonialism." A documentary on the Institute's efforts found that Polynesian locals weren't given much attention at the Seasteading Institute's events. In a description that might not have displeased Peter Thiel, a local radio and TV personality called the project a cross between "visionary genius" and "megalomania."[44]

Thiel had in fact already backed out of the Seasteading Institute because he decided the plans for island nations were unrealistic—amazingly, not in terms of politics. "They're not quite feasible from an engineering perspective," he told *The New York Times*.[45] It seems likely, however, that even if his islands had been perfectly designed (by an elite contingent of Plato-ish designers, no doubt) *and* accepted by existing governments, things could easily have strayed from the plan.

As Arendt observes, part of what these escapes from politics are specifically avoiding is the "unpredictability" of "a plurality of agents." It's this ineradicable plurality of real people that spells the downfall of the Platonic city. She writes that the all-seeing plan is unable to withstand the weight of reality, "not so much the reality of exterior circumstances as of the real human relationships they could not control."[46] Writing about *Walden Two*, psychology professor Susan X. Day observes an unrealistic absence of friend groups or pairs among the people in the novel, even though this phenomenon is so natural that it occurs in other animals and "proceeds inevitably from the differentiation of individuals."[47] That Skinner struggled in his novel with plurality is suggested not only by the implication that all members of Walden Two are white and heteronormative, but by the fact that Skinner originally had a chapter on race that he decided to take out.[48] Combined with memory (might someone smuggle in a history book?), it's not hard to see how such differences and alliances might lead to the dreaded *politics*, thus contaminating the scientific experiment that is Walden Two.

Like Frazier's pastoral scene with which he wordlessly answers the accusation of fascism, Thiel's "escape from politics" could never be anything more than an image that existed outside of time and reality. Preemptively calling it a "peaceful project" avoids the fact that regardless of how high-tech your society might be, "peace" is an endless negotiation among free-acting agents whose wills cannot be engineered. Politics necessarily exist between even two individuals with free will; any attempt to reduce politics to design (Thiel's "machinery of freedom") is also an attempt to reduce people to machines or mechanical beings. So when Thiel writes of "new technologies that may create a new space for freedom," I hear only an echo of Frazier: "Their behavior is determined, yet they're free."

OF COURSE, THE distance between image and reality is an issue endemic to the idea of utopia itself, *utopia* meaning literally "no-

place," as opposed to the all-too-placeful-ness of reality. There is no such thing as a clean break or a blank slate in this world. And yet, amid the debris of the present, escape beckons. To me, at least, the stories of the 1960s communes exert as strong an allure as they ever did, especially now.

It was something like this allure that led the Swiss curator Harald Szeemann to put on an unusual show in 1983 called *Der Hang Zum Gesamtkunstwerk* (*The Tendency Toward the Total Artwork*). The artists he included in the Zurich exhibition ranged from very famous to obscure outsider artists, but they all had one thing in common: a total conflation of art with life, sometimes even an attempt to live one's art. Alongside a scale model of Vladimir Tatlin's never-built *Monument to the Third International*, one might find a costume from Oskar Schlemmer's techno-utopian *Triadisches Ballett*, the spiritual color theories of Wassily Kandinsky, a score by John Cage (for whom "all sounds are music"), or documentation of the *Palais Idéal*, a structure hand-built with thousands of rocks by a mailman, after he tripped over one and decided it was beautiful. The domes and other art from the Drop City commune would not have been out of place here. Because the show was full of reconstructions of things never built and documentation of short-lived dreams, the collection has a potentially melancholy air. Its mix of inspiration and failure echoes Brian Dillon's description of *Monument to the Third International*, in which the tower "survives as a monument of the mind: half ruin and half construction site, the receiver and transmitter of confused messages regarding modernity, communism and the utopian dreams of the century gone by."[49]

Szeemann was not interested in finished, fully materialized visions. Instead he was preoccupied with the energy generated by the gap between art and life, holding that "one could only learn from the model of art as long as art remained the Other—something that differs from life and transcends life, without being assimilated by life."[50] He was looking for records of an impulse that strained the bounds of representation. The writer Hans Müller offers a

name for that impulse: "After all, individual stories of totality were still in place and even if no single grand idea was feasible, the great intensity—the *Hauptstrom*, as Beuys called it—the grand idea was still essential to energize society."[51] *Hauptstrom* translates to something like "main stream," in the sense of electrical current. And the word *Hang* in the exhibition's title, *Der Hang Zum Gesamtkunstwerk*, translates variously to "addiction," "penchant," or even "downward slope," implying an innate tendency in humans to imagine ever-new, electrified visions of perfection.

It was not only despair but hope and inspiration—the *Hauptstrom*—that had gotten people out to the communes, and it was the same *Hauptstrom* that left behind the stories, the architecture, the art, and the ideas. This electrical current, which Szeemann once described as a "joyfully grasped, albeit pre-Freudian energy unit that doesn't give a damn whether it is expressed or can be applied in a socially negative, positive, harmful or useful way,"[52] runs throughout history, throwing off new forms each time.

When we look at those forms now, we can still see evidence of the spark. Interspersed throughout Houriet's *Getting Back Together* are some glorious and fantastical scenes: small moments of utopia where you can see what they were aiming for, even if they couldn't hold on to it for long. At Michael Weiss's communal house, things sound rather hopeful by the end of his book. He describes a scene that sounds positively Epicurean, with commune members growing food in and around the house, making beer, sprouting seeds from the "glorious grass" they'd smoked the summer before, and just watching the flowers grow. At least in that moment, it seems to be working:

> All these makings and growings were giving me the feeling that we were healthy and sufficient, that we were learning a little bit at a time how to escape the poisons which sometimes seemed to seep through every pore in the avaricious face of our society, in its polluted environment, its adulterated food,

its distortion of language, its discriminatory laws, its brutal pursuit of war abroad.[53]

The *Hauptstrom* that occurs in the space between art and life is helpful for understanding the most important and obvious legacy of the communes: even if only briefly, they opened up new perspectives on the society they had left. Some commune members were activists and teachers, and they traveled not only to marches and protests but to schools where they gave lectures. Though heavily visited communes like Drop City suffered from the publicity, they did show visitors a different way of life, an option where there hadn't been one before. The communes continue to be important touchstones of dissent for those of us despairing fifty years later. In 2017, at the Berkeley Art Museum, I saw an amazing spinning painting from Drop City that looked completely different based on the rate of a strobe light that the viewer could control. It was just as beautiful as ever, just as earnest a question about what art could be, what life could be.

Even the crowd-shunning Epicurus, who taught that one shouldn't speak in public unless requested to do so, showed some orientation toward the outside world by using his house as a base for publishing the writings of the school. It's only for this reason that in 2018, someone (me) is reading them in another garden. It's in this exchange that such experiments become valuable for the world, as points in a dialogue between inside and outside, real and unrealized. As Ursula K. LeGuin writes in *The Dispossessed*, a novel in which a man returns to Earth for the first time from an anarchist colony: "The explorer who will not come back or send back his ships to tell his tale is not an explorer, only an adventurer."[54]

Indeed, so instinctively do we understand the value of an outsider's perspective that history is full of people seeking remote hermits and sages, desperate for knowledge from a mind unconcerned with familiar comforts. Just as I need someone to observe things about myself or my writing that I can't see, mainstream society needs the

perspective of its outsiders and recluses to illuminate problems and alternatives that aren't visible from the inside. That same journey that takes the seeker toward the sage takes him out of the world as he knows it.

In Athanasius's biography of St. Anthony, a hermit who lived in the Egyptian desert, there is a story of two managerial employees of the Roman emperor going for a walk while the emperor is transfixed by a circus. Wandering in the gardens outside the palace walls, the men come across the cottage of some poor hermits and discover a book on St. Anthony's self-exile in the desert. Reading this, one of the emperor's employees, "his mind stripped of the world," turns to the other and says:

> Tell me, prithee, with all these labours of ours, wither are we trying to get? What are we seeking? For what are we soldiering? Can we have a higher hope in the palace, than to become friends of the emperor? And when there, what is not frail and full of danger? . . . And how long will that last?[55]

These despairing questions might sound familiar to anyone who has force-ejected themselves from an absorbing situation only to find its pretenses are totally, frighteningly questionable. Indeed, Levi Felix might have been asking himself these questions on the plane to Cambodia after quitting his ruthless job. At least in this story, the two men decide to abandon their entire lives (including their fiancées!) and become hermits like St. Anthony. No going back to work on Monday for them. In any narrative of escape, this is a pivotal point. Do you pack all your things in a van, say, "Fuck it," and never look back? What responsibility do you have to the world you left behind, if any? And what are you going to do out there? The experiences of the 1960s communes suggest that these are not easy questions to answer.

THERE IS ANOTHER story of a hermit that starts the same but ends differently. Some of those who split for the communes may have known the writings of the anarchist Trappist monk, Thomas Merton, who died in 1968. (Houriet reports seeing a passage of Merton's taped to the wall in the kitchen at High Ridge Farm.) Merton was an unlikely candidate for the Catholic order: he worked on the college humor magazine at Columbia in the 1930s and hung around with an irreverent and hard-drinking group of proto-Beatniks. In *The Man in the Sycamore Tree: The Good Times and Hard Life of Thomas Merton*, Merton's friend Edward Rice recalls the mood in the 1930s: "[T]he world is crazy, war threatens, one has lost a sense of identity . . . People are dropping out . . . The rest of us are lost. We read *Look Homeward, Angel* and send each other postcards saying, 'O lost!'"[56]

But while the others were despairing and drinking themselves into a stupor, Merton was zeroing in on spirituality and the idea of renouncing the world. "I am not physically tired, just filled with a deep, vague, undefined sense of spiritual distress, as if I had a deep wound running inside me and it had to be stanched." He became fixated on the idea of joining the Trappists, a Catholic order of monks who, although they don't take a strict vow of silence, are generally resigned to a silent and ascetic life. "It fills me with awe and desire," Merton wrote in a letter. "I return to the idea again and again: 'Give up *everything*, give up *everything*!'" [57]

Merton arrived and was accepted at the Abbey of Gethsemani in rural Kentucky in 1941. So much did he desire solitude that he spent years petitioning to become a hermit on the monastery grounds. In the meantime, between his duties, he found time to keep a journal that eventually grew into a book. In 1948, the same year he was ordained as a monk, he published the autobiography, *The Seven Storey Mountain*, which besides chronicling his move to the monas-

tery was an embodiment of *contemptus mundi*—a spiritual rejection of the world. It contained, as Rice describes it, the "evocation of a young man in an age when the soul of mankind had been laid open as never before, during world depression and unrest and the rise of both Communism and Fascism, when Europe and America seemed destined to war on a brutal and unimaginable scale." The book sold tens of thousands of copies within a few months of publication and was only kept off *The New York Times* bestseller list on the grounds that it was considered a religious book. It went on to sell multiple millions of copies.[58]

But only three years after its publication, Merton wrote to Rice, disowning the book: "I have become very different from what I used to be . . . *The Steven Storey Mountain* is the work of a man I never even heard of." It had to do, he said, with an epiphany he had while accompanying a fellow clergyman on a trip to Louisville:

> In Louisville, at the corner of Fourth and Walnut, in the center of the shopping district, I was suddenly overwhelmed with the realization that I loved all these people, that they were mine and I theirs, that we could not be alien to one another even though we were total strangers. It was like waking from a dream of separateness, of spurious self-isolation in a special world, the world of renunciation and supposed holiness.[59]

From that point until the end of his life, Merton published a score of books, essays, and reviews that not only commented on social issues (particularly the Vietnam War, the effects of racism, and imperialist capitalism) but also lambasted the Catholic Church for giving up on the world and retreating into the abstract. In short, he participated.

In one of those books, *Contemplation in a World of Action*, Merton reflects on the relationship between contemplation of the spiritual and participation in the worldly, two things the Church had long articulated as opposites. He found that they were far from mutually

exclusive. Removal and contemplation were necessary to be able to see what was happening, but that same contemplation would always bring one back around to their responsibility to and in the world. For Merton, there was no question of whether or not to participate, only how:

> If I had no choice about the age in which I was to live, I nevertheless have a choice about the attitude I take and about the way and the extent of my participation in its living ongoing events. To choose the world is . . . an acceptance of a task and a vocation in the world, in history and in time. In my time, which is the present.[60]

This question—of *how* versus *whether*—has to do with the attention economy insofar as it offers a useful attitude toward despair, the very stuff the attention economy runs on. It also helps me distinguish what it is I really feel like running away from. I've already written that the "doing nothing" I propose is more than a weekend retreat. But that doesn't mean I propose a permanent retreat either. Understanding the impossibility of a once-and-for-all exit— for most of us, anyway—sets the stage for a different kind of retreat, or refusal-in-place, that I will elaborate on in the next chapter.

Here's what I want to escape. To me, one of the most troubling ways social media has been used in recent years is to foment waves of hysteria and fear, both by news media and by users themselves. Whipped into a permanent state of frenzy, people create and subject themselves to news cycles, complaining of anxiety at the same time that they check back ever more diligently. The logic of advertising and clicks dictates the media experience, which is exploitative by design. Media companies trying to keep up with each other create a kind of "arms race" of urgency that abuses our attention and leaves us no time to think. The result is something like the sleep-deprivation tactics the military uses on detainees, but on a

larger scale. The years 2017 and 2018 were when I heard so many people say, "It's just something new every day."

But the storm is co-created. After the election, I also saw many acquaintances jumping into the melee, pouring out long, emotional, and hastily written diatribes online that inevitably got a lot of attention. I'm no exception; my most-liked Facebook post of all time was an anti-Trump screed. In my opinion, this kind of hyper-accelerated expression on social media is not exactly helpful (not to mention the huge amount of value it produces for Facebook). It's not a form of communication driven by reflection and reason, but rather a reaction driven by fear and anger. Obviously these feelings are warranted, but their expression on social media so often feels like firecrackers setting off other firecrackers in a very small room that soon gets filled with smoke. Our aimless and desperate expressions on these platforms don't do much for us, but they are hugely lucrative for advertisers and social media companies, since what drives the machine is not the content of information but the rate of engagement. Meanwhile, media companies continue churning out deliberately incendiary takes, and we're so quickly outraged by their headlines that we can't even consider the option of not reading and sharing them.

In such a context, the need to periodically step away is more obvious than ever. Like the managerial employees who wandered away from their jobs, we *absolutely require* distance and time to be able to see the mechanisms we thoughtlessly submit to. More than that, as I've argued thus far, we need distance and time to be functional enough to do or think anything meaningful at all. William Deresiewicz warns of this in "Solitude and Leadership," a speech to an audience of college students in 2010. By spending too much time on social media and chained to the news cycle, he says, "[y]ou are marinating yourself in the conventional wisdom. In other people's reality: for others, not for yourself. You are creating a cacophony in which it is impossible to hear your own voice, whether it's yourself you're thinking about or anything else."[61]

Given the current reality of my digital environment, distance for me usually means things like going on a walk or even a trip, staying off the Internet, or trying not to read the news for a while. But the problem is this: I can't stay out there forever, neither physically nor mentally. As much as I might want to live in the woods where my phone doesn't work, or shun newspapers with Michael Weiss at his cabin in the Catskills, or devote my life to contemplating potatoes in Epicurus's garden, total renunciation would be a mistake. The story of the communes teaches me that there is no escaping the political fabric of the world (unless you're Peter Thiel, in which case there's always outer space). The world needs my participation more than ever. Again, it is not a question of *whether*, but *how*.

Thinking about this unavoidable responsibility, I'm reminded of a more recent stay in a mountain cabin. This time, it was in the Santa Cruz Mountains, and I was specifically trying to focus on writing this book. But on my leisurely hikes through the redwoods, I noticed that the light filtering through the trees was red in the afternoon. That was because the up north mountains, like so many other mountains in California, were on fire—part of yet another devastating fire season exacerbated by climate change, drought, and ecological mismanagement. The day I left, fire broke out in the foothills near my parents' house.

Some hybrid reaction is needed. We have to be able to do both: to contemplate and participate, to leave and always come back, where we are needed. In *Contemplation in a World of Action*, Merton holds out the possibility that we might be capable of these movements entirely within our own minds. Following that lead, I will suggest something else in place of the language of retreat or exile. It is a simple disjuncture that I'll call "standing apart."

To stand apart is to take the view of the outsider without leaving, always oriented toward what it is you would have left. It means not fleeing your enemy, but knowing your enemy, which turns out not to be the world—*contemptus mundi*—but the channels through which you encounter it day to day. It also means giving yourself

the critical break that media cycles and narratives will not, allow-
ing yourself to believe in another world while living in this one.
Unlike the libertarian blank slate that appeals to outer space, or
even the communes that sought to break with historical time, this
"other world" is not a rejection of the one we live in. Rather, it is a
perfect image of *this world* when justice has been realized with and
for everyone and everything that is already here. To stand apart is
to look at the world (now) from the point of view of the world as it
could be (the future), with all of the hope and sorrowful contempla-
tion that this entails.

Both apart from and responsible to the present, we might allow
ourselves to sense the faint outline of an Epicurean good life free
from "myths and superstitions" like racism, sexism, homophobia,
transphobia, xenophobia, climate change denial, and other fears
with no basis in reality. This is no idle exercise. As the attention
economy works to keep us trapped in a frightful present, it only
becomes more important not just to recognize past versions of our
predicament but to retain the capacity for an imagination some-
how untainted by disappointment.

But most important, standing apart represents the moment in
which the desperate desire to leave (forever!) matures into a com-
mitment to live in permanent refusal, *where one already is*, and to
meet others in the common space of that refusal. This kind of
resistance still manifests as participating, but participating in the
"wrong way": a way that undermines the authority of the hege-
monic game and creates possibilities outside of it.

Chapter 3

Anatomy of a Refusal

From: X

Sent: February 27 2008 00:16

To: Z, Y

Subject: marketing-trainee

Importance: High

Hi,

As I already mentioned to Z, there has been a person sitting in the Tax library space and staring out of the window with a glazed look in her eyes . . .

Female, very short hair, she said when asked that she's a trainee in Marketing.

She sat in front of an empty desk from 10:30am, went for lunch . . .[1]

In 2008, employees at an office for the accounting firm Deloitte were troubled by the behavior of a new recruit. In the midst of a bustling work environment, she didn't seem to be doing anything except sitting at an empty desk and staring into space. Whenever someone would ask what she was doing, she would reply that she was "doing thought work" or "working on [her] thesis." Then there was the day that she spent riding the elevators up and down repeat-

edly. When a coworker saw this and asked if she was "thinking again," she replied: "It helps to see things from a different perspective."[2] The employees became uneasy. Urgent inter-office emails were sent.

It turned out that the staff had unwittingly taken part in a performance piece called *The Trainee*. The silent employee was Pilvi Takala, a Finnish artist who is known for videos in which she quietly threatens social norms with simple actions. In a piece called *Bag Lady*, for instance, she spent days roaming a mall in Berlin while carrying a clear plastic bag full of euro bills. Christy Lange describes the piece in *Frieze*: "While this obvious display of wealth should have made her the 'perfect customer,' she only aroused suspicion from security guards and disdain from shopkeepers. Others urged her to accept a more discreet bag for her money."[3]

The Trainee epitomized Takala's method. As observed by a writer at Pumphouse Gallery, which showed her work in 2017, there is nothing inherently unusual about the notion of not working while at work; people commonly look at Facebook on their phones or seek other distractions during work hours. It was the image of utter inactivity that so galled Takala's colleagues. "Appearing as if you're doing nothing is seen as a threat to the general working order of the company, creating a sense of the unknown," they wrote, adding solemnly, "The potential of nothing is everything."[4]

LOOKING AT *THE TRAINEE*, it's clear that the reactions of others are what make such acts humorous and often legendary. Stopping or refusing to do something only gains this status if everyone else is doing what is expected of them, and have never allowed that anyone would ever deviate. A crowded sidewalk is a good example: everyone is expected to continue moving forward. Tom Green poked at this convention when he performed "the Dead Guy," on his Canadian public access TV show in the 1990s. Slowing his walk to a halt, he carefully lowered himself to the ground and lay facedown

and stick-straight for an uncomfortable period of time. After quite a crowd had amassed, he got up, looked around, and nonchalantly walked away.[5]

As alarmed as the sidewalk crowd might have been, the TV audience delights more and more in Green's performance the longer it goes on. Likewise, Takala might be bemusedly remembered by even those who sent the frantic emails, as the one employee who did the (very) unexpected. At their loftiest, such refusals can signify the individual capacity for self-directed action against the abiding flow; at the very least, they interrupt the monotony of the everyday. From within unquestioned cycles of behavior, such refusals produce bizarre offshoots that are not soon forgotten. Indeed, some refusals are so remarkable that we remember them many centuries later.

That seems to be the case with Diogenes of Sinope, the Cynic philosopher who lived in fourth-century Athens and later Corinth. Many people are familiar with "the man who lived in a tub," scorning all material possessions except for a stick and a ragged cloak. Diogenes's most notorious act was to roam through the city streets with a lantern, looking for an honest man; in paintings, he's often shown with the lantern by his side, sulking inside a round terracotta tub while the life of the city goes on around him. There are also paintings of the time he dissed Alexander the Great, who had made it a point to visit this famous philosopher. Finding Diogenes lazing in the sun, Alexander expressed his admiration and asked if there was anything Diogenes needed. Diogenes replied, "Yes, stand out of my light."[6]

Plato's designation of Diogenes as "Socrates gone mad" wasn't far off the mark. While he was in Athens, Diogenes had come under the influence of Antisthenes, a disciple of Socrates. He was thus heir to a development in Greek thought that prized the capacity for individual reason over the hypocrisy of traditions and customs, even and especially if they were commonplace. But one of the differences between Socrates and Diogenes was that, while Socrates

famously favored conversation, Diogenes practiced something closer to performance art. He lived his convictions out in the open and went to great lengths to shock people out of their habitual stupor, using a form of philosophy that was almost slapstick.

This meant consistently doing the opposite of what people expected. Like Zhuang Zhou before him, Diogenes thought every "sane" person in the world was actually insane for heeding any of the customs upholding a world full of greed, corruption, and ignorance. Exhibiting something like an aesthetics of reversal, he would walk backward down the street and enter a theater only when people were leaving. Asked how he wanted to be buried, he answered: "Upside down. For soon down will be up."[7] In the meantime, he would roll over hot sand in the summer, and hug statues covered with snow.[8] Suspicious of abstractions and education that prepared young people for careers in a diseased world rather than show them how to live a good life, he was once seen gluing the pages of a book together for an entire afternoon.[9] While many philosophers were ascetic, Diogenes made a show of even that. Once, seeing a child drinking from his hands, Diogenes threw away his cup and said, "A child has beaten me in plainness of living." Another time, he loudly admired a mouse for its economy of living.[10]

When Diogenes did conform, he did it ironically, employing what the twentieth-century conceptual artists the Yes Men have called "overidentification." In this case, refusal is (thinly) masked as disingenuous compliance:

> When news came to the Corinthians that Philip and the Macedonians were approaching the city, the entire population became immersed in a flurry of activity, some making their weapons ready, or wheeling stones, or patching the fortifications, or strengthening a battlement, everyone making himself useful for the protection of the city. Diogenes, who had nothing to do and from whom no one was willing to ask anything, as soon as he noticed the bustle of those sur-

rounding him, began at once to roll his tub up and down the Craneum with great energy. When asked why he did so, his answer was, "Just to make myself look as busy as the rest of you."[11]

That Diogenes's actions in some ways prefigured performance art has not gone unnoticed by the contemporary art world. In a 1984 issue of *Artforum*, Thomas McEvilley presented some of Diogenes's best "works" in "Diogenes of Sinope (c. 410–c. 320 BC): Selected Performance Pieces." Arranged in this context, his acts indeed sound like the cousins of the works from the twentieth-century antics of Dada and Fluxus.

McEvilley, as so many others throughout history have, admires Diogenes's courage when it came to flouting customs so *customary* that they were not even spoken about. He writes, "[Diogenes's] general theme was the complete and immediate reversal of all familiar values, on the ground that they are automatizing forces which cloud more of life than they reveal."[12] When McEvilley says that Diogenes's actions "[thrust] at the cracks of communal psychology" and "laid bare a dimension of hiding possibilities he thought might constitute personal freedom," it's easy to think not only of how easily Pilvi Takala unsettled her coworkers at Deloitte, but every person who, by refusing or subverting an unspoken custom, revealed its often-fragile contours. For a moment, the custom is shown to be not the horizon of possibility, but rather a tiny island in a sea of unexamined alternatives.

THERE ARE MANY stories about Diogenes that may be apocryphal. As Luis E. Navia writes in *Diogenes of Sinope: The Man in the Tub*, his status as an uncompromising "dog" who "stood proudly as the living refutation of his world" must have inspired a huge number of stories with varying degrees of embellishment. To this day, although he has his critics, Diogenes is often hailed as a hero. For

Foucault, he was the model of the philosopher who tells it like it is;[13] for Nietzsche, he was the originator of the Cynic approach behind any genuine philosophy.[14]

In the eighteenth century, Jean-Baptiste le Rond d'Alembert wrote that "[e]very age . . . needs a Diogenes."[15] I would agree. We need a Diogenes not just for entertainment, nor just to show that there are alternatives, but because stories like his contribute to our vocabulary of refusal even centuries later. When we hear about Diogenes blowing off Alexander the Great, it's hard not to laugh and think, "Fuck yeah!" Although most people aren't likely to do something so extreme, the story provides a locus for our wish to do so.

But beyond showing that refusal is possible—highlighting the "cracks" in the crushingly habitual—Diogenes also has much to teach us about *how* to refuse. It's important to note that, faced with the unrelenting hypocrisy of society, Diogenes did not flee to the mountains (like some philosophers) or kill himself (like still other philosophers). In other words, he neither assimilated to nor fully exited society; instead he lived in the midst of it, in a permanent state of refusal. As Navia describes it, he felt it was his duty to stand as a living refusal in a backward world:

> [Diogenes] opted for remaining in the world for the express purpose of challenging its customs and practices, its laws and conventions, by his worlds and, more so, by his action. Practicing his extreme brand of Cynicism, then, he stood as a veritable refutation of the world and, as the Gospel would say of Saint John the Baptist, as "a voice crying in the wilderness" (Matt. 3:3).[16]

So to a question like "Will you or will you not participate as asked?" Diogenes would have answered something else entirely: "I will participate, but not as asked," or, "I will stay, but I will be your gadfly." This answer (or non-answer) is something I think of

as producing what I'll call a "third space"—an almost magical exit to another frame of reference. For someone who cannot otherwise live with the terms of her society, the third space can provide an important if unexpected harbor.

DELEUZE ONCE FOUND a handy formula for finding this space in one of our most famous tales of refusal: Herman Melville's short story, "Bartleby, the Scrivener." Bartleby, the clerk famous for repeating the phrase, "I would prefer not to," uses a linguistic strategy to invalidate the requests of his boss. Not only does he not comply; he refuses the terms of the question itself.

The fact that the story of "Bartleby, the Scrivener" is so widely known speaks to its importance in the cultural imagination. The narrator, a comfortable Wall Street lawyer, hires a copyist named Bartleby, a mild man who performs his duties well enough until asked to check his own writing against an original. Without agitation, Bartleby says he would prefer not to, and from that point on continues to give the same answer when asked to perform a task. He eventually stops working, and then even moving; the lawyer finds that he's taken up residence in his workspace. At a loss for what to do, the lawyer changes offices, but the next occupant is not so accommodating—he has Bartleby taken to jail.

Just as the best part of The Trainee is the stunned Deloitte workers, my favorite parts of "Bartleby, the Scrivener" are the lawyer's reactions, which so quickly progress from disbelief to despair. Not just that, but each subsequent refusal produces more and more extreme variations of the same phenomenon: the lawyer, who is often in a rush going about his business, is stopped dead in his tracks, grasping for sense and meaning like Wile E. Coyote having run off a cliff. For example, the first time he asks Bartleby to review a piece of writing, the lawyer is so absorbed and hurried that he simply hands the paper to Bartleby without looking at him, with the "haste and natural expectancy of instant compliance." When

Bartleby says he "would prefer not to," the lawyer is so surprised, he is rendered speechless: "I sat awhile in perfect silence, rallying my stunned faculties." After a second refusal the lawyer is "turned into a pillar of salt," needing a few moments to "recover [himself]." Best of all, when the lawyer is on his way into work only to find the door locked from within by Bartleby (who politely refuses to open the door because he is "occupied"), the lawyer is thunderstruck:

> For an instant I stood like the man who, pipe in mouth, was killed one cloudless afternoon long ago in Virginia, by a summer lightning; at his own warm window he was killed, and remained leaning out there upon the dreamy afternoon, till some one touched him, when he fell.[17]

At one point the lawyer is so unsettled by Bartleby's ongoing refusals that he feels compelled to read Jonathan Edwards's *Freedom of the Will* and Joseph Priestley's *The Doctrine of Philosophical Necessity*, both treatises on the possibility of free will. The former holds that man has the free will to pursue what is good, but what is good is foreordained by God (this might remind us of Frazier's description of "freedom" from *Walden Two*); the latter claims that all of our decisions follow from predetermined dispositions, in a somewhat mechanistic fashion (another good description of *Walden Two*). In other words, everything happens for a reason, and people can't help the way they act. "Under those circumstances," says the lawyer, "those books induced a salutary feeling."[18]

Those "circumstances," of course, are Bartleby's abiding inscrutability. When the lawyer asks Bartleby if he'll tell him where he was born, Bartleby answers, "I would prefer not to." The lawyer asks desperately: "Will you tell me *any thing* about yourself?" "I would prefer not to." But why? "At present I prefer to give no answer." There is no reason given, no reason given as to why no reason is given, and so on.

This gets at Bartleby's next-level refusal: he not only will not do

what he is asked, he answers in a way that negates the terms of the question. Alexander Cooke summarizes Deleuze's reading of the story:

> Bartleby does not refuse to do anything. If Bartleby had said, "I will not," his act of resistance would have merely negated the law. Having negated in relation to the law, this transgression would have perfectly fulfilled the law's function.[19]

Indeed, this explains why the lawyer wishes that Bartleby would just outright refuse so that they could at least do battle on the same plane: "I felt strangely goaded on to encounter him in new opposite, to elicit some angry spark from him answerable to my own. But indeed I might as well have essayed to strike fire with my knuckles against a bit of Windsor soap." Bartleby, who remains maddeningly placid throughout the story, exposes and inhabits a space around the original question, undermining its authority. For Deleuze, by its very linguistic structure, Bartleby's response "carve[s] out a kind of foreign language within language, to make the whole confront silence, make it topple into silence."[20]

The lawyer tells us that a refusal from anyone else would have been grounds for banishment, but with Bartleby, "I should have as soon thought of turning my pale plaster-of-paris bust of Cicero out of doors."[21] I find the mention of Cicero significant. In a partially lost work called *De Fato*, the first-century BC statesman and philosopher comes to a very different conclusion about free will than Edwards or Priestley, and his writings would decidedly *not* "induce a salutary feeling" in the lawyer. For Cicero, there can be no ethics without free will, and that is enough to put an end to the question. In "Cicero's Treatment of the Free Will Problem," Margaret Y. Henry writes:

> Cicero is far from denying the law of causality. He freely admits that antecedent and natural causes give men a tendency

in one direction or another. But he insists that men are never-
theless free to perform specific acts independent of such ten-
dencies and even in defiance of them . . . Thus a man may build
a character quite at variance with his natural disposition.[22]

Cicero cites the examples of Stilpo and Socrates: "It was said
that Stilpo was drunken and Socrates was dull, and that both were
given to sensual indulgence. But these natural faults they uprooted
and wholly overcame by will, desire, and training (*voluntate, studio,
disciplina*)."[23]

If we believed that everything were merely a product of fate or
disposition, Cicero reasons, no one would be accountable for any-
thing and therefore there could be no justice. In today's terms, we'd
all just be algorithms. Furthermore, we'd have no reason to try to
make ourselves better or different from our natural inclinations.

VOLUNTATE, STUDIO, DISCIPLINA — IT is through these things that we
find and inhabit the third space, and more important, how we stay
there. In a situation that would have us answer yes or no (on its
terms), it takes work, and *will*, to keep answering something else.
This perhaps explains why Diogenes's hero was Hercules, a man
whose accomplishments were largely tests of his own will. For ex-
ample, one of Diogenes's favorite stories about Hercules was the
time he decided to clean the excrement of thousands of oxen from
a king's stable, which hadn't been cleaned in at least thirty years.
(Telling this story on a stage at the Isthmian Games, Diogenes had
his own little test of will. As a punch line to this tale of shit, he lifted
his cloak, squatted, and did "something vulgar" on the stage.[24])

Discipline and sheer force of will explain much of why we
valorize our culture's refuseniks. Imagine how disappointed we
would be, for instance, if we found out that later in life Diogenes
got a taste for comfort and took up residence in the suburbs, or if
Bartleby had either complied or looked the lawyer in the eye and

said loudly, "Fine!" or "No!" It's uncomfortable to assert one's will against custom and inclination, but that's what makes it admirable. The longer Tom Green lies on the sidewalk, the more awkward (both physically and socially) it is for him to stay there, yet he remains. It was probably this kind of social stamina that Diogenes had in mind when he said he would only accept disciples who were willing to carry a large fish or piece of cheese in public.

The performance artist Tehching Hsieh would have likely been accepted as a disciple of Diogenes. In 1978, he built a roughly nine-foot-square cage in his studio for *Cage Piece*, a performance in which he would remain inside the cage for exactly a year. Every day, a friend would visit to bring food and remove waste. Beyond that, Hsieh drew up some draconian terms for himself: He was not allowed to talk, read, or write (except for marking each day on the wall); no television or radio was allowed. In fact, the only other thing in the cell besides the bed and the sink was a clock. The performance was open to the public once or twice a month; otherwise, he was alone. Asked later how he spent his time, Hsieh said that he had kept himself alive and thought about his art.

At the start of *Cage Piece*, Hsieh had a lawyer visit the cage at the beginning to witness it being sealed shut and return at the end to confirm that the seal had not been broken. In an essay on Hsieh, arts writer Carol Becker notes the irony of appealing to the law "even though the law that governs Hsieh's work is a rigorous system of his own invention."[25] She compares him to an athlete — a high jumper or a pole-vaulter who impresses the viewer with his training and "mastery of self." Indeed, Hsieh is an artist known for his discipline. After *Cage Piece*, he continued making pieces that each lasted a year: *Time Clock Piece*, in which he punched a time clock every hour on the hour; *Outdoor Piece*, in which he wouldn't allow himself to go inside (including cars and trains); *Rope Piece*, in which he was tied to the artist Linda Montano (they had to stay in the same room but could not touch each other); and *No Art Piece*, in which he didn't make, look at, read about, or talk about art.

In a 2012 interview, Hsieh says that he is not an endurance artist, yet he also says that the most important word to him is "will."[26] This makes sense if we accept that *Cage Piece* is less a feat of endurance than an experiment. In the interview, Hsieh, who was preoccupied with time and survival, described the process by which people fill up their time in an attempt to fill their lives with meaning. He was earnestly interested in the opposite: What would happen if he emptied everything out? His search for this answer occasioned the experiment's many harsh "controls"—for it to work, it needed to be pure. "I brought my isolation to the public while still preserving the quality of it," he said.[27]

The formulation of this project as an experiment in subtraction reminds many people of another well-known refusenik. Explaining his need to live sparely in a cabin away from the customs and comforts of society, Henry David Thoreau famously wrote:

> I went to the woods because I wished to live deliberately, to front only the essential facts of life, and see if I could not learn what it had to teach, and not, when I came to die, discover that I had not lived . . . I wanted to live deep and suck out all the marrow of life, to live so sturdily and Spartan-like as to put to rout all that was not life, to cut a broad swath and shave close, to drive life into a corner, and reduce it to its lowest terms, and, if it proved to be mean, why then to get the whole and genuine meanness of it, and publish its meanness to the world; or if it were sublime, to know it by experience, and be able to give a true account of it in my next excursion.[28]

THOREAU, TOO, SOUGHT a third space outside of a question that otherwise seemed given. Disillusioned by the country's treatment of slavery and its openly imperialist war with Mexico, the question for Thoreau was not which way to vote but whether to vote—or to do something else entirely. In "On the Duty of Civil

Disobedience," that "something else" is refusing to pay taxes to a system that Thoreau could no longer abide. While he understood that technically this meant breaking the law, Thoreau stood outside the question and judged the law itself: "If [the law] is of such a nature that it requires you to be the agent of injustice to another, then, I say, break the law," he wrote. "Let your life be a counter friction to stop the machine."[29]

Like Plato with his allegory of the cave, Thoreau imagines truth as dependent on perspective. "Statesmen and legislators, standing so completely within the institution never distinctly and nakedly behold it," he says. One must ascend to higher ground to see reality: the government is admirable in many respects, "but seen from a point of view a little higher they are what I have described them; seen from a higher still, and the highest, who shall say what they are, or that they are worth looking at or thinking of at all?" As for Plato, for whom the escapee from the cave suffers and must be "dragged" into the light, Thoreau's ascent is no Sunday stroll in the park. Instead it is a long hike to the top of a mountain when most would prefer to stay in the hills:

> They who know of no purer sources of truth, who have traced up its stream no higher, stand, and wisely stand, by the Bible and the Constitution, and drink at it there with reverence and humility; but they who behold where it comes trickling into this lake or that pool, gird up their loins once more, and continue their pilgrimage to its fountain-head.[30]

Things look different from up there, which explains why Thoreau's world, like that of Diogenes and Zhuang Zhou, is full of reversals. In a society where men have become law-abiding machines, the worst men are the best, and the best men are the worst. The soldiers going to fight the war in Mexico "command no more respect than men of straw or a lump of dirt"; the government would "crucify Christ, and excommunicate Copernicus and Luther, and pronounce

Washington and Franklin rebels," and the only place in town where Thoreau feels truly free is prison. For him, to be alive is to exercise moral judgment, but by those standards, almost everyone around him is already dead. In their place he sees man-machines that are not unlike the programmed and free-within-bounds members of *Walden Two* or *Westworld*.

Thoreau's title, "On the Duty of Civil Disobedience," is a riposte to another piece he mentions, William Paley's "Duty of Submission to Civil Government." For Thoreau, Paley is one such basically dead man, since Paley views the occasion for resistance as "a computation of the quantity of danger and grievance on the one side, and of the probability and expense of redressing it on the other."[31] Moral judgment is replaced by cost-benefit analysis; Paley's idea sounds like the way an AI would decide when and whether resistance was necessary. But from Thoreau's perch atop the mountain of reason, Paley looks trapped in the flatlands, where he "never appears to have contemplated those cases to which the rule of expediency does not apply, in which a people, as well as an individual, must do justice, cost what it may."

This means, however, that even when he's let out of jail, Thoreau's perspective confines him to a life of permanent refusal. He "quietly declare[s] war on the state" and must live as an exile in a world that shares none of his values. Thoreau's own "state" is in fact what I described previously as "standing apart." Viewing the present from the future, or injustice from the perspective of justice, Thoreau must live in the uncomfortable space of the unrealized. But hope and discipline keep him there, oriented toward "a still more perfect and glorious State, which also I have imagined, but not yet anywhere seen."

Like any expression of discontent, "Civil Disobedience" is already an attempt to seek out those who might harbor the same feelings. Thoreau's ultimate hope was that if enough individual people decided at once to exercise their moral judgment instead of continuing to play the game, then the game might actually

change for once. This jump from the individual to the collective entails another version of what I've so far been describing as *voluntate, studio, disciplina*. In Diogenes, Bartleby, and Thoreau, we see how discipline involves strict alignment with one's own "laws" over and against prevailing laws or habits. But successful collective refusals enact a second-order level of discipline and training, in which individuals align with each other to form flexible structures of agreement that can hold open the space of refusal. This collective alignment emerges as a product of intense individual self-discipline—like a crowd of Thoreaus refusing in tandem. In so doing, the "third space"—not of retreat, but of refusal, boycott, and sabotage—can become a spectacle of noncompliance that registers on the larger scale of the public.

WHEN I WAS working at my corporate marketing job in San Francisco, I used to take long lunch breaks as a small, selfish act of resistance. I'd sit on the Embarcadero waterfront, looking plaintively out at the Bay Bridge and the diving ducks. I didn't yet know they were actually double-crested cormorants. The other thing I didn't know yet was that I was sitting at the site of an unprecedented and awe-inspiring coordination of resistance that had happened in 1934.

Before shipping shifted mostly to the Oakland port, longshoremen worked the bustling piers near my future lunch spot. Mostly living on subsistence wages, they endured ever-shifting combinations of working too hard and lining up to get hired again—a demoralizing process known as the "shape-up." Their hours were subject not only to the whims of the nepotistic gang bosses who would or would not hire them, but to the unpredictable rhythms of the shipping economy. Once on the job, they encountered the "speed-up," being expected to work faster and faster and facing increasing rates of injury and risk. But in their atomized state, the longshoremen had not been able to refuse these terms; there was always someone who'd happily take their place, abuses and all. A

former longshoreman who recalled working anywhere from two to thirty hours in a single shift said that complaint was not an option: "If you would say anything of that kind you would just simply be fired."[32]

In 1932, an anonymous group began producing and distributing a paper called The Waterfront Worker from an unknown location. Self-described "rank-and-file journalist" Mike Quin writes that "it merely said what every longshoreman had long known to be a fact, and put into frank language the resentment that was smoldering in every dock worker's heart."[33] A scrappy publication, it was soon circulating a few thousand copies. Then, in 1933, the National Industrial Recovery Act guaranteed the right to join a trade union and engage in collective bargaining, and many of the longshoremen left their largely useless company-run unions to join the International Longshoremen's Association (ILA). They began organizing a new political body consisting of actual dockworkers instead of salaried union officials.

Leading up to the strike, the longshoremen organized a convention in San Francisco where the delegates—all of whom worked on the docks—represented fourteen thousand longshoremen up and down the coast. I consider the activities of the rank and file an instance of what I've been calling the "third space," since it was a racially inclusive and distinctly democratic space that stood outside the usual lines of battle. "While employers and union officials engaged in totally unproductive negotiations," writes Quin, "the men on the docks proceeded with arrangements for the strike."[34]

Things came to a head when the Industrial Association would not accept the demand for a union-run hiring hall for longshoremen. This was a sticking point, because hiring halls would determine who was hired, and if they weren't run by the union, the political choke hold of the shape-up would go essentially unchanged and strikers would suffer retribution. The longshoremen voted, nearly unanimously, to call a strike. On May 9, longshoremen walked out in all West Coast ports, tying up almost two thousand miles of the waterfront.

The daily reality of the strike required disciplined coordination both within and outside of the union. Networks of support formed as sympathizers from around the country sent in thousands of dollars. Soup kitchens, which served thousands of strikers daily, received truckloads of produce sent in from small farmers. Women organized a Ladies Auxiliary of the ILA and handled relief applications from strikers under financial duress and assisted in the ILA kitchens. Sensing that the police were in the palm of the city and the employers, strikers set up their own waterfront police to address disturbances along the docks, complete with an emergency number that led to a longshoreman-turned-dispatcher.[35] All the while, the union continued having meetings and enlisting the votes of the rank and file.

Much like a picket line itself, a strike is something whose strength lies in its continuity. Thus, as always, employers focused their efforts on breaking the line. Early on, they tried to get each port to negotiate its own separate agreement, thus preventing a coast-wide alliance. They hired strikebreakers—in some cases college football players—offering them a police escort and housing aboard a moored ship with plush treatment: meals, laundry, entertainment, and banking facilities. The employers also attempted to foment racism among the longshoremen; Quin writes that "[b]osses who would never hire Negroes except for the most menial jobs now made special, and relatively unsuccessful, efforts to recruit Negroes as scabs."[36] As thousands of men picketed up and down the Embarcadero, a daily spectacle whose consistency impressed onlookers, the police decided to selectively apply a previously unenforced ordinance against picketing, running the picketers off the sidewalk with horses. Meanwhile, employers ran cloying ads designed to break the will of the strikers, who waited for a free lunch in block-long, four-deep lines along the Embarcadero:

We want to pay you as good wages as the industry can afford. We always have paid top wages—and hope to keep it up.

Recovery is not yet here—it is only on the way. You're hurt-
ing, not helping, to bring it back for yourselves, for us, and for
San Francisco.

It is an ill-advised strike.

Be reasonable![37]

In fact, it was just such an effort to break the line that set off
events that led to the General Strike of 1934. The Industrial Associa-
tion, representing employers, forcibly opened the port and maneu-
vered trucks through the picket lines. When they tried to open it
farther, violence erupted and two men were killed by police—one a
striking longshoreman and the other a volunteer at a strike kitchen.
People immediately lined the site with flowers and wreaths. Police
arrived to remove the flowers and the strikers, but strikers returned
later, replaced the flowers, and stood guard.

The Friends and family held a small, somber memorial the next day.
But as they proceeded down Market Street, they were unexpectedly
joined by thousands of strikers, sympathizers, and spectators who
silently marched alongside them. In his history of the strike, David
Selvin writes that papers afterward struggled to describe the magni-
tude and silence of the event. "Here they came as far as you could see
in a silent, orderly line of march," wrote the *Chronicle*'s Royce Brier,
"a mass demonstration of protest which transcended anything of the
like San Francisco has ever seen."[38] Tillie Olsen imagined the shock
the Industrial Association must be experiencing: "[W]here did the
people come from, where was San Francisco hiding them, in what
factories, what docks, what are they doing there, marching, or stand-
ing and watching, not saying anything, just watching."[39]

The haunting image proved to be a turning point. Selvin writes
that while talk had circulated about a general strike, "this grim,
silent parade made it inevitable." In the coming days, one hundred
and fifty thousand people around the Bay walked off the job.

IF WE THINK about what it means to "concentrate" or "pay attention" at an individual level, it implies alignment: different parts of the mind and even the body acting in concert and oriented toward the same thing. To pay attention to one thing is to resist paying attention to other things; it means constantly denying and thwarting provocations outside the sphere of one's attention. We contrast this with distraction, in which the mind is disassembled, pointing in many different directions at once and preventing meaningful action. It seems the same is true on a collective level. Just as it takes alignment for someone to concentrate and act with intention, it requires alignment for a "movement" to move. Importantly, this is not a top-down formation, but rather a mutual agreement among individuals who pay intense attention to the same things and to each other.

I draw the connection between individual and collective concentration because it makes the stakes of attention clear. It's not just that living in a constant state of distraction is unpleasant, or that a life without willful thought and action is an impoverished one. If it's true that collective agency both mirrors and relies on the individual capacity to "pay attention," then in a time that demands action, distraction appears to be (at the level of the collective) a life-and-death matter. A social body that can't concentrate or communicate with itself is like a person who can't think and act. In Chapter 1, I mentioned Berardi's distinction between connectivity and sensitivity in *After the Future*. It's here that we see *why* this difference matters. For Berardi, the replacement of sensitivity with connectivity leads to a "social brain" that "appears unable to recompose, to find common strategies of behavior, incapable of common narration and of solidarity."

This "schizoid" collective brain cannot act, only react blindly and in misaligned ways to a barrage of stimuli, mostly out of fear

and anger. That's bad news for sustained refusal. While it may seem at first like refusal is a reaction, the decision to actually refuse—not once, not twice, but perpetually until things have changed—means the development of and adherence to individual and collective commitments from which our actions proceed. In the history of activism, even things that seemed like reactions were often planned actions. For example, as William T. Martin Riches reminds us in his accounting of the Montgomery bus boycott, Rosa Parks was "acting, not reacting" when she refused to get up from her seat. She was already involved with activist organizations, having been trained at the Highlander Folk School, which produced many important figures in the movement.[40] The actual play-by-play of the bus boycott is a reminder that meaningful acts of refusal have come not directly from fear, anger, and hysteria, but rather from the clarity and attention that makes organizing possible.

THE PROBLEM IS that many people have a lot to fear, and for good reason. The relationship between fear and the ability to refuse is clear when we consider that historically, some can more easily afford to refuse than others. Refusal requires a degree of latitude—a margin—enjoyed at the level of the individual (being able to personally afford the consequences) and at the level of society (whose legal attitude toward noncompliance may vary). For her part, Parks and her family were nearly ruined by her arrest. She was unable to find full employment for ten years after the boycott, lost weight and had to be hospitalized for ulcers, and experienced "acute financial hardships" that went unaddressed until the militant trade unionists of a small branch of the NAACP forced the national organization to help her out.[41]

Even Diogenes, who would seem to have nothing to lose, existed in a kind of margin. Navia quotes Farrand Sayre, a critic of Diogenes, who suggests that Greek cities were friendly to him in their laws and weather:

the felicity of Diogenes life, which he seems to have credited to his own wisdom, was largely due to favoring circumstances over which he had no control. Greece has a mild and equable climate which favors life in the open; the governments of Corinth and Athens were liberal to aliens and vagrants, and the Greeks of that period seem to have been generous to beggars.[42]

For his part, Thoreau writes to us from outside of jail because, he reveals at one point, someone quickly paid the tax for him. Bartleby has no such recourse, and his fate is telling: he dies in prison.

Differences in social and financial vulnerability explain why participants in mass acts of refusal have often been, and continue to be, students. James C. McMillan, an art professor at Bennett College who advised students when they participated in the 1960 Greensboro sit-ins, said that black adults were "reluctant" to "jeopardize any gains, economic and otherwise," but that the students "did not have that kind of an investment, that kind of economic status, and, therefore, were not vulnerable to the kind of reprisals that could have occurred."[43] Participating students were under the care of black colleges, not at the mercy of white employers. In contrast, McMillan says that working-class black residents who went so far as to express support for the students were threatened with violence and unemployment. For them, the margin was much smaller.

Institutional support can go a long way toward allowing individuals to "afford" to refuse. During the sit-ins, faculty at black colleges offered advice, the NAACP provided legal support, and other organizations offered nonviolence training workshops. Perhaps just as important, the Bennett administration made it clear to their students that they wouldn't be penalized for their participation in the sit-ins. Dr. Willa B. Player, the president of Bennett, said at the time that "the students were carrying out the tenets of what a liberal arts education was all about, so they should be allowed to continue."[44] (For a more recent example of administrative support, see

MIT's 2018 announcement that they would not turn away accepted high school students who had been arrested for participating in the Parkland, Florida, protests against gun violence.[45])

Acts of collective refusal are obviously more "costly" for participants if they're considered illegal. Unions, especially in the 1930s and 1940s, provided the formal protection needed for striking workers to participate in a strike, and those protections in turn were codified into law (for a time, anyway). In his book on the San Francisco General Strike, Selvin describes the futility of individual acts of refusal before the 1933 National Industrial Recovery Act guaranteed the right to join trade unions:

> In a free labor market, of course, the longshoreman or seaman was free to accept the shipowner's offer or leave it; in practical terms, standing alone, without resources, living on the edge of subsistence, the longshoreman or seaman was powerless to resist.[46]

FOR THOSE WHO have ever enjoyed any kind of margin, it seems to have been shrinking for a long time now. Although they might have little else in common with a longshoreman in the 1930s, many modern workers might relate to the longshoremen's schedule, as it was described by Frank P. Foisie, later the leader of the Waterfront Employers Association:

> [Their labor] suffers the full brunt of a depression, the slack of seasons, and in addition must deal with fluctuations daily and hourly peculiar to itself. Discharging and loading vessels is subject to the variables of uncertain arrival of ships, diverse cargoes, good, bad, and ordinary equipment, regrouping of men and different employers; and is at the mercy of the elements of time, tide, and weather . . . Hiring is by the hour, not the day, and never steadily.[47]

Before the unions, the longshoremen's experience of time was completely beholden to the ups and downs of capital. While the 1932 law enabled union organizing, the tides had already begun to turn against organized labor with the 1947 Taft–Hartley Act, which among other things prohibited the coordination of strike efforts among different unions.

Today, subjection to a ruthless capitalist framework seems almost natural. In his 2006 book *The Great Risk Shift: The New Economic Insecurity and the Decline of the American Dream*, Jacob S. Hacker describes a "new contract" that formed between companies and employees in the absence of regulation from the government in the 1970s and '80s:

> The essence of the new contract was the idea that workers should be constantly pitted against what economists call the "spot market" for labor—the amount that they could command at a particular moment given particular skills and the particular contours of the economy at that time.[48]

The contract is markedly different from the old one, in which companies and employees' fates rose and fell together, like a marriage. He quotes an employee memo from the CEO of General Electric in the 1980s: "If loyalty means that this company will ignore poor performance, then loyalty is off the table."[49] In the global "spot market," companies are driven only by the need to remain competitive, passing the task on to individuals to remain competitive as producing bodies.

This "new contract," alongside other missing forms of government protection, closes the margin for refusal and leads to a life lived in economic fear. When Hacker describes the new situation faced by those for whom precarity was not already a matter of course, the margin has eroded completely: "Americans increasingly find themselves on an economic tightrope, without an adequate safety net if—as is ever more likely—they lose their foot-

ing."[50] Any argument about mindfulness or attention must address this reality. It's hard for me to imagine, for example, suggesting "doing nothing" to anyone who Barbara Ehrenreich meets while working at low-wage jobs for her book *Nickel and Dimed: On (Not) Getting by in America*. Ehrenreich and her coworkers are too busy with the impossible puzzle of making ends (money, time, and the limits of the human body) meet. Even if one solved this puzzle, the question would remain for Ehrenreich: "If you hump away at menial jobs 360-plus days a year, does some kind of repetitive injury of the spirit set in?"[51]

When almost everything and every kind of service can be outsourced, white-collar workers find themselves toeing the line, too. In *The Big Squeeze: Tough Times for the American Worker*, Steven Greenhouse observes among white-collar workers the same attitude as Selvin's longshoremen ("you would just simply be fired"):

> Many workers fear pink slips so much that they are frightened to ask for raises or protest oppressive workloads. Globalization, including the recent rush to offshore hundreds of thousands of white-collar jobs, has increased such fears.[52]

In 2016, the writer and blogger Talia Jane took the risk of protest and lost. She had been working as a customer-service representative at Yelp, but was having trouble making ends meet due to the high cost of living in the Bay Area. After writing an open letter to Yelp about her situation and asking for a living wage, she was fired, given $1,000 severance, and banned from returning. Yelp later raised its wages, though it denied that she had anything to do with it. Jane's story became a touch point in the conversation about Millennials, making her something of a public figure. But in September 2018, she was still looking for meaningful work. About her nonexistent margin, Jane tweeted:

i swear to god if i'm still making smoothies for a living 3 months from now i'm going to freakin . . . get up and keep going to work because i don't have a safety net that affords me the ability to quit a fruitless, unfulfilling, stagnant job in pursuit of my dreams.[53]

WHEN I READ Selvin's descriptions of the 1930s longshoremen before the strike, who lived unprotected from the vicissitudes of capital and "put up with round-the-clock shifts, cut short rest periods between jobs, and missed meal periods," I'm reminded not only of today's "new contract" and Talia Jane's plight, but of a particular group of people: my students.

Back in 2013, students in my first art classes at Stanford were surprised that I didn't know about "Stanford duck syndrome." This phrase, which imagines students as placid-seeming ducks paddling strenuously beneath the water, is essentially a joke about isolated struggle in an atmosphere obsessed with performance. In "Duck syndrome and a culture of misery," *Stanford Daily* writer Tiger Sun describes seeing a friend pull two consecutive all-nighters on her birthday weekend. Sun and his friends grow concerned when they notice her face is flushed, so they take her temperature: 102.1 degrees. But when they implore her to stop, she keeps working. Sun writes:

It's a testament to this toxic "grind or die" atmosphere at universities that, even in the face of major illness, we put the pedal to the metal and continue to drive our health off a cliff. It's not like this is a conscious decision to be miserable, but sometimes it feels as if taking care of our own health is a guilty pleasure . . . We subliminally equate feeling burned out to being a good student.[54]

He adds that even though Stanford emphasizes self-care in its new student orientation, "it seems to have been lost on everyone here."

One of the students' outlets for this stress is a Facebook page for memes specific to Stanford ("Stanford Memes for Edgy Trees"), many of which are about anxiety, failure, and sleep deprivation. Like Tom Green lying down the sidewalk, they're funny precisely because students otherwise consider admitting struggle—the furious paddling of the "Stanford duck"—to be taboo. The jokes have a rueful tone of resignation. When my students told me about the meme page, they echoed what students at other schools told *New York Magazine* about their meme pages: the jokes "come from a place of stress and anxiety"[55] and the page provides a useful space to acknowledge those feelings.

For that reason (and also because the memes are often really funny), I'm glad that "Stanford Memes for Edgy Trees" exists. But it also depresses me. However much the squeeze is humorously acknowledged, and however much Stanford or even the students among themselves might emphasize self-care, they're running up against the same market demands haunting all of us. At least in my experience, students aren't workaholics for the sake of it; the workaholism is driven by a very real fear of very real consequences that exist both within and outside of school. Blowing off steam by commenting "legit me" on a meme about sleep deprivation, or even allowing oneself a day off to catch up on sleep (!), can't help with the overarching issue of economic precarity that awaits the student—and indeed has already reached less privileged students who must work in addition to studying. It does nothing about the specter of student debt, nor about the fear of ending up outside a shrinking pool of security.

Indeed, many of the pages' most cutting jokes attest to the students' awareness of this. One Stanford meme uses a photo of Donald Trump talking to Mike Pence while gesturing toward a large empty space in front of them; Trump is tagged "my college," Pence

is tagged "me, after graduating college," and the empty space is tagged "job prospects."[56] Another is a screenshot, mostly of a ceiling and part of someone's head, with the Stanford University Snapchat geofilter and the caption: "I am surrounded by massive amounts of wealth in this pressure cooker of entrepreneurship and tech that satellites the rest of this endless suburbia where the middle class can't find a one bedroom apartment."[57] On UC Berkeley's meme page, someone has posted the "sold pupper dance video," in which a small dog in a pet store paws adorably at a glass cage labeled "I am sold." The caption: "when you get your summer internship and celebrate committing yourself to being yet another cog in the vast capitalist machine."[58]

Knowing this, I can forgive my students for getting frustrated that my art classes aren't "practical" in any easily demonstrable sense. I've come to suspect that it's not a lack of imagination on their parts. Rather, I'd venture that it's an awareness of the cold hard truth that every minute counts toward the project of gainful employment. In *Kids These Days: Human Capital and the Making of Millennials*, in which Malcolm Harris takes us through the ruthless professionalization of childhood and education, Harris writes that "[i]f enough of us start living this way, then staying up late isn't just about pursuing an advantage, it's about not being made vulnerable."[59] A Millennial himself, he describes the shifting of risk onto students as potential employees, who must fashion themselves to be always on, readily available, and highly productive "entrepreneurs" finding "innovative" ways to forego sleep and other needs. Students duly and expertly carry out complicated maneuvers in which one misstep—whether that's getting a B or getting arrested for attending a protest—might have untenable lifelong consequences.

In the context of attention, I'd further venture that this fear renders young people less able to concentrate individually or collectively. An atomized and competitive atmosphere obstructs individual attention because everything else disappears in a fearful and myopic battle for stability. It obstructs collective attention because

students are either locked in isolated struggles with their own lim-
its, or worse, actively pitted against each other. In *Kids These Days*,
Harris is well aware of the implications of precarity for any kind
of organizing among Millennials: "If we're built top-to-bottom to
struggle against each other for the smallest of edges, to cooperate
not in our collective interest but in the interests of a small class
of employers—and we are—then we're hardly equipped to protect
ourselves from larger systemic abuses."[60]

THERE ARE MANY "systemic abuses" to be refused at the moment,
but I propose that one great place to start is the abuse of our atten-
tion. That's because attention undergirds every other kind of mean-
ingful refusal: it allows us to reach Thoreau's higher perspective,
and forms the basis of a disciplined collective attention that we see
in successful strikes and boycotts whose laser-like focus withstood
all the attempts to disassemble them. But in today's mediascape, it's
hard to imagine what refusal looks like on the level of attention.
For example, when I mention to anyone that I'm thinking about
"resisting the attention economy," their first response is "Cool, so,
like, quitting Facebook?" (usually followed by musings on the im-
possibility of leaving Facebook).

Let's consider that option for a moment. If Facebook is such a big
part of the attention economy problem, then surely quitting it is an
appropriate "fuck you" to the whole thing. To me, though, this is
fighting the battle on the wrong plane. In her 2012 paper, "Media re-
fusal and conspicuous non-consumption: The performative and po-
litical dimensions of Facebook abstention," Laura Portwood-Stacer
interviews people who quit Facebook for political reasons and finds
that the meaning of these isolated actions is often lost on the Face-
book friends left behind. Facebook abstention, like telling someone
you grew up in a house with no TV, can all too easily appear to be
taste or class related. Portwood-Stacer's interviews also show that
"the personal or political decision not to participate in Facebook

may be interpreted [by friends] as a social decision not to interact with them," or worse, as "holier-than-thou internet asceticism." Most important, the decision to leave Facebook involves its own kind of "margin":

> It may be that refusal is only available as a tactic to people who already possess a great deal of social capital, people whose social standing will endure without Facebook and people whose livelihoods don't require them to be constantly plugged in and reachable . . . These are people who have what [Kathleen] Noonan (2011) calls "the power to switch off."[61]

Grafton Tanner makes a similar point in "Digital Detox: Big Tech's Phony Crisis of Conscience," a short piece on the repentant tech entrepreneurs who have realized just how addictive their technology is. Working via initiatives like Time Well Spent, an advocacy group that aims to curb the design of addictive technology, former Facebook president Sean Parker and ex-Google employees Tristan Harris and James Williams have become fervent opponents of the attention economy. But Tanner is unimpressed:

> They fail to attack the attention economy at its roots or challenge the basic building blocks of late capitalism: market fundamentalism, deregulation, and privatization. They reinforce neoliberal ideals, privileging the on-the-move individual whose time needs to be well spent—a neatly consumerist metaphor.[62]

For my part, I, too, will remain unimpressed until the social media technology we use is noncommercial. But while commercial social networks reign supreme, let's remember that a real refusal, like Bartleby's answer, refuses the terms of the question itself.

TO TRY TO imagine what the "third space" would actually look like in the attention economy, I'll turn back to Diogenes, or rather the school of Cynicism he inspired. In sharp contrast to the modern meaning of the word *cynicism*, the Greek Cynics were earnestly invested in waking up the populace from a general stupor. They imagined this stupor as something called *typhos*, a word that also connotes fog, smoke, and storms—as in the word *typhoon* or *tai fung* in Cantonese, meaning "a great wind."[63]

A generation after Diogenes, a pupil of his named Crates wrote of an imaginary island called Pera (named after the leather wallet that Cynics counted among their few possessions) that is "surrounded but not affected" by this storm of confusion:

> *Pera, so name we an island, girt around by the sea of Illusion,*
> *Glorious, fertile, and fair land unpolluted by evil.*
> *Here no trafficking knave makes fast his ships in the harbor,*
> *Here no tempter ensures the unwary with venal allurements.*
> *Onions and leeks and figs and crusts of bread are its produce.*
> *Never in turmoil of battle do warriors strive to possess it,*
> *Here there is respite and peace from the struggle for riches and honor.*[64]

Navia reminds us that the island is obviously more "an ideal state of mind than an actual place," and that inhabitants of Pera, "contemplat[ing] the immensity of that 'wine-colored sea of fog' that surrounds their home," spend their lives trying to bring others who are lost in *typhos* to their shore through the practice of philosophy. In other words, reaching Pera requires nothing more and nothing less than *voluntate, studio, disciplina.*

Civil disobedience in the attention economy means withdrawing attention. But doing that by loudly quitting Facebook and then tweeting about it is the same mistake as thinking that the imaginary Pera is

a real island that we can reach by boat. A real withdrawal of attention happens first and foremost in the mind. What is needed, then, is not a "once-and-for-all" type of quitting but ongoing training: the ability not just to withdraw attention, but to invest it somewhere else, to enlarge and proliferate it, to improve its acuity. We need to be able to think across different time scales when the mediascape would have us think in twenty-four-hour (or shorter) cycles, to pause for consideration when clickbait would have us click, to risk unpopularity by searching for context when our Facebook feed is an outpouring of unchecked outrage and scapegoating, to closely study the ways that media and advertising play upon our emotions, to understand the algorithmic versions of ourselves that such forces have learned to manipulate, and to know when we are being guilted, threatened, and gaslighted into reactions that come not from will and reflection but from fear and anxiety. I am less interested in a mass exodus from Facebook and Twitter than I am in a mass movement of attention: what happens when people regain control over their attention and begin to direct it again, together.

Occupying the "third space" within the attention economy is important not just because, as I've argued, individual attention forms the basis for collective attention and thus for meaningful refusal of all kinds. It is also important because in a time of shrinking margins, when not only students but everyone else has "put the pedal to the metal," and cannot afford other kinds of refusal, *attention may be the last resource we have left to withdraw*. In a cycle where both financially driven platforms and overall precarity close down the space of attention—the very attention needed to resist this onslaught, which then pushes further—it may be only in the space of our own minds that some of us can begin to pull apart the links.

In *24/7: Late Capitalism and the Ends of Sleep*, Jonathan Crary describes sleep as the last vestige of humanity that capitalism cannot appropriate (thus explaining its many assaults on sleep).[65] The cultivation of different forms of attention has a similar character, since the true nature of attention is often hidden. What the attention

economy takes for granted is the quality of attention, because like all modern capitalist systems, it imagines its currency as uniform and interchangeable. "Units" of attention are assumed undifferentiated and uncritical. To give a particularly bleak yet useful example, if I'm forced to watch an ad, the company doesn't necessarily know *how* I am watching the ad. I may indeed be watching it very carefully, but like a practitioner of aikido who seeks to better understand her enemy—or for that matter, like Thomas Merton observing the corruption of the world from his hermitage. My "participation" may be disingenuous, like Diogenes rolling his barrel industriously up and down the hill to appear productive. As a precursor to action, these drills and formations of attention within the mind represent a primary space of volition. Tehching Hsieh referred to these kinds of tactics when, speaking of the year he spent in a cage, he said that nonetheless his "mind was not in jail."[66]

Of course, attention has its own margins. As I noted earlier, there is a significant portion of people for whom the project of day-to-day survival leaves no attention for anything else; that's part of the vicious cycle too. This is why it's even more important for anyone who *does* have a margin—even the tiniest one—to put it to use in opening up margins further down the line. Tiny spaces can open up small spaces, small spaces can open bigger spaces. If you can afford to pay a different kind of attention, you should.

But besides showing us a possible way out of a bind, the process of training one's own attention has something else to recommend it. If it's attention (deciding what to pay attention to) that makes our reality, regaining control of it can also mean the discovery of new worlds and new ways of moving through them. As I'll show in the next chapter, this process enriches not only our capacity to resist, but even more simply, our access to the one life we are given. It can open doors where we didn't see any, creating landscapes in new dimensions that we can eventually inhabit with others. In so doing, we not only remake the world but are ourselves remade.

Chapter 4

Exercises in Attention

In Zen they say: If something is boring after two minutes, try it
for four. If still boring, then eight. Then sixteen. Then thirty-two.
Eventually one discovers that it is not boring at all.

—JOHN CAGE[1]

There's a funny detail about Cupertino that I discovered as a
teenager. Growing up there in the early 2000s, there wasn't
much to do except visit one shopping center after another in what
I experienced as a mind-numbing sprawl with no obvious center.
The one I ended up at the most often was called Cupertino Cross-
roads, and it sat at the intersection of two six-lane roads with a stu-
pefyingly long traffic light. Cupertino Crossroads contained the
usual retail suspects at the time: Whole Foods, Mervyn's, Aaron
Brothers, Jamba Juice, Noah's Bagels. The funny detail was this: the
location of the shopping center was actually of some historical im-
portance. It had once been a "crossroads" that included Cupertino's
first post office, general store, and blacksmith. No sign of them
remained, however. It was actually unclear whether the name of
the shopping center referenced this site or whether it was a coinci-
dence. I remember finding either option equally depressing.

People usually associate Cupertino with Apple, which was
founded there and which recently inaugurated a new, futuristic-
looking campus not too far from Cupertino Crossroads. While it's
true that Cupertino is a city with a reality like any other place, it felt

to me like the technology it produced—something that existed out-
side of space and time. We barely had seasons, and instead of land-
marks we had office parks (where my parents worked), manicured
trees, and ample parking. No one I met seemed to particularly iden-
tify with Cupertino more than any other place, because, I thought,
there simply wasn't anything to identify with. There wasn't even
a clear beginning or ending in Cupertino; instead, like Los Ange-
les, you simply kept driving until at some arbitrary point you were
now in Campbell, now in Los Gatos, now in Saratoga. In excess of
normal teenage angst, I was desperate for something (anything!)
to latch onto, to be interested in. But Cupertino was featureless.
It's perhaps telling that when I meet other people who grew up in
Cupertino, the one thing we have to bond over is an empty husk
of consumer culture: Vallco Fashion Park, a defunct and almost
entirely empty nineties-era mall.

What I lacked was context: anything to tie my experience to this
place and not that place, this time and not that time. I might as well
have been living in a simulation. But now I see that I was looking at
Cupertino all wrong.

IN 2015 I was asked to give a lecture on David Hockney to docents
at the de Young Museum in San Francisco. The pretext was that
they were showing his digital video piece, *Seven Yorkshire Land-
scapes*; as someone who worked in digital art, I was expected to pro-
vide some perspective. But I wasn't sure if I would have anything to
say. Hockney was not only a painter, but really a painter's painter.
Like most people, I associated him with his flat, supersaturated Los
Angeles scenes—like the 1967 painting *A Bigger Splash*, of a pool,
diving board, and peach-colored California bungalow. But as soon
as I started researching his evolving interest in technology—not
just media but technologies of seeing—I realized I might have more
to learn from Hockney than from any other artist.

Hockney valued painting because of the medium's relationship

to time. According to him, an image contained the amount of time that went into making it, so that when someone looked at one of his paintings, they began to inhabit the physical, bodily time of its being painted. It's no surprise, then, that Hockney initially disdained photography. Although he sometimes used it in studies for paintings, he found a snapshot's relationship to time unrealistic: "Photography is alright if you don't mind looking at the world from the point of view of a paralyzed cyclops—for a split second," he said. "But that's not what it's like to live in the world, or to convey the experience of living in the world."[2]

In 1982, a curator from the Centre Pompidou museum came to Hockney's LA house to document some of his paintings with a Polaroid camera and happened to leave behind some blank Polaroid film. Hockney's curiosity got the better of him, and he started walking through his house taking photos in every direction. Developing a technique he would use for years afterward, he joined the photos into a grid whose overall effect is like that of a disjointed fish-eye lens—photos pointing forward are in the center, photos pointing to the left are on the left, etc. Lawrence Weschler contrasts these early pieces with Eadweard Muybridge's grids of photographic motion studies, in which the grid functions as a sequence, like a comic strip. Hockney's grids contain no such sequence. Instead, Weschler writes, the grids depict "the experience of looking as it transpires across time."[3]

In *Gregory in the Pool*, a landscape-orientation grid of photographs of a single swimming pool, Hockney's friend Gregory (or some part of him) appears in almost all of the squares, always in a different position. More than anything, he appears to be swimming through time. When Hockney used this technique for seated portraits, the grid had an even narrower field of focus but the same roving eye: a shoe or a face might appear twice (once from the front, once from the side). Hockney's subjects were recognizable but discontinuous. In that sense, Hockney was trying to use a camera to undo the very essence of how we traditionally understand photography, which is

a static framing of certain elements in an instant of time. More specifically, Hockney was after the phenomenology of seeing:

> From that first day, I was exhilarated . . . I realized that this
> sort of picture came closer to how we actually see, which is
> to say, not at all once but rather in discrete, separate glimpses,
> which we then build up into our continuous experience of
> the world . . . There are a hundred separate looks across time
> from which I synthesize my living impression of you. And
> this is wonderful.[4]

In this pursuit of a "living impression," Hockney took influence from Picasso and cubism in general. He referred to paintings such as Picasso's 1923 *Portrait of Woman in D'Hermine Pass*—in which we appear to see a woman's face from the side but can somehow see the other eye that should be hidden from us, as well as several possible noses—saying that there was actually nothing distorted in such a scene. To him, cubism was quite simple: three noses meant you looked at it three times.[5] This comment attests to his preoccupation not just with the subject of depiction but with the relationship between representation and perception. Comparing Jean-Antoine Watteau's fairly straightforward painting *The Intimate Toilet* to Picasso's *Femme Couchée*—both being intimate interior scenes of a woman—Hockney said that the viewer in the Watteau picture is an alienated voyeur who may as well be looking through a keyhole. In the Picasso painting, however, we are in the room with her. For Hockney, this made the Picasso piece the more realistic of the two, since "[w]e do not look at the world from a distance; we are in it, and that's how we feel."[6]

Though he was using a camera, Hockney did not consider his cubist representations of people and moments to be photographs. Instead he considered what he was doing to be closer to drawing; indeed, he compared his discovery to only using pencils to draw dots and then finding out that you can draw lines. These "lines" evoked movements

of the eye as it takes in a scene, and they're especially evident once Hockney forewent the grid altogether. In *The Scrabble Game, Jan. 1, 1983*, the photos sprawl out unpredictably from the Scrabble board, overlapping in a way that inadvertently evokes the photo-merging capabilities of Photoshop as much as it does the organic growth of a Scrabble game. Following one trajectory we find one player's several facial reactions (serious, laughing, about to speak); following another, we see a woman's face from several angles, resting on her hands in different pensive moments; on the other side, a lazing cat uncovers its face and becomes interested in the game; and looking downward we see the hand of the photographer, which appears to be our own, resting next to the letters we have yet to play.

The most famous of these "joiners," as Hockney called them, is *Pearblossom Highway, 11th–18th April 1986*. As the title makes clear, it took Hockney eight days to make the hundreds of photographs, and he would later take an additional two weeks to assemble them. From far away, the general composition looks like a familiar land-scape, but we soon notice that the STOP AHEAD letters on the road balloon toward us in an odd way. Bits of roadside refuse seem out of proportion; the Joshua trees that are far away are somehow as detailed as the ones that are close to us.

These disjunctures and discrepancies in size undermine any sense of continuity or *punctum*. Without the familiar framework of a consistent vanishing point, the eye roams across the scene, dwell-ing in small details and trying to add it all up. This process forces us to notice our own "construction" of every scene that we perceive as living beings in a living world. In other words, the piece is a collage not so much because Hockney had an aesthetic fondness for collage, but because something like collage is at the heart of the unstable and highly personal process of perception.

Hockney once called *Pearblossom Highway* "a panoramic assault on Renaissance one-point perspective."[7] One-point perspective was worth assaulting because, as the opposite of something like cubism, it was associated with a way of seeing that Hockney didn't like. In a

2015 lecture at the Getty Museum in Los Angeles, Hockney showed a Chinese scroll painting as an example of a way of seeing he was more interested in. The scroll was so long that what he showed was actually a tracking shot, a journey across a multifarious scene that is less an image than a collection of small moments: people lining up to enter a temple, people crossing a river in a small boat, people conversing under a tree. Behind them, the land recedes, but to no particular point. The scroll's narrative is excessive, open, and without direction. It recalls the text from a tourist plaque in Zion Canyon that forms the center of one of Hockney's sprawling photo collages. The plaque reads: YOU MAKE THE PICTURE.

In 2012, after experimenting with early Macintosh computers, fax machines, and the earliest version of Photoshop, Hockney found yet another way to "make the picture." He mounted twelve cameras to the side of a car and drove slowly down different country roads in Yorkshire, near where he grew up. Each piece in *Seven Yorkshire Landscapes* is displayed as a three-by-six grid of screens displayed edge to edge. Because the field of view and zoom level of each camera is intentionally misaligned, the effect is like that of a kaleidoscopic, almost hallucinatory Google Street View. Like *Pearblossom Highway*, the slight disconnection between individual "pictures" tricks our eyes into looking closely, suggesting that there is something to be seen in every panel—and indeed there is.

But in these video pieces, Hockney augments his usual disjointed technique with the video's ant-like pace—one more "trick" to get you to look more closely. One casual viewer's YouTube video of the work, in which young children run back and forth across the screens, pointing and jumping and stopping to stare at certain leaves, seems to bear out Hockney's description of his own project: "The composition stays the same and you just slowly go past a bush. There's so much to look at that you don't get bored. Everybody watches because there's a lot to see. There's a lot to look at." Comparing it to TV, he says that "[i]f you show the world better, it's more beautiful, a lot more beautiful. The process of looking is the beauty."

When I talked to docents at the de Young about *Seven Yorkshire Landscapes*, they mentioned something interesting. Some museumgoers who had seen the piece came back to tell them that afterward everything outside had looked different from what they were used to. Specifically, the de Young is not far from the San Francisco Botanical Garden, and those who visited it directly afterward found that Hockney's piece had trained them to look a certain way—a notably slow, broken-up luxuriating in textures. They saw the garden anew, in all its kaleidoscopic beauty.

Hockney, who defines looking as a "positive act," would have been pleased. For him, actual looking was a skill and a conscious decision that people rarely practiced; there was "a lot to see" only if you were willing and able to see it.[8] In this sense, what Hockney and countless other artists offer is a kind of attentional prosthesis. Such an offering assumes that the familiar and proximate environment is as deserving of this attention, if not more, than those hallowed objects we view in a museum.

I HAVE NO trouble believing the accounts of these museumgoers because, a few years prior, I'd had a very similar experience—with sound instead of sight. It was at San Francisco's Davies Symphony Hall, which I would occasionally visit alone after work for the comfort of old favorite pieces, an overpriced plastic cup of wine, and anonymity among an older crowd. This particular night, I had come to see the symphony perform pieces from John Cage's *Song Books*. Cage is most famous for *4'33"*, a three-movement piece in which a pianist plays nothing. While that piece often gets written off as a conceptual art stunt, it's actually quite profound: each time it's performed, the ambient sound, including coughs, uncomfortable laughter, and chair scrapes, is what makes up the piece. This approach is not that different from Eleanor Coppola's in her *Windows* piece, but with sound instead of visual activity.

At the time, I was somewhat familiar with Cage and his philos-

ophy that "everything we hear is music"; I had seen the interview where he sits by an apartment window, rapt at the sound of traffic outside. In my class, I sometimes show a video of him performing *Water Walk* on the 1960s TV show *I've Got a Secret*, where the audience grows mystified and then titillated as he waters plants in a tub, bonks a piano, and squeezes a rubber ducky. I knew that his pieces were procedural, full of chance operations, so I was not surprised that in the section of the liner notes that lists duration, it simply said it would last "anywhere from 15 to 45 minutes, depending on what happens."

But I had never experienced a live performance of a Cage piece, much less in a traditional symphony setting with the usual crowd. Instead of the customary rows of musicians dressed in all black, the people onstage were dressed in plain clothes, moving about various props and devices like a typewriter, a set of cards, or a blender. Three vocalists made strange and haunting sounds while someone shuffled cards into a microphone and another walked into the audience to give someone a present—all, in some way, part of the score. As I imagine is the case at many Cage performances, the audience seemed to be shifting in their seats, trying very hard not to laugh, which would be inappropriate in a symphony hall. But the breaking point came when Michael Tilson Thomas, the conductor of the San Francisco Symphony, used the blender to make a smoothie. He took a sip and appeared satisfied. After that, all bets were off, with laughter tumbling down from the seats toward the stage and integrating itself into the piece.

More than just the conventions of the symphony hall were broken open that night. I walked out of the symphony hall down Grove Street to catch the MUNI, and heard every sound with a new clarity—the cars, the footsteps, the wind, the electric buses. Actually, it wasn't so much that I heard these clearly as that I heard them *at all*. How was it, I wondered, that I could have lived in a city for four years already—even having walked down this street after a symphony performance so many times—and never have actually heard anything?

For months after this, I was a different person. At times, it was enough to make me laugh out loud. I started to act a lot like the protagonist of a movie I had seen on accident a year earlier. The film is called *The Exchange*, by Eran Kolirin, and to be honest, it doesn't have much of a plot. A PhD student forgets something at home, goes back to get it, and finds that his apartment looks unfamiliar at that particular time of the day. (I'm convinced that many of us have had this experience as a child, coming home sick from school in the middle of the day and finding that our home feels strange.) Critically unmoored from the familiar, the man spends the rest of the film doing things like pushing a paperweight matter-of-factly off a coffee table, throwing a stapler out a window, standing in bushes, or lying on the floor of his apartment's basement level. In place of a man going about his business, he becomes like an alien who encounters people, objects, and the laws of physics for the first time.

I have always prized this film for its deceptive quietness; it shows how even the smallest disjuncture can suddenly throw everything into relief. Like the visitors to the Hockney piece who reported "seeing things" afterward—or like myself walking down Grove Street transfixed by sound—the film's turning point is entirely perceptual. It has to do with how endlessly strange reality is when we look *at it* rather than through it.

ANYONE WHO HAS experienced this unmooring knows that it can be equally exhilarating and disorienting. There is more than a touch of delirium in William Blake's description when he invites us "[to] see a World in a Grain of Sand / And a Heaven in a Wild Flower / Hold Infinity in the palm of your hand And Eternity in an hour." This way of looking, in which we are Alice and everything is a potential rabbit hole, is potentially immobilizing; at the very least, it brings us out of step with the everyday. Indeed, the only real drama of *The Exchange* happens between the protagonist and everyone else, especially his girlfriend, to whom his actions appear insane.

So why go down the rabbit hole? First and most basically, it is enjoyable. Curiosity, something we know most of all from child-hood, is a forward-driving force that derives from the differential between what is known and not known. Even morbid curiosity assumes there is something you haven't seen that you'd like to see, creating a kind of pleasant sensation of unfinished-ness and of something just around the corner. Although it's never seemed like a choice to me, I live for this feeling. Curiosity is what gets me so involved in something that I forget myself.

This leads into a second reason to leave behind the coordinates of what we habitually notice: doing so allows one to transcend the self. Practices of attention and curiosity are inherently open-ended, oriented toward something outside of ourselves. Through attention and curiosity, we can suspend our tendency toward instrumental understanding—seeing things or people one-dimensionally as the products of their functions—and instead sit with the unfathomable fact of their existence, which opens up toward us but can never be fully grasped or known.

In his 1923 book *I and Thou*, the philosopher Martin Buber draws a distinction between what he calls I-It and I-Thou ways of seeing. In I-It, the other (a thing or a person) is an "it" that exists only as an instrument or means to an end, something to be appropriated by the "I." A person who only knows I-It will never encounter any-thing outside himself because he does not truly "encounter." Buber writes that such a person "only knows the feverish world out there and his feverish desire to use it . . . When he says You, he means: You, my ability to use!"[9]

In contrast to I-it, I-Thou recognizes the irreducibility and abso-lute equality of the other. In this configuration, I meet you "thou" in your fullness by giving you my total attention; because I neither project nor "interpret" you, the world contracts into a moment of a magical exclusivity between you and me. In I-Thou, the "thou" does not need to be a person; famously, Buber gives the example of different ways of looking at a tree, all but one of which he classifies

as I-It. He can "accept it as a picture," describing its visual elements; he can consider an instance of a species, an expression of natural law, or a pure relation of numbers. "Throughout all of this the tree remains my object and has its place and its time span, its kind and condition," he says. But then there is the I-Thou option: "it can also happen, if will and grace are joined, that as I contemplate the tree I am drawn into a relation, and the tree ceases to be an It. The power of exclusiveness has seized me."[10]

Here, we encounter the tree in all its otherness, a recognition that draws us out of ourselves and out of a worldview in which everything exists for us. The tree exists *out there*: "The tree is no impression, no play of my imagination, no aspect of a mood; it confronts me bodily and has to deal with me as I deal with it— only differently. One should not try to dilute the meaning of the relation: relation is reciprocity." (In his translation from the German, Walter Kaufmann notes that "it confronts me bodily" uses a highly unusual verb—*leibt*, where *leib* means body—so that a more precise translation would be "it *bodies* across from me.") Does this then mean that the tree has consciousness in the way that we would understand it? For Buber, the question is misguided because it relapses into I-It thinking: "must you again divide the indivisible? What I encounter is neither the soul of a tree nor a dryad, but the tree itself."[11]

One of my favorite examples of an I-Thou encounter is Emily Dickinson's poem "A Bird came down the walk." The poet and Dickinson scholar John Shoptaw, who also happened to be my undergraduate thesis adviser at Berkeley, showed it to me recently, and it became one of my favorites of her poems:

A Bird came down the Walk -
He did not know I saw -
He bit an Angleworm in halves
And ate the fellow, raw,

And then he drank a Dew
From a Convenient Grass -
And then hopped sidewise to the Wall
To let a Beetle pass -

He glanced with rapid eyes
That hurried all around -
They looked like frightened Beads, I thought -
He stirred his Velvet Head

Like One in danger, Cautious,
I offered him a Crumb,
And he unrolled his feathers
And rowed him softer home -

Than Oars divide the Ocean,
Too silver for a seam -
Or Butterflies, off Banks of Noon
Leap, plashless as they swim.[12]

Knowing my habit of feeding birds, Shoptaw pointed out that the line "Like one in danger, Cautious" is placed so that it could refer either to the bird or the speaker who offers it a crumb. To explain this, he asked me to think about how I must look when I'm approaching a skittish Crow or Crowson on my balcony with a peanut. It wasn't something I had ever thought about, but when I did, I realized that both the crow and I acted "like one in danger, Cautious," each almost frozen, completely focused on the other, affected by and adjusting to the other's tiniest movements.

What's more, even after years of observing the same crows, their behavior—like the seemingly haphazard procedure of Dickinson's bird—is ultimately inscrutable to me (as much as mine must be to them). Just as Dickinson's bird "row[s] him softer" to some unknown "home," nothing indicates that something exists

beyond you as much as its departure into the sky, as sudden and unceremonious as its arrival. All of this makes for a being that cannot be "understood" or "interpreted" (I-It), only "perceived" (I-Thou). And that which cannot be understood—a once-and-for-all matter—demands constant and unmixed attention, an ongoing state of encounter.

IN THE MID-TWENTIETH century, responding to a long history of representational art, many abstract and minimalist painters sought to induce an "I-Thou" kind of encounter between viewer and painting. One example is Barnett Newman's 1953 painting *Onement VI*, an eight-and-a-half-by-ten-foot field of deep blue divided by a rough white line. When the critic and philosopher Arthur C. Danto wrote about the piece, he called it Newman's first "real" painting. The earlier works, though they were technically paintings, were for Danto "merely pictures." He gives the example of Renaissance scenes where the picture functions as a window that the viewer looks through and sees events happening in some other space we don't occupy (Hockney wouldn't have liked this kind of painting either). But an actual painting, as opposed to a picture, confronts us in physical space:

> [Newman's new] paintings are objects in their own right. A picture represented something other than itself; a painting represents itself. A picture mediates between a viewer and an object in pictorial space; a painting is an object to which the viewer relates without mediation . . . It is on the surface and in the same space as we are. Painting and viewer coexist in the same reality.[13]

Incidentally, this points to another way in which attention brings us outside the self: it's not just the other that becomes real to us, but our attention itself that becomes palpable. Thrown back on

ourselves by a "wall" and not a window, we can also begin to see ourselves seeing.

Recently this sort of encounter actually stopped me in my tracks. Killing time before a meeting with someone at SFMOMA, I was wandering through the different floors and ended up in the exhibition *Approaching American Abstraction*. At some point I turned a corner and saw Ellsworth Kelly's *Blue Green Black Red*, which is exactly what it sounds like: four separate panels of one color each, about the size of myself. At first, I wrote this off as quickly as anyone might, not thinking it was "about" anything other than abstraction (whatever that might mean). But when I got closer to the first panel, I was completely caught off guard by a physical sensation. Although the covering was consistent and flat, the color blue was not stable: it vibrated and seemed to push and pull my vision in different directions. For lack of a better description, the painting seemed *active*.

I can't stress enough that this was a bodily feeling—like Buber's tree, the painting "bodied" across from me. I realized I needed to look at every single panel, spending the same amount of time on each one, since each color vibrated differently, or rather, my perception of the color did. Strange as it sounds to call a flat, monochromatic painting a "time-based medium," there was actually something to *find out* in each one—or rather, between me and each one—and the longer time I spent, the more I found out. Somewhat sheepishly, I thought about how someone across the room, too far away to understand, would see me: a person matter-of-factly staring at one after another of panels with "nothing" on them.

These paintings taught me about attention and duration, and that what I'll see depends on how I look, and for how long. It's a lot like breathing. Some kind of attention will always be present, but when we take hold of it, we have the ability to consciously direct, expand, and contract it. I'm often surprised at how shallow both my attention and my breathing are by default. As much as breathing deeply and well requires training and reminders, all of the artworks

I've described so far could be thought of as training apparatuses for attention. By inviting us to perceive at different scales and tempos than we're used to, they teach us not only how to sustain attention but how to move it back and forth between different registers. As always, this is enjoyable in and of itself. But if we allow that what we see forms the basis of how we can act, then the importance of directing our attention becomes all too clear.

IT'S PERHAPS HELPFUL here to look at some less artistic and more functional examples of training attention. In 2014, Dr. Aaron Seitz, a neuroscientist at University of California, Riverside, developed a visual training app called ULTIMEYES and tested it on university baseball players. The app, which specifically addressed dynamic visual acuity—the ability to make out the fine details of moving objects—seemed to have a positive overall effect on players' performance. In a Q&A on Reddit, Seitz noted that poor vision comes from a mix of two things: actual ocular impairments and brain-based impairments. Clearly, the former would require medical intervention; it was the latter that the program aimed to improve.[14]

Incidentally, the app might be good for training other kinds of attention. One review on the App Store, titled "The Dumbest," reports that the user was only able to use it for ten minutes before getting bored and deleting it.[15] I will say that the experience is rather spare. When I decided to give it a try, I was faced over and over again with a gray screen onto which a sneaky group of Gabors (a kind of soft-edged striped spot) would appear, waiting to be tapped. If I didn't see one, which was often, it would start to wiggle insistently until I did.

Every three sessions, I had my visual acuity evaluated with a different kind of exercise. Sure enough, my score improved each time I was evaluated. But more than improvement, using the app became a rigorous reminder for me of the many ways it's possible *not* to see something. I became fixated on the moments where I would

know (intellectually) that there was something on the screen and that I couldn't for the life of me see it, either because it was too faint or I was looking in the wrong place.

In some ways, this was a firsthand experience of some research I had read about on "inattentional blindness." Berkeley researchers Arien Mack and Irvin Rock coined the term in the 1990s while studying the drastic difference in our ability to perceive something if it lies outside our field of visual attention. In a simple experiment, they asked subjects to look at a cross on the screen and try to determine whether any of the lines were longer than the other. But this was a made-up task to distract subjects from the actual experiment. While the subjects were staring at the cross, a small stimulus would flash somewhere on the screen. When the stimulus fell inside the circular area circumscribing the cross lines, the subjects were much more likely to see it. "In short, when the inattention stimulus falls *outside* the area to which attention is paid, it is much less likely to capture attention and be seen," the researchers write.[16]

That's intuitive enough, but it gets more complicated. If the briefly flashing stimulus was outside the area of visual attention, but was something distinct like a smiley face or the person's name, the subject *would* notice it after all. This effect depended on how recognizable it was; for example, it didn't work with a sad or scrambled face, or with a word similar to the person's name. (If they flashed in the very same spot, I'd see "Jenny," but "Janny" would go unnoticed.) From this, Mack and Rock concluded that all of the information—noticed and not noticed—must actually be getting processed, and that it was only some at a late stage of processing that the brain determined whether the stimulus would be perceived or not. "If this were not the case," they write, "it becomes difficult to explain why 'Jack' is seen but 'Jeck' goes undetected, or why a happy face is seen and a sad or scrambled one is detected so much less frequently." The researchers suggest that attention is "a key that unlocks the gate dividing unconscious perception . . . from

conscious perception. Without this attentional key, there simply is no awareness of the stimulus."[17]

As an artist interested in using art to influence and widen attention, I couldn't help extrapolating the implications from visual attention to attention at large. It's a commonplace that we only see what we're looking for, but this idea of information that makes it into our brains without being admitted into consciousness seemed to explain the eeriness of suddenly seeing something that has been there all along. For instance, the many times I had walked down Grove Street after a symphony performance, noises had presumably been making it into my ears and were being processed; after all, I wasn't physiologically hard of hearing. It was the performance of the John Cage piece, or rather its attunement of my attention, that provided the "key" for those sounds to pass through the "gate" toward conscious perception. When I moved the focus of my attention, those signals that had been traveling into my head were finally granted admission into conscious perception.

There are potentially wider parallels to be made, since inattentional blindness is basically a form of visual bias, and something like inattentional blindness seems to be at work in broader forms of bias. In her *Atlantic* piece "Is This How Discrimination Ends?" the author Jessica Nordell takes part in a session of the Prejudice Lab, a project run by psychology professor Patricia Devine. As a graduate student, Devine had done experiments around the psychological aspects of implicit racial bias: "She demonstrated that even if people don't believe racist stereotypes are true, those stereotypes, once absorbed, can influence people's behavior without their awareness or intent." The Prejudice Lab runs workshops at businesses and schools with the aim of showing people their own biases—in effect, to help learn how to see what they're not seeing.[18]

In the two-hour workshop that Nordell attended, Devine and her colleague Will Cox explained the science of bias, "barreled through mountains of evidence," and invited students to share stories of how bias had played out in their own lives—stories none of

them had a hard time coming up with. Nordell writes that while many other psychology experiments treat bias as a condition to be adjusted, Devine's treats it as a behavior, aiming simply to "make unconscious patterns conscious and intentional." In effect, the Prejudice Lab was the "attentional key" that brought racist thought and behavior to consciousness. So far, Nordell writes, the data suggest that the Prejudice Lab's approach is working. But the success of the intervention largely rests on the individual: "To [break a habit], Devine said, you have to be aware of it, motivated to change, and have a strategy for replacing it."

IT'S HERE THAT I want to come back to the relationship between discipline and attention from the previous chapter. An element of effort and straining exists in the word *attention* itself, which comes from Latin *ad + tendere*, "to stretch toward." This relationship finds one of its most compelling expressions in William James's 1890 *The Principles of Psychology*. Defining attention as the ability to hold something before the mind, James observes that the inclination of attention is toward fleetingness. He quotes the physicist and physician Hermann von Helmholtz, who had experimented on himself with various distractions:

> The natural tendency of attention when left to itself is to wander to ever new things; and so soon as the interest of its object is over, so soon as nothing new is to be noticed there, it passes, in spite of our will, to something else. If we wish to keep it upon one and the same object, we must seek constantly to find out something new about the latter, especially if other powerful impressions are attracting us away.[19]

If, as I've said, attention is a state of openness that assumes there is something new to be seen, it is also true that this state must resist our tendency to declare our observations finished—to be done

with it. For James as for von Helmholtz, this means that there is no such thing as voluntary sustained attention. Instead, what passes for sustained attention is actually a series of successive efforts to bring attention back to the same thing, considering it again and again with unwavering consistency. Furthermore, if attention attaches to what is new, we must be finding ever newer angles on the object of our sustained attention—no small task. James thus makes explicit the role of will in attention:

> Though the spontaneous drift of thought is all the other way,
> the attention must be kept strained on that one object until at
> last it grows, so as to maintain itself before the kind with ease.
> This strain of attention is the fundamental act of will.[20]

Nordell closes her piece on the Prejudice Lab with an eloquent example of this constant, effortful return. She writes that the day she left University of Wisconsin–Madison, where the workshop had taken place, she saw two people in her hotel lobby wearing "worn, rumpled clothes, with ragged holes in the knees." A story about them formed in her mind before she could catch it, wherein they couldn't possibly be guests of the hotel and must have been friends of the clerk. "It was a tiny story, a minor assumption," she writes, "but that's how bias starts: as a flicker—unseen, unchecked—that taps at behaviors, reactions, and thoughts." The Prejudice Lab had helped train her to catch it, though, and she could catch it again. Her commitment to do so demonstrates the vigilance at the core of sustained attention:

> Afterwards, I kept watching for that flutter, like a person with
> a net in hand waiting for a dragonfly. And I caught it, many
> times. Maybe this is the beginning of how my own prejudice
> ends. Watching for it. Catching it and holding it up to the
> light. Releasing it. Watching for it again.[21]

IF ATTENTION AND will are so closely linked, then we have even more reason to worry about an entire economy and information ecosystem preying on our attention. In a post about ad blockers on the University of Oxford's "Practical Ethics" blog, the technology ethicist James Williams (of Time Well Spent) lays out the stakes:

> We experience the externalities of the attention economy in little drips, so we tend to describe them with words of mild bemusement like "annoying" or "distracting." But this is a grave misreading of their nature. In the short term, distractions can keep us from doing the things we want to do. In the longer term, however, they can accumulate and keep us from living the lives we want to live, or, even worse, undermine our capacities for reflection and self-regulation, making it harder, in the words of Harry Frankfurt, to "want what we want to want." Thus there are deep ethical implications lurking here for freedom, wellbeing, and even the integrity of the self.[22]

I first learned about James Williams from a recent Stanford master's thesis by Devangi Vivrekar, called "Persuasive Design Techniques in the Attention Economy: User Awareness, Theory, and Ethics." The thesis is mainly about how Vivrekar and her colleagues in the Human-Computer Interaction department designed and experimented with a system called Nudget. In an effort to make the user aware of persuasive design, Nudget used overlays to call out and describe several of the persuasive design elements in the Facebook interface as the user encountered them.[23]

But the thesis is also useful simply as a catalog of the many forms of persuasive design—the kinds that behavioral scientists have been studying in advertising since the mid-twentieth century. For

example, Vivrekar lists the strategies identified by researchers Marwell and Schmitt in 1967: "reward, punishment, positive expertise, negative expertise, liking/ingratiation, gifting/pre-giving, debt, aversive stimulation, moral appeal, positive self-feeling, negative self-feeling, positive altercasting, negative altercasting, positive esteem of others, and negative esteem of others." Vivrekar herself has study participants identify instances of persuasive design on the LinkedIn site and compiles a staggering list of 171 persuasive design techniques.[24] A few for example:

Screen #	#	Persuasive Vehicle	Method of Persuasion
1A	1	Notification badges on the horizontal toolbar for "notifications," "messages," and "network"	Makes you want to click and see new notifications (arouses curiosity)
1A	2	Red color of notification badges on the horizontal toolbar	Stands out / catches your attention / indicates urgency in order to redirect your clicks to other people's or companies' pages
1A	3	Number on the notification badges on the horizontal toolbar	Makes it feel like a to-do list and makes you want to get the number to 0 (arouses our "base desire for having order instead of chaos")
1A	4	Intermittent variable notifications	The delivery schedule of notifications is varied and intermittent, which keeps it changing and thus interesting
1A	5	Textual ad at the top: "Ready for a change . . ."	Tries to get you to click on that page by appearing organic and relevant

This detailed vocabulary of persuasion and eagle-eyed attentiveness to its many forms aligns with my interest in "knowing your enemy" when it comes to the attention economy. For example, one

could draw parallels between the Nudget system, which teaches users to see the ways in which they are being persuaded, and the Prejudice Lab, which shows participants how bias guides their behavior.

But as for the results of this accounting, Vivrekar and I come to very different conclusions. Indeed, I found a helpful articulation of my own argument for discipline in a section of hers titled "Counter-Arguments." She writes, "Proponents of the 'agency' side in the agency vs. structure debate claim that instead of focusing on the problem of how to make persuasion more ethical, we should focus on empowering people to have more self control" (that's me!). Vivrekar and the technology ethicists she cites, however, are less than optimistic about this approach:

> Portraying the problem as one in which we just need to be more mindful of our interaction with apps can be likened to saying we need to be more mindful of our behavior while interacting with the artificial intelligence algorithms that beat us at chess; equally sophisticated algorithms beat us at the attention game all the time.[25]

For Vivrekar, persuasion is a given, and the only thing we can do about it is redirect it:

> When we remember that hundreds of engineers and designers predict and plan for our every move on these platforms, it seems more justified to shift the focus of the discussion towards ethical persuasion.

This argument takes a few important things for granted. "Ethical persuasion" means persuading the user to do something that is good for them, using "harmonious designs that continuously empower us instead of distracting and frustrating us." Reading this, I can't help but ask: Empower me to do what? Good for me according to whom? And according to what standards? Happiness, productiv-

ity? These are the same standards that Frazier uses when designing Walden Two. The idea that I've already lost the battle of attention doesn't sit right with me, an agential being interested in gaining control of my attention rather than simply having it directed in ways that are deemed better for me.

This solution also takes the attention economy itself for granted—something to be corrected but which is otherwise inevitable. Vivrekar notes that "metrics that align better with user values are not always contrary to the long-term business profits of companies in the attention economy; they actually pose a market opportunity." She quotes Eric Holmen, the Senior Vice President of Urban Airship, a company on whom "[e]very day, marketers and developers depend on . . . to deliver one billion mobile moments that inspire interest and drive action." Holmen sees big bucks in authenticity:

> People increasingly want to spend time well, not spend more of it . . . If it's our shallowest self which is reflected to us every time we open Facebook, Instagram and YouTube, the best business opportunity around might be to begin to cater for our aspirational selves.[26]

But just who is this "our"? What does persuasive design look like when someone else tries to bring out my "aspirational self," and does it for profit? Help!

Lastly, there is attention itself, which this approach also takes for granted. It assumes not only that our attention will always be captured, but that our attention remains the same throughout. I described in the previous chapter how the attention economy targets our attention as if it were an undifferentiated and interchangeable currency; the "ethical persuasion" approach is no exception. When we think about the different kinds of attention we are actually capable of—the pinnacle being the kind that William James describes, if we only have the discipline—it becomes clear that most forms of

persuasive design (whether nefarious or "empowering") assume a rather shallow form of attention. We might extrapolate from this to conclude that deeper, hardier, more nuanced forms of attention are less susceptible to appropriation, because discipline and vigilance inhere within them.

JUST A DAY before reading Vivrekar's thesis, I had seen the film *Blindspotting* at an old Oakland theater in Grand Lake. Daveed Diggs (of *Hamilton* fame) and the poet Rafael Casal, both of whom grew up in the East Bay, wrote and starred in what is essentially a virtuosic poem on the gentrification of Oakland. In the film, Diggs plays Collin, a young black man in the last days of his yearlong probation after prison, and Casal plays Miles, his hot-tempered white friend from childhood. Tantalizingly close to a year without incident, Collin struggles emotionally after witnessing a white police officer gun down a black man running and yelling, "Don't shoot!"

On top of that, Miles keeps getting them in trouble, jeopardizing Collin's probation and risking his return to prison. At an obnoxious hipster party in West Oakland, where one of the few Black attendees assumes Miles is a hipster newcomer because he's white, Miles gets so angry that he beats the man senseless and pulls out a gun, which Collin has to take away from him—all this on the night before his probation is up. Having fled the scene, Collin and Miles have a screaming fight in which the racial dimension of their friendship finally surfaces. They are angry at each other not just as friends but as a black man and a white man for whom the stakes are very different.

There is only one other scene in the film in which the two face each other so intensely. It happens much earlier, in Johansson Projects, a small gallery downtown. Collin and Miles are visiting a middle-aged photographer who makes portraits of Oakland residents. As the camera zooms in on each portrait, bringing the eyes of each subject into focus, the photographer tells Collin and Miles that this is his way of fighting gentrification: by presenting viewers

with the faces of the people being pushed out. Then, seemingly out of the blue, he asks Collin and Miles to stand and look at each other without speaking. Initially sheepish, the two oblige, and what follows is a long, weird, magical moment. The camera cuts back and forth, but we can have no idea what each is seeing in the other. This opacity reflects the experience each might be having of the other as an unfathomable, undeniably real being. Eventually the spell is broken, and the two men laugh, embarrassed, deflecting emotion by poking fun at the photographer for his strange request.

In the discomfort and unnaturalness of the moment in which Collin and Miles stare at each other, you can feel the "stretching toward" (*ad tendere*) in attention. They do not just have their eyes directed toward each other; they are seeing each other. It was this scene that made clear for me the connection between attention, perception, bias, and will. In effect, the opposite of a racist view is Buber's "I-Thou" perception, which assiduously refuses to let the other collapse into any one instrumental category. Recall that Buber refuses to see the tree as image, species, or relationship of numbers. Instead "thou" has the same depth as I. Seeing this way means foregoing all of the many easier and more habitual ways to "see," and as such, it is a fragile state requiring the discipline to continue.

As a response to the attention economy, the argument for ethical persuasion happens on a two-dimensional plane that assumes that attention can only be directed this way or that way. I am not as interested in that plane as I am interested in a disciplined deepening of attention. While I am all for legal restrictions on addictive technology, I also want to see what's possible when we take up William James's challenge and bring attention back, over and over again, to an idea "held steadily before the mind until it fills the mind." I am personally unsatisfied with untrained attention, which flickers from one new thing to the next, not only because it is a shallow experience, or because it is an expression of habit rather than will, but because it gives me less access to my own human experience.

To me, the only habit worth "designing for" is the habit of ques-

tioning one's habitual ways of seeing, and that is what artists, writers, and musicians help us to do. It's no accident that in *Blindspotting*, the moment between Collin and Miles is organized by a photographer, whose work confronts viewers' "blind spots" with the reality of Oakland residents in all their human fullness. It's in the realm of poetics that we learn how to encounter. Significantly, these encounters are not optimized to "empower" us by making us happier or more productive. In fact, they may actually completely unsettle the priorities of the productive self and even the boundaries between self and other. Rather than providing us with drop-down menus, they confront us with serious questions, the answering of which may change us irreversibly.

THERE ARE MORE reasons to deepen attention than simply resisting the attention economy. Those reasons have to do with the very real ways in which attention—what we pay attention to and what we do not—renders our reality in a very serious sense. From the same set of "data," we draw conclusions based on our past experiences and assumptions. In her piece on the Prejudice Lab, Nordell speaks with Evelyn R. Carter, a social psychologist at UCLA, who tells her that "people in the majority and the minority often see two different realities" based on what they do and do not notice. For example, "[w]hite people . . . might only hear a racist remark, while people of color might register subtler actions, like someone scooting away slightly on the bus."

Thinking about the idea of rendering, I sometimes borrow from my experience with (literal, computational) rendering. For the last couple of years, I've been teaching my students Blender, an open-source 3-D modeling program. One of the hardest things to explain to students who have never worked in 3-D before is the concept of "a render." That is, for those who are used to working in something like Photoshop, the image shown in the workspace generally reflects the resulting image, to the point where there is little distinc-

tion. It can be difficult to get used to the idea of a program in which there is no image until you render it, and furthermore that the render may seem to have absolutely nothing to do with what you see in the workspace. (I often have students render a completely black image because they've accidentally deleted the only lamp from the scene.) Yes, there are objects in the file. But the actual image relies on a long list of variables like camera angle, lighting, textures, material, render engine, and render quality. Any one scene could thus produce an infinite number of different images depending on how it is rendered, each image essentially a different treatment of the same set of objects.

It's not hard to expand this into a more general model of rendering, where the objects in the scene are the objects, events, and people of the outside world, and the rendering decisions are the particular map of our attention. Already in 1890, William James wrote about how interest and attention renders the world from a "gray chaotic indiscriminateness," inadvertently evoking the default gray of an un-rendered scene in Blender:

> Millions of items of the outward order are present to my senses which never properly enter into my experience. Why? Because they have no interest for me. My experience is what I agree to attend to. Only those items which I notice shape my mind—without selective interest, experience is an utter chaos. Interest alone gives accent and emphasis, light and shade, background and foreground intelligible perspective, in a word. It varies in every creature, but without it the consciousness of every creature would be a gray chaotic indiscriminateness, impossible for us even to conceive.[27]

Most of us have experienced changes in rendering: you notice something once (or someone points it out to you) and then begin noticing it everywhere. As a simplistic example, my attention now "renders" to me a world more full of birds than before I was an

avid bird-watcher. Visitors to the de Young had their attention re-mapped by David Hockney to include small details, rich colors, and kaleidoscopic arrangement; the John Cage performance remapped my attention to include sound beyond melodic music. When the pattern of your attention has changed, you render your reality differently. You begin to move and act in a different kind of world.

I have already described the moment in which I discovered the ground. But I have not yet described what followed, which was a complete re-rendering of my reality. As I disengaged the map of my attention from the destructive news cycle and rhetoric of productivity, I began to build another one based on that of the more-than-human community, simply through patterns of noticing. At first this meant choosing certain things to look at; I also pored over guides and used the California Academy of Science's app, iNaturalist, to identify species of plants I had walked right by my entire life. As a result, more and more actors appeared in my reality: after birds, there were trees, then different kinds of trees, then the bugs that lived in them. I began to notice animal communities, plant communities, animal-plant communities; mountain ranges, fault lines, watersheds. It was a familiar feeling of disorientation, realized in a different arena. Once again, I was met with the uncanny knowledge that these had all been here before, yet they had been invisible to me in previous renderings of my reality.

IN ESSENCE, WHAT I was encountering without yet knowing the name for it was bioregionalism. Similar to many indigenous cultures' relationships to land, bioregionalism is first and foremost based on observation and recognition of what grows where, as well as an appreciation for the complex web of relationships among those actors. More than observation, it also suggests a way of identifying with place, weaving oneself into a region through observation of and responsibility to the local ecosystem. (Asked where he was from, Peter Berg, an early proponent of bioregionalism, used

to answer, "I am from the confluence of the Sacramento River and San Joaquin River and San Francisco Bay, of the Shasta bioregion, of the North Pacific Rim of the Pacific Basin of the Planet Earth."[28]) In these ways, bioregionalism is not just a science, but a model for community.

As I came to know my bioregion, I found myself increasingly identifying with a totemic complex of fellow inhabitants: Western fence lizards, California towhees, gray pines, manzanita, thimble-berries, giant sequoias, poison oak. When I travel, I no longer feel like I've arrived until I have "met" the local bioregion by walking around, observing what grows there, and learning something about the indigenous history of that place (which, in all too many places, is the last record of people engaging in any meaningful way with the bioregion). Interestingly, my experience suggests that while it initially takes effort to notice something new, over time a change happens that is irreversible. Redwoods, oaks, and black-berry shrubs will never be "a bunch of green." A towhee will never simply be "a bird" to me again, even if I wanted it to be. And it follows that this place can no longer be any place.

A YEAR AND a half ago I came across an aerial map of Rancho Rin-conada, the Cupertino neighborhood I grew up in, as it was being built in the 1950s. Looking back and forth between the photo and Google Maps, I was able to figure out which street was which and thus pinpoint my house, otherwise indistinguishable amid the rows of tiny faux-Eichler bungalows. But there was one odd, wiggly road that didn't seem to correspond to anything, that is, until I realized that it was not a road but Saratoga Creek. When I thought about it, I did remember seeing a creek running past the neighborhood swimming pool, but I hadn't known it had a name. In my memory, it was just "the creek"; it didn't come from anywhere in particular, nor was it going anywhere.

I zoomed out on Google Maps and saw yet another creek, wind-

ing past the school where I went to kindergarten. Again I searched my memory, where it showed up only once. When I was five, the creek was the place that you couldn't get your ball back from if it went over the fence at the edge of the schoolyard. I barely remembered looking through that fence at its tangled and mysterious green depths and the strange pillowy cement bags that made up its banks. Back then, it merely represented the unknown, like an unruly foil to the manicured school grounds behind me. That is the only time that Calabazas Creek had surfaced to the level of my consciousness; all the other times I must have looked at the creek or walked or driven past it, it was like the unseen stimuli in Arien Mack and Irvin Rock's vision experiments—seen but not noticed.

Recognizing the creek unfolded a whole topography of what I had not noticed. Where was Calabazas Creek going? The Bay, obviously, but I had never made that connection in my mind. Where was it coming from? Table Mountain, something I had looked at every day but only now learned the name of! I'd complained about Cupertino being so flat; what if I had known that that was because, for millions of years, that entire part of the Bay Area was an inland sea, and after that marshland? How was it possible for me to know the names of cities like Los Gatos, Saratoga, and Almaden, but not notice that they lay in a distinct curve—a curve defined by the nearby mountains, Loma Prieta, Mount Umunhum, Mount McPherson? How could I have not noticed the shape of the place I lived?

Last year I told my friend Josh about (re)noticing Calabazas Creek. He lives in Oakland but had grown up, in near me Sunnyvale, and he, too, had buried memories of a creek. Josh's creek was fenced off and had a trapezoidal concrete bottom, looking more like a piece of infrastructure than a natural element as it passed unnoticed through the neighborhood. At some point, Josh and I realized we were talking about the same creek—he had lived downstream from me.

In December 2017 we drove to Cupertino and shimmied through

a gate in a chain-link fence affixed with a sign reading EMERGENCY ACCESS TO CREEK. ("What if the emergency is curiosity?" I wondered aloud.) The first thing I saw was the exact tableau I hadn't seen since I was five: a tangle of green around those cement bags, which I now knew were for flood control. It hadn't yet rained much and we were at the end of a six-year drought, so the creek bed was dry enough to use as a trail. We walked over riprap, a mixture of conglomerate stone that included bits of brick building surreally carved by water into organic-looking rock shapes. Above us were the trees I now knew the names of—valley oak and bay laurel—mixed in with some surprises, like an entire hillside of rogue prickly pear cacti escaped from someone's backyard.

From the creek bed, we looked up and out at a Bank of America building, a strange and alienating angle on the familiar. We saw the backs of wooden fences around homes, some of whose inhabitants might never have been down here. Approaching a tunnel under Stevens Creek Boulevard, the road that both the Vallco Fashion Park and the Cupertino Crossroads shopping center are on, we found a dark gallery of graffiti. Had we continued into the tunnel, we would have ended up in total darkness underneath something called Main Street Cupertino, ironically one of Cupertino's newest shopping centers. Further on, we would have emerged from the tunnel into the grounds of Apple's new "spaceship" campus.

Nothing is so simultaneously familiar and alien as that which has been present all along. Between, under, and amid all these things wound this entity that was older than I was, older than Cupertino. It represented a kind of primordial movement, even if its course had been altered by engineering in the nineteenth century. Long before cars drove from Whole Foods to the Apple campus, the creek moved water from Table Mountain to the San Francisco Bay. It continues to do this just as it always has, and whether I or any other humans care to notice. But when we do notice, like all things we give our sustained attention to, the creek begins to reveal its significance. Unlike the manufactured Main Street Cupertino, it is

not there because someone put it there; it is not there to be pro-
ductive; it is not there as an amenity. It is witness to a watershed
that precedes us. In that sense, the creek is a reminder that we do
not live in a simulation—a streamlined world of products, results,
experiences, reviews—but rather on a giant rock whose other life-
forms operate according to an ancient, oozing, almost chthonic
logic. Snaking through the midst of the banal everyday is a deep
weirdness, a world of flowerings, decompositions, and seepages,
of a million crawling things, of spores and lacy fungal filaments,
of minerals reacting and things being eaten away—all just on the
other side of the chain-link fence.

It would not have been the same if I had gone to Calabazas Creek
alone. The moment that Josh and I combined the fragments in our
memories into the same body of water, the creek came not just
to individual attention but to collective attention. It became part
of a shared reality, a reference point outside of each of us. Picking
our way over the riprap in this sunken, otherwise-unnoticed path-
way—attending to the creek with the presence of our bodies—we
were also rendering a version of the world in which the creek does
appear, alongside its tributaries and its mountain and all the things
growing and swimming within it.

Realities are, after all, inhabitable. If we can render a new reality
together—with attention—perhaps we can meet each other there.

Chapter 5

Ecology of Strangers

There are more things in mind, in the imagination, than "you" can
keep track of—thoughts, memories, images, angers, delights,
rise unbidden. The depths of mind, the unconscious, are our in-
ner wilderness areas, and that is where a bobcat is right now.
I do not mean personal bobcats in personal psyches, but the
bobcat that roams from dream to dream.

—GARY SNYDER, *THE PRACTICE OF THE WILD*[1]

On a lazy Saturday at the end of 2017, I was walking from the
Rose Garden to Piedmont Grocery, a route I've taken hun-
dreds of times. As I crested the hill, I saw a young woman walking
her dog in the opposite direction. We were just about to pass each
other when she stopped and fell to the ground—luckily in a patch of
grass in front of a church— and started having a seizure. I don't re-
member the order of events immediately following that. I do know
that I dialed 911 and yelled "help" loud enough that people in the
apartment building across the street came out, and that I somehow
summoned the presence of mind to give the dispatcher the cross
street and describe the circumstances. Initially, the woman's eyes
were open and looking directly at me, returning my gaze without
seeing. It was as surreal as it was terrifying. Before others arrived,
on that otherwise empty street, I felt completely responsible to this
person I had never seen before a few minutes ago.

When she came to, the woman was suspicious of me and the
people from the apartment building who had brought water; I

learned that people who have seizures can be confused and even belligerent as they regain consciousness. For her, we had come out of nowhere. While the paramedics gently questioned her, I sat nearby and held on to her dog's leash; I felt responsible to the dog, too, who was clearly distressed. Eventually the people from the apartment building went back inside, and I stayed to answer questions because I was the only person who had seen what had happened. It became clear that (probably because we looked the same age) the paramedics assumed I was her friend and that we had been walking together. No, I said, I was just a passerby. At this, one of the paramedics thanked me for staying, implying that this was an inconvenience. But that other world—in which I had been walking to the grocery store to buy things for dinner—was so remote that I could barely remember what I was supposed to have been doing.

When everything seemed to be taken care of, at least as much as it was going to be at that moment, I continued down the hill with shaky knees. I stopped in a parklet next to Glen Echo Creek to collect myself. This, too, was a familiar scene, but now everything in it appeared in stark contrast—a contrast not between anything in the scene, but between the scene itself and the possibility of its nonexistence (or rather, my nonexistence). Just as earthquakes remind us that we live on floating plates, once I'd been confronted with the fragility of another person's life, I was momentarily unable to see anything as given.

When I finally did get to the grocery store, I walked the aisles with a thousand-yard stare, struggling to remember what I'd come to buy. All around me were people calmly going about their business, trying to choose among a wide selection of cereals, picking through the apples, contemplating the eggs. But for the moment, I couldn't inhabit that scale of decision-making. All I could see was that all of us here were alive, and that was a miracle. I thought of a print by Hallie Bateman that my boyfriend had bought and which was hanging nonchalantly in our apartment. It was a drawing of

a street scene with words scattered across the sidewalk, buildings, and sky, reading: *We're all here together, AND WE DON'T KNOW WHY.*

A GROCERY STORE full of strangers has a similar effect in David Foster Wallace's 2005 commencement speech at Kenyon College, titled "This Is Water: Some Thoughts, Delivered on a Significant Occasion, about Living a Compassionate Life." Wallace gives the students what is basically a brutal description of adult life, in which you find yourself at the "hideously, fluorescently lit" grocery store full of annoying people after a long day of work and a horrible traffic jam. In that moment, you have a choice of how to perceive the situation and the people in it. As it turns out, that choice is basically one of attention:

> if I don't make a conscious decision about how to think and what to pay attention to, I'm going to be pissed and miserable every time I have to food-shop, because my natural default-setting is the certainty that situations like this are really all about me, about my hungriness and my fatigue and my desire to just get home, and it's going to seem, for all the world, like everybody else is just in my way, and who are all these people in my way?[2]

This makes room for the possibility, in Wallace's examples, that the guy in the Hummer who just cut you off is maybe trying to rush a child to the hospital—"and he's in a way bigger, more legitimate hurry than I am—it is actually I who am in his way." Or that the woman in front of you in line who just screamed at you is maybe not usually like this; maybe she's going through a rough time. Whether this is actually true isn't the point. Just considering the possibility makes room for the lived realities of other people, whose depths are the same as your own. This is a marked depar-

ture from the self-centered "default setting," whose only option is to see people as inert beings who are in the way:

> But if you've really learned how to think, how to pay atten-
> tion, then you will know you have other options. It will ac-
> tually be within your power to experience a crowded, loud,
> slow, consumer-hell-type situation as not only meaningful
> but sacred, on fire with the same force that lit the stars—
> compassion, love, the sub-surface unity of all things.[3]

That Wallace frames this as a choice, one made against the "de-
fault setting," speaks to the relationship between discipline, will,
and attention that I outlined in the last chapter. If we're to truly
encounter anything outside of ourselves (transcending Buber's I-It
relationship), we have to want it.

This encounter is something I often think about when I take
the bus through downtown Oakland to my studio, at the water's
edge and the end of the line. For many people, myself included,
public transportation is the last non-transactional space in which
we are regularly thrown together with a diverse set of strangers, all
of whom have different destinations for different reasons. Strang-
ers have a reality to me on the bus that they cannot have on the
freeway, simply because we've agreed to be in an enclosed space in
which we are subject to each other's actions. Because we share an
understanding that we all need to get where we're going, for the
most part people act respectfully, literally making space for others
when necessary.

Last week, after a meeting, I took the F streetcar from Civic Cen-
ter to the Ferry Building in San Francisco. It's a notoriously slow,
crowded, and halting route, especially in the middle of the day.
This pace, added to my window seat, gave me a chance to look at
the many faces of the people on Market Street with the same alien-
ation as the slow scroll of Hockney's *Yorkshire Landscapes*. Once I ac-
cepted the fact that each face I looked at (and I tried to look at each

of them) was associated with an entire life—of birth, of childhood, of dreams and disappointments, of a universe of anxieties, hopes, grudges, and regrets totally distinct from mine—this slow scene became almost impossibly absorbing. As Hockney said: "There's a lot to look at." Even though I've lived in a city most of my adult life, in that moment I was floored by the density of life experience folded into a single city street.

In his *Philosophy of the Encounter*, as a contrast to what constitutes an actual society, Louis Althusser outlines the way in which true society requires some kind of spatial constraint. He contrasts the urban with Jean-Jacques Rousseau's idealized "natural state," a kind of primeval forest where people move unseen and encounter rarely happens. Describing this natural state, Althusser invokes the paintings of "the other Rousseau" (Henri Rousseau, the artist), "whose paintings show us isolated individuals who have no relations to each other wandering out: individuals without encounters." In order to construct a society in which encounters can begin to happen, Althusser writes, people must be "forced to have encounters that last: forced by a force superior to them." To create a society, he replaces the image of the forest with that of an island. It's this "island" of forced encounter that I'm reminded of when I think about the bus, or the city more generally. Spatial proximity has everything to do with it, since the urban experience is a state of tension maintained against the instinct to disperse:

> It would be possible for this encounter not to last if the constancy of external constraints did not maintain it in a constant state in the face of the temptation of dispersion, did not literally impose its law of proximity without asking men for their opinion; their society thus emerges behind their backs, so to speak, and their history emerges as the dorsal, unconscious constitution of this society.[4]

———

THE DAY AFTER I saw *Blindspotting* at the theater near my apartment, I was walking around Lake Merritt, thinking about the role I might be playing in gentrification by having moved to the place I did, when I did. As if on cue, a group of local elementary school children came up to me, each holding a clipboard, and announced in a businesslike fashion that they were doing a project about Oakland and wanted to ask me some questions. The first one was seemingly straightforward: "How long have you been part of this community?"

Actually, it wasn't straightforward at all. Even as I answered, "Two years," I was asking myself what it meant to be part of a community, versus just living somewhere. Sure, I had grown up in the Bay Area, and I felt that I was part of a community—of Bay Area artists and writers, as well as people in other cities who I was connected to via social media—but this community? What, if anything, had I contributed to the place where I now lived—besides rent, and maybe the one article I had written for *Sierra Magazine* on the local night herons?

Their other questions were similarly fraught for me, mostly because after that first question, I felt I had no right to be answering the rest. What did I appreciate the most about Oakland? The diversity. ("Of people?" one kid quickly asked.) What would I like to see more of in Oakland? More funding for public libraries and parks. What did I think was the biggest challenge facing Oakland? Fumbling a little, I said something about how "different groups of people should talk to each other more."

The kid in front looked up from his clipboard, scrutinizing me. "So would you say . . . care?" he asked.

I suggested "communication," but days later, his clarification stayed with me. After all, communication requires us to care enough to make the effort. I thought about how it's possible to

move to a place without caring about who or what is already there (or what was there before), interested in the neighborhood only insofar as it allows one to maintain your existing or ideal lifestyle and social ties. Like Buber's "I-It" relationship, a newcomer might only register other people and things in the neighborhood to the extent that they seem in some way useful, imagining the remainder as (at best) inert matter or (at worst) a nuisance or inefficiency.

Compared to the algorithms that recommend friends to us based on instrumental qualities—things we like, things we've bought, friends in common—geographical proximity is different, placing us near people we have no "obvious" instrumental reason to care about, who are neither family nor friends (nor, sometimes, even potential friends). I want to propose several reasons we should not only register, but care about and co-inhabit a reality with, the people who live around us being left out of our filter bubbles. And of course, I mean not only social media bubbles, but the filters we create with our own perception and non-perception, involving the kind of attention (or lack thereof) that I've described so far.

THE MOST OBVIOUS answer is that we should care about those around us because we are beholden to each other in a practical sense. This is where I would place my encounter with the woman having a seizure: I was helpful because I was nearby. Neighborhoods can be networks of support in situations both banal and extreme. Let's not forget that, in a time of increasing climate-related events, those who help you will likely not be your Twitter followers; they will be your neighbors. This is also a good place to return to Rebecca Solnit's *Paradise in Hell*, in which ad hoc networks of support were erected in the wake of disaster by neighbors who may never have had the occasion to meet each other. Not only did these neighbors organize and provide each other with food, water, shelter, medical aid, and moral support—often crossing social boundaries or upending norms in order to do so—but these local, flexible, and

rhizomatic networks often got the job done better, or at least faster, than the more institutional aid that followed.

But Solnit's book is almost more useful as an illustration of a second reason to care about those around us, which is that an "I-It" world without "Thous" is an impoverished and lonely place to live. Solnit repeatedly finds survivors who recount the exhilaration of commingling with their neighbors and finding common purpose, making clear the necessity of emotional sustenance as much as material sustenance. As a poet who lived through the 1972 earthquake in Nicaragua tells her:

> All of a sudden you went from being in your house the night before, going to bed alone in your own little world to being thrown out on the street and mingling with neighbors you might not have said hello to very much or whatever and getting attached to those people, minding them, helping, trying to see what you could do for one another, talking about how you felt.[5]

In fact, I have experienced this sudden transformation, although thankfully not because of a disaster. My boyfriend and I live in a large apartment complex that's next to the house of a family of four, and when we're sitting on our balcony and they're sitting on their porch, we can easily see each other. The sound of the man listening to dad rock while weeding, or the outbursts of the two young sons (such as fart noises followed by cackling), became comforting background noise for us. But we didn't learn each other's names for two years, and we may not have chatted at all if it hadn't been for the neighborliness of Paul, the dad.

One day Paul invited us over for dinner. Because I hadn't been in a neighbor's home since I was a teenager, it was unexpectedly surreal to be inside the house that forms a permanent part of the view from our apartment. The interior of the house went from being an idea to a palpable reality. And just like their view of the street—

similar to ours, but slightly different—our neighbors were people who we had no reason not to know, but who we probably wouldn't have met in our usual circles, online or otherwise. That meant that there were things that we had to explain to each other that might have been taken for granted in our respective habitual contexts— and in these explanations we probably all saw ourselves from a new angle. For my part, the experience made me realize how similar the life situations of most of my friends are, and how little time I spend in the amazing bizarro world of kids.

When we arrived back to our apartment, it felt different to me— less like the center of things. Instead the street was full of such "centers," and each one contained other lives, other rooms, other people turning in for the night and worrying their own worries for the next day. Of course I had already accepted all of this in an abstract sense, but it wasn't felt. And as silly as this story may sound to anyone who is used to knowing their neighbors, I find it worthwhile to recount because it bears out what I've experienced with other expansions of attention: they're hard to reverse. When something goes from being an idea to a reality, you can't easily force your perception back into the narrow container it came from.

Just this one experience made me view my entire street, in fact every street, differently. There's something of this shift in *A Paradise Built in Hell*. In the chapter on the 1906 San Francisco earthquake and fire, Solnit quotes Pauline Jacobson's piece in the *San Francisco Bulletin*, called "How It Feels to Be a Refugee and Have Nothing in the World, by Pauline Jacobson, One of Them." Jacobson describes this irreversible expansion of attention to the neighbors:

> Never even when the four walls of one's own room in a new city shall close around us again shall we sense the old lonesomeness shutting us off from our neighbors. Never again shall we feel singled out by fate for the hardships and ill luck that's going. And that is the sweetness and the gladness of the earthquake and the fire. Not of bravery nor of strength, nor

of a new city, but of a new inclusiveness. The joy in the other fellow.[6]

This brings me to a final reason for the "care" that was suggested to me at Lake Merritt. Let's say I decided to spend my entire life caring only about my family, current friends, and potential friends recommended to me by an algorithm—even or especially an impressive one which is often "right," according to criteria like "people who are knowledgeable about my interests" or "people who in some way will help me advance along my career path" or even "people who have things I want." Let's further imagine that I only interacted with those friends in similarly "recommended" ways, like going to art openings, having conversations about art, or activities that start to sound more like networking. I'd venture that something would begin to happen to me and my social world that's similar to what's happened with the Discover Weekly playlist on my Spotify account.

Over the years, the Spotify algorithms have correctly identified that I tend to like "chill" music of a certain BPM: smooth, inoffensive songs from the 1960s and '70s, or more recent ones with washy synths, echo-y guitars, and vocals that are either passive or nonexistent. As I continue to listen to the playlist, dutifully saving the songs that I like, the weekly playlist begins to hone in, if not on an archetypal song, then an archetypal mix—we could call this "the Jenny mix"—and other potential mixes are measured for their likeness to whatever the current archetype is.

But it also so happens that my car is from 2006 and has no auxiliary input—which means when I drive to Stanford twice a week, I listen to the radio. My presets are KKUP (Cupertino public radio), KALX (UC Berkeley college radio), KPOO (a San Francisco community station owned by Poor People's Radio), KOSF (iHeart80s), KRBQ ("the Bay Area's Throwback Station"), and KBLX ("the Soul of the Bay"). Especially when I'm driving home late on Interstate 880, feeling anonymous in the dark, flat expanse, I'm comforted by

the fact that some other people are hearing the same thing I am. I've come to know the physical coverage of the radio waves so well that I can predict when a station will fuzz out on a certain freeway interchange, and when it'll come back.

More important, none of these stations ever play anything like "the Jenny mix." Instead they will occasionally play a song that I like even more than my archetypal song, in a different way and for reasons I can't really pinpoint. The songs fall into genres I normally say I dislike, including Top 40. (It was only on KBLX that I heard Toni Braxton's Top 40 hit "Long as I Live," which I listened to obsessively for weeks afterward.) Especially with something as intuitively appealing or unappealing as music, to acknowledge that there's something I didn't know I liked is to be surprised not only by the song but by myself.

My dad, a musician for much of his life, says that this is actually the definition of good music: music that "sneaks up on you" and changes you. And if we're able to leave room for the encounters that will change us in ways we can't yet see, we can also acknowledge that we are each a confluence of forces that exceed our own understanding. This explains why, when I hear a song I unexpectedly like, I sometimes feel like something I don't know is talking to something else I don't know, through me. For a person invested in a stable and bounded ego, this kind of acknowledgment would be a death wish. But personally, having given up on the idea of an atomic self, I find it to be the surest indicator that I'm alive.

By contrast, at its most successful, an algorithmic "honing in" would seem to incrementally entomb me as an ever-more stable image of what I like and why. It certainly makes sense from a business point of view. When the language of advertising and personal branding enjoins you to "be yourself," what it really means is "be more yourself," where "yourself" is a consistent and recognizable pattern of habits, desires, and drives that can be more easily advertised to and appropriated, like units of capital. In fact, I don't know what a personal brand is other than a reliable, unchanging pattern

of snap judgments: "I like this" and "I don't like this," with little room for ambiguity or contradiction.

Thinking about what it would mean to submit to such a process, becoming a more and more reified version of "myself," I'm reminded of the way Thoreau described unthinking people in "Civil Disobedience": as basically dead before their time. If I think I know everything that I want and like, and I also think I know where and how I'll find it—imagining all of this stretching endlessly into the future without any threats to my identity or the bounds of what I call my self—I would argue that I no longer have a reason to keep living. After all, if you were reading a book whose pages began to seem more and more similar until you were reading the same page over and over again, you would put the book down.

Extrapolating this into the realm of strangers, I worry that if we let our real-life interactions be corralled by our filter bubbles and branded identities, we are also running the risk of never being surprised, challenged, or changed—never seeing anything outside of ourselves, including our own privilege. That's not to say we have nothing to gain from those we have many things in common with (on paper). But if we don't expand our attention outside of that sliver, we live in an "I-It" world where nothing has meaning outside of its value and relation to us. And we're less prone to the encounters with those who turn us upside down and reorganize our universe—those who stand to change us significantly, should we allow it.

Of course, having encounters entails risks that not everyone is willing to take. For example, I once dated someone whose very intelligent brother only ate at chain restaurants when he traveled, his reasoning being that he wanted to know what he was getting and that he didn't want to waste time risking something he wouldn't like. This used to infuriate my then-boyfriend whenever he visited, since we lived in a part of San Francisco famous for its Mexican, Salvadorian, and Ecuadorian food. The idea of eating at Chipotle instead of La Palma Mexicatessen or Los Panchos, especially when

you were only going to be in San Francisco for a few days, seemed absurd. Food-wise, this man had achieved the strange feat of going somewhere without actually going anywhere.

To live without encountering plurality, both within oneself and without, brings about a phenomenon that Sarah Schulman describes in her book *The Gentrification of the Mind: Witness to a Lost Imagination*. Schulman gives a firsthand account of what happened in 1980s New York, when the children of suburban families who had been part of post–World War II white flight filled the vacancies left by the dying, AIDS-affected queer community in places like the Lower East Side. Both in urban and psychological space, Schulman witnessed "the replacement of complex realities with simplistic ones," a process leading to a kind of social monoculture. Afraid of anyone who differed from the suburban archetype, the newcomers to Schulman's neighborhood were not only uninterested in learning anything about the incredibly dynamic place they had moved to, but ignorant of their role in destroying that dynamism. They, too, had gone somewhere without going anywhere. Schulman compares the first gentrifying businesses in her neighborhood—beacons that signaled to newcomers using aesthetics and price—as isolated outposts, like "the hard currency kiosks in the Soviet Union that sold Marlboros to apparatchiks and tourists."[7]

What's especially tragic about a mind that imagines itself as something separate, defensible, and capable of "efficiency" is not just that it results in a probably very boring (and bored) person; it's that it's based on a complete fallacy about the constitution of the self as something separate from others and from the world. Although I can understand it as the logical outcome of a very human craving for stability and categories, I also see this desire as, ironically, the intersection of many forces inside and outside this imagined "self": fear of change, capitalist ideas of time and value, and an inability to accept mortality. It's also about control, since if we recognize that what we experience as the self is completely bound to others, determined not by essential qualities but by relationships, then we

must further relinquish the ideas of a controllable identity and of a neutral, apolitical existence (the mythology that attends gentri-fication). But whether we are the fluid product of our interactions with others is not our choice to make. The only choice is whether to recognize this reality or not.

Any loss of control is always scary, but to me, giving up on the idea of a false boundary makes sense not only conceptually but phenomenologically. That's not to say there's no such thing as a self, only that it's hard to say where it begins and ends when you think about it for even a few moments. Alan Watts once called the sensation of an ego a hallucination, "a completely false conception of ourselves as an ego inside a bag of skin."[8] Learning to see past this boundary can also be a relief. In "My Adventures with the Trip Doctors," Michael Pollan experiences something like this relief during an ayahuasca experience with a seasoned guide. At some point during the trip, Pollan's traditional self disintegrates: "'I' now turned into a sheaf of little papers, no bigger than Post-its, and they were being scattered to the wind." Later, his "I" changes again: "Everything I once was and called me, this self six decades in the making, had been liquefied and dispersed over the scene. What had always been a thinking, feeling, perceiving subject based in here was now an object out there. I was paint!"[9]

But then who is the self perceiving the paint? Pollan is forced to conclude that there is more to consciousness than the ego. Signifi-cantly, the result is a feeling not of fear but of relief:

The sovereign ego, with all its armaments and fears, its backward-looking resentments and forward-looking worries, was simply no more, and there was no one left to mourn its passing. And yet something had succeeded it: this bare, dis-embodied awareness, which gazed upon the scene of the self's dissolution with benign indifference. I was present to re-ality but as something other than my usual self. And although there was no self left to feel, exactly, there was a feeling tone,

and that was calm, unburdened, content. There was life after the death of the ego.

YOU MIGHT BE surprised to find me emphasizing the importance of other people in a book that started out with my solitary retreat to a rose garden. Recall that in "Solitude and Leadership," William Deresiewicz warns that one needs to remove herself in order to be able to think critically. But in the part that I quoted earlier—where he warns against "marinating yourself in the conventional wisdom"—Deresiewicz is talking about "Facebook and Twitter and even *The New York Times.*" In the very same essay, he mentions the importance of having a close friend to have real and substantive conversations with. If critical distance is what we're after, I think there is an important distinction to make between isolating oneself versus removing oneself from the clamor and undue influence of public opinion.

After all, it is public opinion that social media exploits, and public opinion that has no patience for ambiguity, context, or breaks with tradition. Public opinion is not looking to change or to be challenged; it is what wants a band to keep making songs exactly like the hit they once had. Conversations, whether with oneself or with others, are different. The book you are reading—as I would guess is the case with most books—is the result of many conversations I've had over the course of many years, in my case with both humans and nonhumans. Many of them happened while I was writing this, and all of them changed my mind. Now, as you read it, this book forms a conversation with you as well.

Even when I go to the Rose Garden, I'm not really alone. Although I generally keep to myself, the park, whose visitors are diverse in pretty much every way, is where I've had by far the most conversations with strangers. And those are just the humans. I've always found the phrase "alone in nature" to be a humorous oxymoron, an utter impossibility. When the garden is empty of people,

I still consider it a social place where I spend time with jays, ravens, dark-eyed juncos, hawks, turkeys, dragonflies, and butterflies, not to mention the oaks, the redwoods, the buckeyes, and the roses themselves. I will often look up from a book and let my attention wander over to a foraging towhee, settling into its scale of perception, lingering in the minute bug universe under a rosebush. Over the years I've noticed that, on hearing birds that are out of sight, I've gone from asking "What's there?" to "Who's there?" Every day, and indeed every thought, is different depending on who's there.

When I try to think about thinking, for instance retracing where an idea of mine came from, the limitations of English force me to say that "I" "produced" an "idea." But none of these things are stable entities, and this grammatical relationship among them is misleading. The "idea" isn't a finished product with identifiable boundaries that one moment sprung into being—one of the reasons artists so hate the interview question, "So what was your inspiration for this?" Any idea is actually an unstable, shifting intersection between myself and whatever I was encountering. By extension, thought doesn't occur somehow inside of me, but between what I perceive as me and not-me. Cognitive scientists Francisco J. Varela, Evan Thompson, and Eleanor Rosch back up this intuition with fascinating scientific studies in *The Embodied Mind*, a book that draws comparisons between modern cognitive science and ancient Buddhist principles. Using examples like the coevolution of vision with certain colors that occur in nature, they fundamentally complicate the idea that perception merely gives information about what's "out there." As they put it, "Cognition is not the representation of a pre-given world by a pre-given mind but is rather the enactment of a world and a mind"[10]

When we recognize the ecological nature not only of biotic communities but of culture, selfhood, and even thought—that indeed, consciousness itself arises from the intersection between what's "inside" and "outside" (troubling the distinction thereof)—it's not just the boundary between self and other that falls away. We're in

a position to see past another supposedly insurmountable barrier: the one between the human and the nonhuman.

This thought visited me one day in the Rose Garden, as the intersection of a book I was reading and the arrival of a bird. The book was *Braiding Sweetgrass: Indigenous Wisdom, Scientific Knowledge, and the Teachings of Plants*, by Robin Wall Kimmerer, an ecological scientist who is also a member of the Citizen Potawatomi Nation. The bird was a song sparrow. As the sparrow inched along and pecked at the ground in its customary way, I read for the first time about "species loneliness," the melancholy alienation of humans from other life-forms. Kimmerer writes,

> I'm trying to imagine what it would be like going through life not knowing the names of the plants and animals around you. Given who I am and what I do, I can't know what that's like, but I think it would be a little scary and disorienting—like being lost in a foreign city where you can't read the street signs.[11]

She adds that "[a]s our human dominance has grown, we have become more isolated, more lonely when we can no longer call out to our neighbors."

I looked over at my neighbor, the song sparrow, and thought about how just a few years ago, I wouldn't have known its name, might not have even known it was a sparrow, might not have even seen it at all. How lonely that world seemed in comparison to this one! But the sparrow and I were no longer strangers. It was no stretch of the imagination, nor even of science, to think that we were related. We were both from the same place (Earth), made of the same stuff. And most important, we were both alive.

EARLIER THIS YEAR, I went to a wedding in Palm Springs that was being held at the Ace Hotel. Ironically, given that each city's Ace Hotel has a very distinct theme, I felt like I was at every other Ace

I have ever been in—an aesthetic simulacrum. I sat by the pool, where media influencers took artful selfies, and where I was privately tortured by the allure of the San Jacinto Mountains. In fact, I found it hard to look at anything else, as though we should all drop what we were doing and behold this unimaginable body of rock. I kept asking myself, "How can that be?" Unlike the fuzzy blue Santa Cruz Mountains I grew up seeing, these mountains rose *straight up*, austere, rocky, and purple at sunset. I wanted nothing more than to look at them all day, more closely if possible. But although they didn't seem that far away, there was no way to walk to them, and I hadn't rented a car.

After a few days of this, I took a cab out to Murray Canyon, a trail maintained by the Agua Caliente Band of Cahuilla Indians on their reservation. For the first time since I'd arrived, I was able to look seriously at where I was. As I made my way through the canyon, a seam in those Martian-looking mountains where things managed not only to live but to thrive, I clumsily relied on iNaturalist to learn their names: brittlebush, chuparosa, sacred thorn apple, fan palms (first time I'd seen them in their natural habitat). There was desert lavender, in the form of shrubs that seemed to speak unintelligible words when the wind went through them. I saw a phainopepla, looking like a svelte all-black version of our Steller's jay but of a completely different family of birds altogether, and a common chuckwalla (nothing common about it to me, as it was larger than a pet iguana) tucked into the crevice of a giant red boulder.

Once, when I was giving a talk on my research for this book at a Stanford urban studies working group, somebody asked whether using iNaturalist wasn't alienating me from the landscape, since it represented an itemizing, scientific view. I answered that while I had to admit it looked that way, the app was a necessary step in the remediation of my ignorance, a temporary crutch. Learning the names of things was my first step in perceiving not just "land" or "greenery," but living bodies instead. And, at least at home, it wasn't

as though I stopped paying attention once I learned their names. In-stead I remained observant over the seasons, learning not just their names but what they did, or rather, who they were. And at some point, this led to something in excess of disinterested observation—not just with Crow and Crowson or the local night herons, but with everything, the plants and the rocks and the fungus. Eventually, to behold is to become beholden to.

Kimmerer, as both an Anishinaabe woman and a classically trained scientist, allows in *Braiding Sweetgrass* that the right kind of scientific gaze can be part of rebuilding the relationships with land that we lost, or rather pushed out, beginning in the eighteenth century. Describing ecologists trying to bring the salmon back to a re-stored watershed in the Pacific Northwest, she writes that "[s]cience can be a way of forming intimacy and respect with other species that is rivaled only by the observations of traditional knowledge hold-ers. It can be a path to kinship." But it must be animated by some-thing more than pure analysis. In one of my favorite images from her book, Kimmerer tells us that in the Anishinaabe creation story, Nanabozho, the first man, is placed on earth with the instruction to absorb the wisdom of other inhabitants and to learn their names. Kimmerer imagines a friendly rapport between Anishinaabe and Carl Linnaeus, the father of the modern taxonomic system. Walking together and observing the local flora and fauna, the two observers complement each other: "Linnaeus lends Nanabozho his magnifying glass so he can see the tiny floral parts. Nanabozho gives Linnaeus a song so he can see their spirits. And neither of them are lonely."[12]

It's in the combination of the special capacities of Nanabozho and Linnaeus that I can begin to understand the nascent feelings I have toward the different forms of life I observe. This version of the observational eros doesn't just recognize or appreciate the in-habitants of a place, but is willing to perceive the special agency of those beings and receive their attention in turn. Overcoming spe-cies loneliness is impossible if our subjects appear inert and lifeless to us, be they hummingbirds or rocks. In *Becoming Animal*, David

Abram writes about what is lost when we speak and think about the rest of the world as less than animate:

> If we speak of things as inert or inanimate objects, we deny their ability to actively engage and interact with us—we foreclose their capacity to reciprocate our attentions, to draw us into silent dialogue, to inform and instruct us.[13]

This is of course a relatively recent problem of language; the communities who lived here for thousands of years had no problem conceiving of the nonhuman actors they lived with. In the introduction to *Reinventing the Enemy's Language: Contemporary Native Women's Writings of North America*, Gloria Bird writes about the way her grandmother talks about a mountain:

> In the long process of colonization, what has survived in spite of the disruption of native language is a particular way of perceiving the world. For example, my aunt once, when we were looking at what was left of Mount St. Helens, commented in English, "Poor thing." Later, I realized that she spoke of the mountain as a person. In our stories about the mountain range that runs from the Olympic Peninsula to the border between southern Oregon and northern California our relationship to the mountains as characters in the stories is one of human-to-human. What was contained in her simple comment on Mount St. Helens, Loowit, was sympathy and concern for the well-being of another human being—none of which she had to explain.[14]

Reading this, I began to see that my reaction to the San Jacinto Mountains was something that Western culture and language gave me no way to conceptualize. It was a deep and hopeful suspicion that these forms were something more than rock, that they embodied something, that someone was there.

Even though I know I am often getting an insufficient English (and written) version of them, I have long appreciated the way that indigenous stories animate the world. They are not only repositories of observations and analyses made over millennia, but also models of gratitude and stewardship. As it turns out, these stories kept their nonhuman actors alive not only in the human imagination, but literally in physical reality. Kimmerer writes about overseeing a study by her graduate student on the decline of sweetgrass, a plant traditionally harvested by Kimmerer's ancestors and which figures in the Anishinaabe creation story. The study revealed that the sweetgrass was suffering not from over-harvesting but from under-harvesting. The species had co-evolved with specific indigenous harvesting practices, which in turn had specifically evolved to increase the success of the plant. A specific type of human attention, use, and stewardship had become environmental factors on which the plants depended on, and without these things, they've begun to disappear.[15]

The sweetgrass study suggests that the plants were dying from none other than a lack of attention. And in a world where our survival is absolutely bound up with the survival of the ecologies in which we are embedded, it becomes clear that reciprocal attention is what ensures our survival as well. While this kind of attention to the living world certainly involves reverence, it's something very different from fawning over cuteness or beauty or appreciating nonhuman entities as intelligent or even sentient. (What's less cute or sentient than intestinal bacteria? And yet we rely on it.) In *Feminism and Ecological Communities: An Ethic of Flourishing*, Chris J. Cuomo critiques the animal rights stance that proceeds solely from the logic that some animals are sentient and can feel pain, because it privileges sentience in an ecology that relies on both sentient and non-sentient beings. This privileging, she writes, "comes out of the assumption that human beings are paradigmatic ethical objects, and that other life-forms are valuable only in so far as they are seen as similar to humans."[16]

The implication is that the actual paradigmatic ethical object, if there is one, is the ecosystem itself. This echoes the conservationist Aldo Leopold's observation that "you cannot love game and hate predators; you cannot conserve waters and waste the ranges; you cannot build the forest and mine the farm. The land is one organism."[17] Even if you cared only about human survival, you'd still have to acknowledge that this survival is beholden not to efficient exploitation but to the maintenance of a delicate web of relationships. Beyond the life of individual beings, there is the life of a place, and it depends on more than what we can see, more than just the charismatic animals or the iconic trees. While we may have fooled ourselves into thinking we can live cut off from that life, to do so is physically unsustainable, not to mention impoverished in still other ways. If what I've said about the ecology of the self is true, then it may only be among the most elaborate web of the nonhuman that we can most fully experience our own humanity.

ALL OF THAT said, the reason I suggest the bioregion as a meeting grounds for our attention is not simply because it would address species loneliness, or because it enriches the human experience, or even because I believe our physical survival may depend on it. I value bioregionalism for the even more basic reason that, just as attention may be the last resource we have to withhold, the physical world is our last common reference point. At least until everyone is wearing augmented reality glasses 24/7, you cannot opt out of awareness of physical reality. The fact that commenting on the weather is a cliché of small talk is actually a profound reminder of this, since the weather is one of the only things we each know any other person must pay attention to.

In a time when meaningful action will require us to form new alliances and recognize differences at the same time, bioregionalism is also useful as a model of difference without boundary, a way

of understanding place and identity that avoids essentialism and reification. As a scientific fact and simple matter of observation, there is no disputing that bioregions exist. If you go to the bioregion known as Cascadia (aka the Pacific Northwest), you are going to see Douglas fir and ponderosa pine, whereas if you go to the Southwest, you will not. But it's impossible to draw a hard line around a bioregion. That's because bioregions aren't anything more than loose conglomerations of species that grow well together in certain conditions that necessarily vary geographically—a similar pattern to human language and culture.

The borders of bioregions are not only impossible to define; they are permeable. I learned this most of all last March, when I idly noticed an article on the front page of a local newspaper about an "atmospheric river" that would be arriving from the Philippines. I had never heard the term, and when I looked it up, I learned that atmospheric rivers are temporary narrow regions in the atmosphere that transport moisture from the tropics, in this case to the West Coast (the most well-known being the Pineapple Express). As the river makes landfall, its water vapor cools and falls in the form of rain. Atmospheric rivers are hundreds of miles wide and can carry many times the amount of water as the Mississippi River. I was surprised to find that California gets 30–50 percent of its rainfall from atmospheric river events.

This was all very interesting, but it pointed toward something even more obvious that I hadn't been paying attention to. I had never really thought about where rain comes from, other than the sky. Or more precisely, where *my rain* comes from. I suppose if you had asked me, and I'd considered it for a moment, I could have told you that rain comes from somewhere else, but I wouldn't have been able to say where precisely, how, and in what shape. Reading the article, I couldn't put out of my mind the idea that the coming rain had just been in a country where half my family was from, a place I had never been. Wanting to see it more closely, I put out a large jar in the alley behind my apartment building. (And I learned some-

thing else: it takes a really long time to collect even a small amount of rainwater, even when it seems to be raining really hard.) I used some of the water with drugstore watercolors to paint a picture of a sampaguita, the national flower of the Philippines, and gave it to my mom. The rest sits on my desk in a small jar: water from another place.

Unbeknownst to me at the time, I had approached this very same society of water from the other side earlier that year. In the course of researching bioregionalism, I had just learned that Oakland's drinking water comes from the Mokelumne River, and wanted to see it "in person"—which meant visiting the river in a handful of different locations, as it proceeded from the towering and forested Sierras to dry, ghost-pine-filled chaparral. (This was the trip during which I stayed in the reception-less cabin I mentioned in Chapter 2.) There wasn't much on my agenda other than finding points of access; at each place, I would stop to simply look and listen to this water that I nonchalantly put in my body every day. I found myself amazed at how it never stopped moving: the river was always coming from somewhere and always going somewhere too. There was nothing stable about this "body" of water.

Not only that, it was still impossible to say where my drinking water came from. In every watershed there are headwaters, the closest thing to the origin of a creek. On Google Maps, I traced the North Fork Mokelumne River up the mountains to a place called Highland Lakes. But along its course, the river is also fed by creeks coming in from different locations. And even if I had gone to the headwaters of Mokelumne Creek, I would have searched in vain for its point of origin, or even a bounded area. Like bioregions at large, headwaters defy delineation, since every creek starts as the dispersed accumulation of snow or rain, trickling underground into streams that join larger streams that later emerge as springs—a gradual collecting of pathways that looks like a delta in reverse. So where did the water come from? It arrived from somewhere else. In the Sierra Nevada, much of the snowfall comes from atmospheric

rivers. Sometimes, those atmospheric rivers come from the Philippines.

I find something comfortingly anti-essentialist in the way ecology works. As someone who is both Asian and white, I am an anomaly or a nonentity from an essentialist point of view. It's not possible for me to be "native" to anywhere in any obvious sense. But things like the atmospheric river, or even the sight of Western tanagers (a favorite bird) migrating through Oakland in the spring, gives me an image of how to be from two places at once. I remember that the sampaguita, while it's the national flower of the Philippines, actually originated in the Himalayas before being imported in the seventeenth century. I remember that not only is my mother an immigrant, but that there is something immigrant about the air I breathe, the water I drink, the carbon in my bones, and the thoughts in my mind.

An ecological understanding allows us to identify "things"— rain, cloud, river—at the same time that it reminds us that these identities are fluid. Even mountains erode, and the ground below us moves in giant plates. It reminds us that—while it's useful to have a word for that thing called a cloud—when we really get down to it, all we can really point to is a series of flows and relationships that sometimes intersect and hold together long enough to be a "cloud."

By now, this might sound familiar. Indeed, it's a similar framework to the one I described regarding the self, a slippery thing at the intersection of phenomena inside and outside of the imagined "bag of skin." Resisting definition like headwaters resist pinpointing, we emerge from moment to moment, just as our relationships do, our communities do, our politics do. Reality is blobby. It refuses to be systematized. Things like the American obsession with individualism, customized filter bubbles, and personal branding—anything that insists on atomized, competing individuals striving in parallel, never touching—does the same violence to human society as a dam does to a watershed.

We should refuse such dams first and foremost within ourselves.

In "Age, Race, Class, and Sex: Women Redefining Difference," Au-
dre Lorde describes the pain of definitions that block natural flows
within the self:

> As a Black lesbian feminist comfortable with the many differ-
> ent ingredients of my identity, and a woman committed to ra-
> cial and sexual freedom from oppression, I find I am constantly
> being encouraged to pluck out some one aspect of myself and
> present this as the meaningful whole, eclipsing or denying the
> other parts of self. But this is a destructive and fragmenting
> way to live. My fullest concentration of energy is available to
> me only when I integrate all the parts of who I am, openly,
> allowing power from particular sources of my living to flow
> back and forth freely through all my different selves, without
> the restrictions of externally imposed definition. Only then
> can I bring myself and my energies as a whole to the service of
> those struggles which I embrace as part of my living.[18]

This description could suit a group as well as an individual, and
indeed, Lorde advocates for a similar freedom of flow within a
community. In a speech at a feminist conference where she is one
of only two black speakers, she vents exasperation with the prevail-
ing reaction to difference, which is either one of fearful tolerance or
total blindness. "Difference must be not merely tolerated, but seen
as a fund of necessary polarities between which our creativity can
spark like a dialectic," she says. "Only then does the necessity for
interdependency become unthreatening."[19] Difference is strength,
a prerequisite for creativity that allows individual growth and com-
munal political innovation. Lorde's words are especially resonant
now, when our politics play out on platforms ill designed for differ-
ence, plurality, and encounter.

TODAY, WHEN WE are threatened not only with biological desertification but cultural desertification, we have so much to learn from the basics of ecology. A community in the thrall of the attention economy feels like an industrial farm, where our jobs are to grow straight and tall, side by side, producing faithfully without ever touching. Here, there is no time to reach out and form horizontal networks of attention and support—nor to notice that all the non-"productive" life-forms have fled. Meanwhile, countless examples from history and ecological science teach us that a diverse community with a complex web of interdependencies is not only richer but more resistant to takeover. When I read Schulman's *The Gentrification of the Mind*, I picture the difference between a permaculture farm and a commercial corn farm that could be devastated by a single parasite:

> Mixed neighborhoods create public simultaneous thinking, many perspectives converging on the same moment at the same time, in front of each other. Many languages, many cultures, many racial and class experiences take place on the same block, in the same buildings. Homogenous neighborhoods erase this dynamic, and are much more vulnerable to enforcement of conformity. [20]

I'm struck by a detail that Schulman recounts about her building, where she finds that "the 'old' tenants who pay lower rents are much more willing to organize for services, to object when there are rodents or no lights in the hallways." Despite entreaties from the older tenants, "the gentrified tenants are almost completely unwilling to make demands for basics. They do not have a culture of protest" Schulman struggles to account for this "weird passivity that accompanies gentrification."[21] I would venture that the

newer tenants, though they were troubled by the conditions, ran up against the wall of individualism. Once they understood that something was not just their problem but a collective problem, requiring collective action and identification with a community to be solved, it was preferable to them to just drop it. That is, even rats and dark hallways were not too high a price to pay for the ability to keep the doors of the self shut to outsiders, to change, and to the possibility of a new kind of identity.

Unlike the dams that interrupt a river's flow, these barriers are not concrete: they are mental structures, and they can be dismantled through practices of attention. When we take an instrumental or even algorithmic view of friendship and recognition, or fortify the imagined bastion of the self against change, or even just fail to see that we affect and are affected by others (even and especially those we do not see)—then we unnaturally corral our attention to others and to the places we inhabit together. It is with acts of attention that we decide who to hear, who to see, and who in our world has agency. In this way, attention forms the ground not just for love, but for ethics.

Bioregionalism teaches us of emergence, interdependence, and the impossibility of absolute boundaries. As physical beings, we are literally open to the world, suffused every second with air from somewhere else; as social beings, we are equally determined by our contexts. If we can embrace that, then we can begin to appreciate our and others' identities as the emergent and fluid wonders that they are. Most of all, we can open ourselves to those new and previously unimaginable ideas that may arise from our combination, like the lightning that happens between an evanescent cloud and the ever-shifting ground.

Chapter 6

Restoring the Grounds for Thought

We are accustomed to say in New England that few and fewer
pigeons visit us every year. Our forests furnish no mast for them.
So, it would seem, few and fewer thoughts visit each growing man
from year to year, for the grove in our minds is laid to waste.

—HENRY DAVID THOREAU, "WALKING"[1]

So far, I've argued that practices of close attention can help us
see into nuanced ecologies of being and identity. This kind of
understanding has a few important requirements. First, it asks us to
loosen our grip on the idea of discrete entities, simple origin stories,
and neat A-to-B causalities. It also requires humility and openness,
because to seek context is already to acknowledge that you don't
have the whole story. And perhaps most important, an ecological
understanding takes time. Context is what appears when you hold
your attention open for long enough; the longer you hold it, the
more context appears.

Here's an example: I obviously like birds. In the first year that I
really got into bird-watching, I used *The Sibley Field Guide to Birds
of Western North America*. The book has a checklist in the back
where you mark the different species you've seen. That many bird-
ing books have such a list tells you a lot about how people tend to
approach this activity; in its most annoying form, bird-watching
potentially resembles something like Pokémon GO. But this was
somewhat inevitable for me as a beginner, learning to pick out dis-

crete, individual birds. After all, when you learn a new language, you start with the nouns.

Over the years, my continued attention began to dissolve the edges of the checklist approach. I noticed that certain birds were only in my neighborhood during part of the year, like cedar wax- wings and white-crowned sparrows. In the winter, my crows came by less often. (Perhaps they were joining up with the huge swarms of crows in the sycamore trees downtown, an annual gathering I refer to as "Crow Burning Man.") Even if they stay in the same place, birds can look different not only throughout their life but during different seasons, so much so that many pages of the Sibley guide have to show different ages, as well as breeding and non- breeding versions, of the same bird. So, there were not only birds, but there was bird time.

Then there was bird space. Magpies abounded near my parents' house an hour south, but never here. There were mockingbirds in West Oakland but not in Grand Lake. Song sparrows had dif- ferent songs in different places. The blue of scrub jays got duller as you went inland. Crows sounded different in Minneapolis. The dark-eyed juncos I saw at Stanford had brown bodies and black heads (the Oregon subgroup), but had I traveled east, I would have seen slate-colored, pink-sided, white-winged, or gray-headed and red-backed variations.

Inevitably, my recognition of certain species became bound up with the environments where I knew I would find them. Ravens perched high up in redwoods and pines; towhees liked to scurry under parked cars. If I saw a bare tree half submerged in a pond, I looked for night herons. Wrentits were so consistently in bram- bly shrubs that their high-pitched buzzing came to seem like the voice of the shrub itself. There was no wrentit, only wrentit-shrub. I started paying more attention to the berries that cedar waxwings love (and sometimes get drunk on!) and even came to appreciate bugs, since the gnats I constantly swatted away on the local trails now looked to me like bird food.

At some point, the impossibility of paying attention to the discrete category "birds" became apparent. There were simply too many relationships determining what I was seeing—verb conjugations instead of nouns. Birds, trees, bugs, and everything else were impossible to extricate from one another not only physically but conceptually. Sometimes I would learn about a relationship that involved many different kinds of organisms that I would never think were associated. For example, a 2016 study showed that woodpeckers and wood-decaying fungi may have a symbiotic relationship that also benefits other animals. It appeared that the woodpeckers' holes helped disperse multiple fungi throughout the trees, which in turn softened the wood and made it easier for other birds, squirrels, insects, snakes, and amphibians to find homes within the trees.[2]

This context, of course, also included me. I remember going for a walk near my parents' house once and hearing a scrub jay shrieking in a valley oak tree. It was such a good example of a scrub jay shriek that I was about to get out my phone and record it, when I realized that it was shrieking at me (to go away). As Pauline Oliveros writes in *Deep Listening* "When you enter an environment where there are birds, insects or animals, they are listening to you completely. You are received. Your presence may be the difference between life and death for the creatures of the environment. Listening is survival!"[3]

IT'S PRETTY INTUITIVE that truly understanding something requires attention to its context. What I want to emphasize here is that the way this process happened for me with birds was spatial and temporal; the relationships and processes I observed were things adjacent in space and time. For me, a sensing being, things like habitat and season helped me make sense of the species I saw, why I was seeing them, what they were doing and why. Surprisingly, it was this experience, and not a study on how Facebook makes us depressed, that helped me put my finger on what bothers me so much

about my experience of social media. The information I encounter there lacks context, both spatially and temporally.

For example, let's take a look at my Twitter feed right now, as I'm sitting inside my studio in Oakland in the summer of 2018. Pressed up against each other in neat rectangles, I see the following:

- An article on Al Jazeera by a woman whose cousin was killed at school by ISIL
- An article about the Rohingya Muslims fleeing Myanmar last year
- An announcement that @dasharezøne (a joke account) is selling new T-shirts
- Someone arguing for congestion pricing in Santa Monica, California
- Someone wishing happy birthday to former NASA worker Katherine Johnson
- A video of NBC announcing the death of Senator McCain and shortly afterward cutting to people dressed as dolphins appearing to masturbate onstage
- Photos of Yogi Bear mascot statues dumped in a forest
- A job alert for director of the landscape architecture program at Morgan State University
- An article on protests as the Pope visits Dublin
- A photo of a yet another fire erupting, this time in the Santa Ana Mountains
- Someone's data visualization of his daughter's sleeping habits during her first year
- A plug for someone's upcoming book about the anarchist scene in Chicago
- An Apple ad for Music Lab, starring Florence Welch

Spatial and temporal context both have to do with the neighboring entities around something that help define it. Context also helps establish the order of events. Obviously, the bits of informa-

tion we're assailed with on Twitter and Facebook feeds are missing both of these kinds of context. Scrolling through the feed, I can't help but wonder: What am I supposed to think of all this? How am I supposed to think of all this? I imagine different parts of my brain lighting up in a pattern that doesn't make sense, that forecloses any possible understanding. Many things in there seem important, but the sum total is nonsense, and it produces not understanding but a dull and stupefying dread.

This new lack of context can be felt most acutely in the waves of hating, shaming, and vindictive public opinion that roll unchecked through platforms like Facebook and Twitter. Though I believe the problem is built into the platforms themselves, and people throughout the political spectrum are implicated, it's a favorite tool of far-right propagandists like Mike Cernovich (who helped propagate the #pizzagate conspiracy theory) to dig through someone's old tweets and re-present the ones that look the most offensive out of context. Lately, journalists and other public figures have been a favorite target. What I find most upsetting about this is not how conniving Cernovich and others are, but how quickly and dutifully everyone else has piled on. If the alt-right is betting on inattention and a knee-jerk reaction that spreads like wildfire, they've won that bet several times. Even when victims of this tactic try to lay out the missing context in idiot-proof language, it's often too little too late.

Vox and other outlets have been quick to identify these experiences as examples of what technology and social-media scholar danah boyd would call "context collapse." A 2011 study that boyd conducted with Alice E. Marwick found that Twitter users who had built the most successful personal brands did so by recognizing the fact that they no longer really knew who their audience was. To tweet was to throw a message into a void that could include close friends, family, potential employers, and (as recent events have shown us) sworn enemies. Marwick and boyd describe how context collapse creates a "lowest-common-denominator philosophy of sharing [that] limits users to topics that are safe for all possible readers."[4]

When the alt-right weaponizes context (or lack thereof) in this way, not only is actual context ignored, but the targeted figures' names can become triggers in themselves. Something like this happened with Sarah Jeong, a left-leaning feminist tech journalist whose old, off-color tweets were collected and disseminated out of context by some alt-right trolls shortly after she was hired by *The New York Times* in 2018. While the *Times* stood by their decision to hire her, the alt-right's creation of so much online noise without context was successful in its own way: for a while afterward, it seemed like merely mentioning her name shut down any meaningful conversation online, making it difficult even for someone who wanted to gather context to find it. Not that there would be time to do it. People read a tweet or a headline, react, and click a button—thousands and millions of times over in a matter of days. I can't help but liken the angry collective tweet storms to watching a flood erode a landscape with no ground-cover plants to slow it down. The natural processes of context and attention are lost. But from the point of view of Twitter's financial model, the storm is nothing but a bounteous uptick in engagement.

IN A 2013 blog post about whether or not she coined the term "context collapse," boyd points to her indebtedness to a book by Joshua Meyrowitz called *No Sense of Place: The Impact of Electronic Media on Social Behavior*. Written in 1985 and mostly concerning electronic media like TV and radio, Meyrowitz's work reads now as eerily prescient, ripe for translation by boyd into online terms. At its very outset, *No Sense of Place* presents a thought experiment that sounds like the analog version of modern-day Twitter. Meyrowitz writes that when he was in college in the 1950s, he'd gone on an exciting three-month summer vacation, and when he got home, he was eager to share his experiences with his friends, family, and other acquaintances. Obviously, he says, he varied the stories and the telling based on the audience: his parents got the clean version,

his friends got the adventurous version, and his professors got the cultured version.

Meyrowitz asks us to consider what would happen to his trip narrative if, on his return, his parents had thrown him a surprise homecoming party where all of those groups were present together. He ventures that he would have either 1) offended one or more of the groups, or 2) created a "synthesized" account that was "bland enough to offend no one." But no matter which one, he writes, "the situation would have been profoundly different from the interactions I had with isolated audiences."[5] Meyrowitz's imagined options are analogous to boyd and Marwick's observations in their paper on Twitter users and personal brands. Option 1 (offending an unintended audience) is what happens with those whose old tweets are dug up; Option 2 ("bland enough to offend no one") is the professional social media star, a person reverse-engineered from a formula of what is most palatable to everyone all the time. Taken to its logical conclusion, Option 2 would eventually create a race to the mediocre bottom that has been repeatedly decried by cultural critics like Jaron Lanier.

The surprise homecoming party is an example of the useful architectural metaphor that Meyrowitz employs in *No Sense of Place*: it's as if all of the walls around different social environments have come down. Unfortunately, those rooms and walls were precisely what provided the spatial context for what was said in them, since they summoned a distinct audience out of the anonymous masses by only letting some people in. In turn, that audience was able to make sense of each utterance by encountering it in the space where the sentiment grew, continuous with or adjacent to other related utterances. If we imagine a collection of these "rooms" as an ecology of contexts, it's hard not to see social media as a contextual monoculture. When Meyrowitz observes of this "one large combined social situation" that certain types of behavior will become impossible, I'm struck by two of these behaviors in particular.

The first has to do with the fact that you cannot strategize vis-à-vis other people if those people are present.[6] Meyrowitz puts words to a feeling I sometimes have when watching protest movements unfold on Facebook, complete with event listings for protests where people voluntarily list themselves as "attending." The whole process is laid out in the open. Sure, this makes it easier for potential participants to see, but it also makes it easier to find for police, detractors, and even just passersby derailing the conversation with irrelevant information.

Something like a hashtag campaign can certainly be effective for raising awareness of an issue or increasing attendance at an event where no surprises are planned. But for successful targeted maneuvers, there always seems to be a strategic alternating between openness and closure. In Martin Luther King, Jr.'s, description of the planning that led up to the Montgomery bus boycott, he describes meetings of varying sizes, all happening in different rooms of homes, schools, and churches over the course just a few days.[7] These meetings were anywhere from very small (King deliberating with his wife at home) to small (King, E. D. Nixon, and Ralph Abernathy alternating calling each other on the phone) to midsize (a meeting with King, L. Roy Bennett, E. D. Nixon, and a handful of others at a church) to large (Montgomery's black leaders from different businesses and organizations, at King's church) to very large (a meeting open to the public, at another church). It was at the smaller meetings that they strategized how to run the larger meetings, collaborating quickly and intensely on ideas that would be put into play in successively wider contexts. And it was at the larger meetings that they strategized how to present their demands to the public at large.

That first behavior—"to plan strategies for dealing with people"—has to do with plurality within the public. The second behavior that Meyrowitz identifies as being impossible in these conditions has do with plurality within the self. He writes that with a completely generalized audience, "we would have trouble pro-

jecting a very different definition of ourselves to different people when so much other information about us was available to each of our audiences." To this I would add the inability to publicly change our minds, i.e., to express different selves over time. This is one of the things I find the most absurd about our current social media, since it's completely normal and human to change our minds, even about big things. Think about it: Would you want to be friends with someone who never changed their mind about anything?

But because apologizing and changing our minds online is so often framed as a weakness, we either hold our tongues or risk ridicule. Friends, family, and acquaintances can see a person who lives and grows in space and time, but the crowd can only see a figure who is expected to be as monolithic and timeless as a brand. Having worked for an old and widely recognized clothing company, I know firsthand that the pillars of any brand are internal coherence and consistency over time. (That's literally what we called them at work: "brand pillars.") For a brand as for a public figure—which, as we now know, any Twitter user can accidentally become overnight—change, ambiguity, and contradiction are anathema. "You have one identity," Mark Zuckerberg famously said. "The days of you having a different image for your work friends or co-workers and for the other people you know are probably coming to an end pretty quickly." He added that "having two identities for yourself is an example of a lack of integrity."[8] Imagine what Audre Lorde, with all her different selves, would have to say to him.

AS *NO SENSE OF PLACE* attests, context collapse is something we can understand spatially. But this process has a temporal cousin, which is an analogous collapse into a permanent instantaneity. Just as a series of rooms are dissolved into one big "situation," instantaneity flattens past, present, and future into a constant, amnesiac present. The order of events, so important for understanding anything, gets drowned out by a constant alarm bell. Veronica Barassi,

in her essay "Social Media, Immediacy and the Time for Democracy," provides an example of this phenomenon among activists using social media. Specifically, she describes three challenges for activists that I think can easily be extended to anyone having problems reading, speaking, and thinking online.

First, instantaneous communication threatens visibility and comprehension because it creates an information overload whose pace is impossible to keep up with. Activists, Barassi says, "have to adapt to the pace of information and constantly produce content." Meanwhile, information overload creates the risk that nothing gets heard. Barassi quotes an activist from Ecologistas en Acción, a confederation of Spanish ecological groups:

> Everybody says that there is no censorship on the internet, or at least only in part. But that is not true. Online censorship is applied through the excess of banal content that distracts people from serious or collective issues.[9]

Second, the immediacy of social media closes down the time needed for "political elaboration." Because the content that activists share online has to be "catchy," "activists do not have the space and time to articulate their political reflections." Barassi's interviewees repeatedly expressed that "social media were not a space for political discussion and elaboration, because the communication was too fast, too quick, and too short." One activist complains specifically that there's no time to "contextualize [ideas] for people" since "we need time and space to do that."[10] Barassi writes that the needed context often shows up in less instantaneous channels, such as activist magazines or in-person group discussion.

Lastly, immediacy challenges political activism because it creates "weak ties." Barassi's research suggests that networks built on social media "are often based on a common reaction / emotion and not on a shared political project and neither on a shared under-

standing of social conflict." Strong ties and well-defined political projects, she says, still come from "action on the ground . . . face-to-face interaction, discussion, deliberation and confrontation." She quotes a participant in the anti-austerity movement in Spain:

> One thing that really surprised me about the 15M was that all the tweeting, all the social media messages and internet campaigns effectively had a unique effect: they made people come together in a single square, sit on the floor and start to talk . . . So technologies have made people come together but what made the movement so powerful was the physical space, the process of discussion, and reflection and the availability of the people to sit down and discuss without the pressure of time.[11]

What becomes clear in Barassi's analysis is that thought and deliberation require not just incubation space (solitude and/or a defined context) but incubation time. My experience suggests that these challenges apply not only to activists but also to an individual trying to communicate with others, or just maintain coherent trains of thought. Whether the dialogue I want is with myself, a friend, or a group of people committed to the same cause as I am, there are concrete conditions for dialogue. Without space and time, these dialogues will not only die, they will never be born in the first place.

SO FAR, I'VE described how the loss of spatial and temporal context happens within the attention economy. Presented with information in the form of itemized bits and sensationalized headlines—each erased by the arrival of new items at the top of the feed—we lose that which was spatially and temporally adjacent to that information. But this loss happens at a more general level as well. As the attention economy profits from keeping us trapped in a fearful present, we risk blindness to historical context at the same

time that our attention is ripped from the physical reality of our surroundings.

I worry about what this means, long term, for our propensity to seek out context, or our ability to understand context at all. Given that all of the issues that face us demand an understanding of complexity, interrelationship, and nuance, the ability to seek and understand context is nothing less than a collective survival skill. Looking both to the troubling present and to successful actions in the past suggests that we will require new kinds of alliances and formations, which will further require periods both of solitude and of intense connection and communication. But how can we do that when our platforms for "connection" and expression detract from the attention to place and time that we need, simultaneously eroding the contexts that would allow new strategies to sharpen and flourish?

I think often about what an online network that attends to the spatiotemporal character of our experience as humans—animals who have evolved to learn things in space and time—would look like. I perform a reverse of Meyrowitz's thought experiment, rebuilding the walls. I wonder what it would be like to experience a social network that was completely grounded in space and time, something you had to travel to in order to use, that worked slowly.

In fact, local history provides me with an example of just such a network. In 1972, the world's first public bulletin board system (BBS) appeared in the form of a coin-operated kiosk at the top of the stairs to Leopold's Records in Berkeley. It was called Community Memory, and it contained a teletype machine connected via a 110-baud modem to 24-foot-long XDS-940 time-sharing computer in San Francisco. Every day, over and over, the modem made and received calls to the San Francisco computer, ultimately printing messages for users on the teletype machine. Community Memory had been installed by a group of three computer-science dropouts from UC Berkeley, who placed it below the store's physical bulletin board in the hopes that it would serve the same purpose, just more efficiently.

The 1972 flyer for Community Memory is almost heartbreaking to read now, amid new commonplaces like "social media fatigue," headlines about Facebook and hate speech, and calls to ban our own president from Twitter:

> COMMUNITY MEMORY is the name we give to this experimental information service. It is an attempt to harness the power of the computer in the service of the community. We hope to do this by providing a sort of super bulletin board where people can post notices of all sorts and can find the notices posted by others rapidly.[12]

True to their motto, "Technology for the People," Resource One outlines their goals for the project, betraying a community-oriented, no-nonsense optimism about the promise of a computer network:

> Our intention is to introduce COMMUNITY MEMORY into neighborhoods and communities in this area, and make it available for them to live with it, play with it, and shape its growth and development. The idea is to work with a process whereby technological tools, like computers, are used by the people themselves to shape their own lives and communities in sane and liberating ways. In this case the computer enables the creation of a communal memory bank, accessible to anyone in the community. With this, we can work on providing the information, services, skills, education, and economic strength our community needs. We have a powerful tool—a genie—at our disposal; the question is whether we can integrate it into our lives, support it, and use it to improve our own lives and survival capabilities. We invite your participation and suggestions.

The "interface" (which I saw in person in the same Berkeley Art Museum show as the spinning painting from the Drop City

commune) was extremely user-friendly. Since the teletype machine was so noisy, the kiosk was encased in plastic, with two arm holes for typing, another hole to see what was being printed, and a coin slot. Above the coin slot, it said, READ: FREE; below: WRITE: 25¢. Several brightly colored panels highlighted key commands that could hardly be misunderstood. But many people at that time had never used a computer, so Community Memory also employed a person to sit next to the kiosk and greet people coming up the stairs.

Community Memory eventually came to be used in many unexpected ways, as Steve Silberman describes in *NeuroTribes: The Legacy of Autism and the Future of Neurodiversity*, an exploration of autism and neurodiversity (Lee Felsenstein, one of the founders of Community Memory, was diagnosed with Asperger's syndrome in the 1990s). At first, people used the system to buy and sell things, and musicians sought other musicians, in a higher-tech version of the analog bulletin board. But soon, Silberman writes, other things began to happen:

> A poet offered sample poems, while others solicited lifts to Los Angeles; at one point, a Nubian goat was put up for sale. Some users posted ASCII art, and one posited a question that has vexed Bay Area residents for decades: "Where can I get a decent bagel?" (A baker replied by offering to provide free bagel-baking lessons.) Others held forth on Vietnam, gay liberation, and the energy crisis. Instead of merely being a computerized bulletin board, the network quickly became "a snapshot of the whole community," Felsenstein says.[13]

The website for information about Community Memory, still up since it was created in the nineties, boasts that the network saw the "the first net personality," a friendly sort of proto-troll who called himself Benway. Named after a drug-addled surgeon in William S. Burroughs's novels, Benway left cryptic messages with phrases like "sensuous keystrokes forbidden" and "grand conclave of the

parties of interzone: check your inbox for details." Since all users
of Community Memory remained anonymous, Benway's identity
remains unknown.

Additional kiosks were installed at the Berkeley Whole Earth
Access Store and the Mission Branch Library in San Francisco. Be-
cause they were unsynchronized, the conversations at each termi-
nal had a slightly different character. It's interesting to contrast this
variance with what happens today, when crowds of people in San
Francisco and Oakland look at Facebook on their phones. Their
information is also in a way asynchronous, since Facebook algo-
rithms show certain things to you and not to me (and vice versa).
But that variance is based on personal customization, which is mo-
tivated by advertising and the desire to increase your engagement.
Variance among the Community Memory terminals, on the other
hand, was based entirely on geographical location. Just as it would
be with cafés, bars, and neighborhoods more generally, the local
"scene" necessarily differed. But while there may have been asyn-
chronicity across the Bay Area, there was coherence within the ki-
osk, an assurance that each piece of information was surrounded
by geographical context—that it had a relationship to its place.

THESE DAYS, IF you ask someone to define a "community network,"
they might point to Nextdoor, a neighborhood-specific social net-
working service founded in 2011. Nextdoor seems to fulfill at least
some of the criteria: its communities are each restricted to physical
neighborhoods, it gives you a way to meet neighbors you might
not otherwise, and it promotes neighborliness: a cheery introduc-
tion video shows cartoon people finding lost dogs, recommending
plumbers, and throwing block parties. In a *New York Times* article on
Nextdoor, Robert J. Sampson, author of *Great American City: Chicago
and the Enduring Neighborhood Effect*, says that "[t]here's a common
misreading that technology inevitably leads to the decline of the
local community. I don't believe that. Technology can be harnessed

to facilitate local interactions."[14] At a glance, Nextdoor seems to be an example of this; as with the Community Memory kiosks, it should be possible to log on and get a sense of what's happening in a neighborhood.

My boyfriend, Joe Veix, writes often about Internet phenomena and spends more time on the Nextdoor site for our neighborhood than I do. When I asked him what he thought the difference was between Nextdoor and something like Community Memory, the first thing he said was that it felt geared toward uppity property owners. Although he meant it somewhat jokingly, when I went to Nextdoor's About page, the first two out of seven suggested uses were "Quickly get the word out about a break-in" and "Organize a Neighborhood Watch Group." Their manifesto suggests that "strong neighborhoods not only improve our property value, they improve each one of our lives."

But Joe's biggest gripe, which is his gripe with most online platforms, has to do with advertising and scale. As of December 2017, Nextdoor was valued at $1.5 billion, and it is as committed to growth and VC funding as any other Silicon Valley startup. In 2017 it invited companies to begin advertising on its network. Now the Nextdoor daily digest email is kicked off by a sponsored post by a company, followed by real estate listings. On Nextdoor's Ads page, which invites businesses to "connect directly with local communities," you see the same language as that of a community network—trust, local relevance, and word of mouth—but directed toward brands:

- **Verified identity**
 Confirmed identities result in a brand-safe environment
- **Local at scale**
 Customized messaging drives authentic, relevant connections between consumers and brands
- **Brand advocates**
 Word of mouth from trusted sources is the most effective form of advertising.[15]

In startup parlance, "at scale" refers to the expansion of a software or service to larger and larger contexts—i.e., the development of a local prototype into a widely used product. Given this meaning, only the phenomenon of national or even multinational corporations advertising simultaneously in many targeted neighborhoods can explain the oxymoron "local at scale."

In this and other ways, Nextdoor is basically of the same species of technology as Facebook and Twitter, even if its communities are geographically bounded. Once again, our interactions become data collected by a company, and engagement goals are driven by advertising. It's not just technology that's being "harnessed to facilitate local interactions," but local interactions that are being harnessed to produce revenue. The rules of engagement are nonnegotiable, the software is a black box, and the whole thing relies on centralized, company-owned servers whose terms of service are the same for everyone everywhere. This "commons" only feels like a commons. As Oliver Leistert puts it in "The Revolution Will Not Be Liked," for social media companies, "the public sphere is an historically elapsed phase from the twentieth century they now exploit for their own interests by simulating it."[16]

WRITING IN *THE ATLANTIC* about a nascent decentralized network called Scuttlebutt, Ian Bogost gives us an image for this absurd situation: "Facebook and Twitter are only like water coolers if there were one, giant, global water cooler for all workplaces everywhere."[17] Dissatisfaction with this standard-issue water cooler has fueled the movement toward a decentralized web, which instead of private companies and servers makes use of peer-to-peer networks and open-source software. The goal is not only for users to own their own data, but to shift that data and software closer to their end points of use. Mastodon, for example, is a federated social network of "instances," each using free software on a community-run server whose users can nonetheless communicate with those in

other instances. As its creators point out, Mastodon can never go bankrupt, be sold, or be blocked by governments, because it consists of little other than open-source software.

It's easy to imagine how the dispersed nodes of decentralized networks could lead to a healthy reintroduction of context, particularly when, for example, anyone can create a Mastodon instance with custom rules of engagement. (For that reason, LGBT, nonbinary, and other frequently harassed communities have flocked to Mastodon.) They allow more granular control of one's intended audience; when you post to Mastodon, you can have the content's visibility restricted to a single person, your followers, or your instance—or it can be public. But while Mastodon instances begin to reintroduce context, that context is not necessarily aligned with physical space, nor is it intended to be. When I asked my friend Taeyoon Choi, cofounder of the School of Poetic Computation in New York, about a network that would allow you to "listen to a place," he suggested local mesh networks like Oakland's Peoples Open.net. The nonprofit Sudo Room, whose volunteers develop the mesh network, describe it as a people-powered, "free-as-in-freedom alternative" to centralized, corporate servers: "Imagine if the wifi router in your home connected to the wifi routers in your neighbours' homes and they again connected to their neighbours to form a huge free wireless network spanning the city! That's exactly what a mesh network is, or at least what it can be."[8]

The volunteers add that mesh networks would be particularly resilient in the event of a natural disaster or state censorship. Alongside instructions for "building your own internet," they provide a directory of other community networks, like NYC Mesh, Philly Mesh, and Kansas City Freedom Network. And PeoplesOpen.net's mission statement seems to echo that of Community Memory:

> [W]e believe in the creation of local internets and locally-relevant applications, the cultivation of community-owned telecommunications networks in the interest of autonomy and

grassroots community collaboration, and ultimately, in owning the means of production by which we communicate.[19]

But for those networks that aren't locally specific, it might simply be the case that the network that allows you to "listen to a place" is just one that doesn't demand that you use it all the time. After telling me about mesh networks in an email, Taeyoon added:

> To me, listening to a place is about discovering a sequence of encounters. I just came back from running in Prospect Park, there were many birds and nature stuff that helped me listen to the place. I don't bring my phone or any device during the run. I develop ideas locally, and reserve them (stage them, as in github terminology) and share them once I'm ready for more encounters.

Taeyoon's strategy echoes the findings of Barassi about the incubation time of activism. Just as activism requires strategic openness and closure, forming any idea requires a combination of privacy and sharing. But this restraint is difficult when it comes to commercial social media, whose persuasive design collapses context within our very thought processes themselves by assuming we should share our thoughts right now—indeed, that we have an obligation to form our thoughts in public! Though I acknowledge that some people enjoy sharing their process publicly, this is personally anathema to me as an artist. The choice—not of what to say ("What's on your mind?") but whether and when to participate—doesn't feel like it belongs to me when I use Facebook and Twitter.

A counterexample would be the sparse UX of Patchwork, a social networking platform that runs on Scuttlebutt. Scuttlebutt is a sort of global mesh network that can go without servers, ISPs, or even Internet connection (if you have a USB stick handy). It can do that because it relies on individual users' computers as the servers, similar to local mesh networks, and because your "account" on a

Scuttlebutt-powered social media platform is simply an encrypted block of data that you keep on your computer.

The interesting thing about Patchwork, and Scuttlebutt generally, is that it reintroduces a choice I didn't think I had. Although Patchwork users have the option to connect to a public server (or "pub") for more and faster connections, it's otherwise a network that relies on two people being on the same local network. As Bogost writes, Scuttlebutt's default model is that friends share with friends via local networks or USB, and "word spreads, slowly and deliberately."

When I asked Jonathan Dahan, also at the School of Poetic Computation, whether it would be possible to use Patchwork to "roll into a coffee shop in a new town and see what the local gossip is," he responded that at first, this had been precisely his experience, and he enjoyed it. Soon, though, he decided to expand his network by joining a pub:

> [I] had a voracious appetite for data, updates. Kinda more traditional "check insta / twitter and something is always new there." Turns out Patchwork doesn't give that dopamine hit, until you start friending tons of people and joining pubs etc. It is a slower network in many ways, and helped me realize some of my traditional feed addictions.

My own experience using Patchwork bears this out. There is nothing on it that could be called persuasive design, and it was surprisingly strange. Left alone in an uncrowded interface with nothing at all being suggested to me, I realized it is finally incumbent on me to decide what to say, when, and to whom—already the beginnings of context. And like Jonathan, I felt the knee-jerk urge to join a pub, because of what I was used to. Only afterward did I question why I assume social media needs to feel like a Wall Street trading floor.

In his article on Scuttlebutt, Bogost asks, "What if isolation and

disconnection could actually be desirable conditions for a computer network?" He says this in the context of describing how Dominic Tarr, the creator of Scuttlebutt, lives largely offline in a sailboat in New Zealand, but it makes me think of the not-yet-wireless phone in my house growing up. Before I got older and started carrying around a heavy black rectangle of potentiality and dread, it worked like this: You thought about the call you needed to make, you went to the phone made the call, and then you walked away. If you decided you had something more to say, you called back later. Not only that, the interaction was with the one other person you had decided to contact. Even calling someone to chat aimlessly had more intention than many of the ways I communicate now.

I feel the same way about libraries, another place where you go with the intention of finding information. In the process of writing this book, I realized that the experience of research is exactly opposite to the way I usually often encounter information online. When you research a subject, you make a series of important decisions, not least what it is you want to research, and you make a commitment to spend time finding information that doesn't immediately present itself. You seek out different sources that you understand may be biased for various reasons. The very structure of the library, which I used in Chapter 2 as an example of a non-commercial and non-"productive" space so often under threat of closure, allows for browsing and close attention. Nothing could be more different from the news feed, where these aspects of information—provenance, trustworthiness, or what the hell it's even about—are neither internally coherent nor subject to my judgment. Instead this information throws itself at me in no particular order, auto-playing videos and grabbing me with headlines. And behind the scenes, it's me who's being researched.

———

———

I THINK OFTEN about how much time and energy we use thinking up things to say that would go over well with a context-collapsed crowd—not to mention checking back on how that crowd is responding. This is its own form of "research," and when I do it, it feels not only pathetic but like a waste of energy.

What if we spent that energy instead on saying the right things to the right people (or person) at the right time? What if we spent less time shouting into the void and being washed over with shouting in return—and more time talking in rooms to those for whom our words are intended? Whether it's a real room or a group chat on Signal, I want to see a restoration of context, a kind of context collection in the face of context collapse. If we have only so much attention to give, and only so much time on this earth, we might want to think about reinfusing our attention and our communication with the intention that both deserve.

Recall that the activists interviewed by Barassi complained that social media did not allow them the space to elaborate their ideas or have real discussions. I think that what social media was lacking for them, and what they eventually found in physical meetings and slower media like magazines, was what Hannah Arendt called "the space of appearance." For Arendt, the space of appearance was the seed of democracy, and it was defined by any collection of people who speak and act meaningfully together. Although it is fragile, the space of appearance can arise anytime these conditions are met, and they have to do with proximity and scale. "The only indispensable factor in the generation of power is the living together of people," Arendt writes. "Only where men live so close together that the potentialities for action are always present can power remain with them."[20]

Basically, the space of appearance is an encounter small and concentrated enough that the plurality of its actors is un-collapsed.

The dynamism of this plural encounter is what underwrites the possibility of power; we know this intuitively from the form of the dialogue, where the interplay of two arguments leads to something new. Audre Lorde's reminder to white feminists that difference generates power comes to mind when I read Arendt's description of power:

> [Power]'s only limitation is the existence of other people, but this limitation is not accidental, because human power corresponds to the condition of plurality to begin with. For the same reason, power can be divided without decreasing it, and the interplay of powers with their checks and balances is even liable to generate more power, so long, at least, as the interplay is alive and has not resulted in a stalemate.[21]

The space of appearance is like a communal "I-Thou" relationship that has resisted the temptation to collapse into an "I-It" one, where no part of the group appears abstract to the other or where, as in Plato's ideal city, "some are entitled to command and others forced to obey." It is a space where I am empowered to see and be seen, hear and be heard, by those whose investment in the space is equal to mine. Unlike the abstract public of Twitter, the space of appearance is my "ideal audience" in that it is a place where I'm addressed, understood, and challenged—thus providing a known context for what I say and what I hear in this space. In this form of encounter, neither I nor anyone else has to waste time or energy on wrangling context, or packaging our messages for the lowest common denominator of public opinion. We gather, we say what we mean, and then we act.

IN RESEARCHING SUCCESSFUL examples of resistance for this book, I came across many iterations of the space of appearance. I'm struck by one thing that hasn't changed: while certainly supported

by other forms of communication, the space of appearance is still
so often a space of physical appearance. The history of collective
action—from artistic movements to political activism—is still one
of in-person meetings in houses, in squats, in churches, in bars, in
cafés, in parks. In these federated spaces of appearance, disagree-
ments and debates were not triggers that shut the whole discussion
down, but rather an integral part of group deliberation, and they
played out in a field of mutual responsibility and respect. In turn,
those groups kept in touch with other groups, who kept in touch
with still other groups, sometimes spanning the country—as in the
case of groups like the Student Nonviolent Coordinating Commit-
tee or the successive layers of organized labor. The coordination of
these groups offers witness to Arendt's observation that dividing
power does not decrease it, and that its plural interplay increases
it. They achieve the best of both worlds: that of coordinated action,
but also of the new ideas (Martin Luther King, Jr.'s, "creative pro-
test") that can only arise out of plurality in the space of appearance.

Even the survivors of the Marjory Stoneman Douglas High
School shooting, who grew up more "connected" than I did, rec-
ognized the importance of in-person meeting when they began
campaigning for gun control in 2018. In *#NeverAgain*, David Hogg
writes that "[a]nger will get you started but it won't keep you go-
ing." Although he was outspoken in the days after the tragedy, he
predicts that by himself, he would have burned out after a few days
or weeks. "The real beginning," Hogg says, "came two days later
at Cameron Kasky's house." Kasky, another student, had begun
holding meetings at his house, and Hogg was invited by Emma
González, a mutual friend. Writing that the students were "ob-
sessive from day one" and often slept over at Kasky's house, Hogg
describes a scene that evokes the emergent tactics of political activ-
isms past: "[I]f [we] thought of something that seemed like it could
work, [we] just did it. Some people did a lot of interviews; some peo-
ple were really good at Twitter; other people focused on organizing
and coordinating."[22] Like the meetings that the Montgomery bus

boycott organizers held behind various closed doors, it was here that the students worked together to outline their demands and make decisions about how to speak to the public at large. While they pulled strings on Twitter and in the media, it was the house— and the group dynamic that it brought into being—that provided the space of appearance.

I WOULD BE surprised if anyone who bought this book actually wants to do nothing. Only the most nihilist and coldhearted of us feels that there is nothing to be done. The overwhelming anxiety that I feel in the face of the attention economy doesn't just have to do with its mechanics and effects, but also with a recognition of, and anguish over, the very real social and environmental injustice that provides the material for that same economy. But I feel my sense of responsibility frustrated. It's a cruel irony that the platforms on which we encounter and speak about these issues are simultaneously profiting from a collapse of context that keeps us from being able to think straight.

This is where I think the idea of "doing nothing" can be of the most help. For me, doing nothing means disengaging from one framework (the attention economy) not only to give myself time to think, but to do something else in another framework.

When i try to imagine a sane social network it is a space of appearance: a hybrid of mediated and in-person encounters, of hours-long walks with a friend, of phone conversations, of closed group chats, of town halls. It would allow true conviviality—the dinners and gatherings and celebrations that give us the emotional sustenance we need, and where we show up for each other in person and say, "I am here fighting for this with you." It would make use of non-corporate, decentralized networking technology, both to include those for whom in-person interaction is difficult and to create nodes of support in different cities when staying in one place is increasingly an economic privilege.

This social network would have no reason to keep us from "logging off." It would respect our need for solitude as much as the fact that we are humans with bodies that exist in physical space and must still encounter each other there. It would rebuild the context we have lost. Most of all, this social network would rehabilitate the role of time and location in our everyday consciousness. It would offer the places where we are right now as the incubation spaces for the empathy, responsibility, and political innovation that can be useful not just here, but everywhere.

DEVELOPING A SENSE of place both enables attention and requires it. That is, if we want to relearn how to care about each other, we will also have to relearn how to care about place. This kind of care stems from the responsible attention that Kimmerer shows us in *Braiding Sweetgrass*, which beyond affecting us by determining what we see, materially affects the very subjects of our gaze.

In collecting my thoughts for this book, I spent countless hours in Bay Area parks—not only in the Rose Garden, but Purisima Creek Redwoods Preserve, Joaquin Miller Park, Sam McDonald County Park, the Pearson-Arastradero Preserve, Henry W. Coe State Park, Henry Cowell Redwoods State Park, Jackson Demonstration State Forest, and the Forest of Nisene Marks State Park. I am speaking literally when I say that without those places, this book would not exist. I went to them not just to escape the landscape of productivity, but to collect different ideas and observations that could never have been mine otherwise. If you have enjoyed reading this, then in some senses you have enjoyed those places, too.

I grew up thinking that parks were somehow just "leftover" spaces, but I've learned that the story of any park or preserve is absolutely one of "redemption preserv[ing] itself in a small crack in the continuum of catastrophe." So many parks had to be actively defended from a never-ending onslaught of private ownership and development, and many contain the names of enterprising indi-

viduals who fought to establish them. For example, when I lived in San Francisco, my usual trail in Glen Canyon Park was named after the "Gum Tree Girls," three women who kept freeways from being built through the canyon, the one of the only places in San Francisco where Islais Creek runs aboveground in its natural state. Parks don't just give us the space to "do nothing" and inhabit different scales of attention. Their very existence, especially in the midst of a city or on the former sites of extraction, embodies resistance.

Obviously, parks are only one type of public space that we must prioritize and protect. But they provide a useful example of the link between space, resistance, and the attention economy. If, as I've argued, certain types of thought require certain types of spaces, then any attempt at "context collection" will have to deal not only with context collapse online, but with preserving public and open space, as well as the meeting places important to threatened cultures and communities. In a time increasingly referred to as the Anthropocene (a geologic era in which the environment is irreversibly shaped by human activity), I find Donna J. Haraway's term for this era even more useful. She calls it the Chthulucene, in which "the earth is full of refugees, human and not, without refuge." In *Staying with the Trouble: Making Kin in the Chthulucene*, Haraway writes, "One way to live and die well as mortal critters in the Chthulucene is to join forces to reconstitute refuges, to make possible partial and robust biological-cultural-political-technological recuperation and re-composition, which must include mourning irreversible losses."[23] With this in mind, when the logic of capitalist productivity threatens both endangered life and endangered ideas, I see little difference between habitat restoration in the traditional sense and restoring habitats for human thought.

IF YOU HAVEN'T noticed yet, it is a habit of mine to disappear for a few days to a cabin in some nearby mountains to spend some time (not) "alone with nature." Most recently, I stayed in a very small

cabin in Corralitos, a small town just south of Santa Cruz, with the intent of going bird-watching at the Elkhorn Slough National Estuarine Research Reserve. At this particular spot on the coast, ocean water comes into a snaking inlet for part of the day and then recedes, leaving mudflats behind. In English, "slough" means "a situation characterized by lack of progress or activity." I always found this funny, since places like Elkhorn Slough are some of the most diverse and biologically productive habitats on Earth.

On the third day of my trip, not having spoken to anyone the entire time, I got into my car to head to the reserve. I turned on the radio. On KZSC Santa Cruz, a stoned-sounding reggae DJ was reading the headline of a *Washington Post* article: "'Seemingly overnight, the oceans are exploding with cyclone activity.' So we're thinking about Hawaii," she said. "We're thinking about Hong Kong, we're thinking about Australia, we're thinking about the Carolinas." She paused, reggae music still playing in the background. "Here in Santa Cruz, we're lucky. I'm looking out the window and . . . everything is fine." She was right. It was sunny and in the seventies, a light breeze wafted through the Monterey pines, and the ocean was calm.

I had never been to Elkhorn Slough before and the route was new to me. I turned off Highway 1 South onto a road that tunneled through oak trees and rolling hills, enjoying the scenery but feeling haunted by a dull dread from the morning's news. All of a sudden, as I rounded a turn, part of the slough came into view. In that brilliant, surprising blue, I saw them: hundreds, maybe thousands of birds, congregating in the shallows and rising into the sky in giant glittering flocks that turned from black to silver as they changed direction.

Unexpectedly, I started crying. Although this site would certainly be classified as "natural," it appeared to me like nothing short of a miracle, one I felt I or this world somehow didn't deserve. In its unlikely splendor, the slough seemed to represent all of the threatened spaces, all that stood to be lost, that was already being lost.

But I also realized for the first time that my wish to preserve this place was also a self-preservation instinct, insofar as I needed spaces like this too, and insofar as I couldn't feel truly at home in a solely human community. I withered without this contact; a life without other life didn't seem worth living. To acknowledge that this space and everything in it was endangered meant acknowledging that I, too, was endangered. The wildlife refuge was my refuge.

It's a bit like falling in love—that terrifying realization that your fate is linked to someone else's, that you are no longer your own. But isn't that closer to the truth anyway? Our fates are linked, to each other, to the places where we are, and everyone and everything that lives in them. How much more real my responsibility feels when I think about it this way! This is more than just an abstract understanding that our survival is threatened by global warming, or even a cerebral appreciation for other living beings and systems. Instead this is an urgent, personal recognition that my emotional and physical survival are bound up with these "strangers," not just now, but for life.

It's scary, but I wouldn't have it any other way. That same relationship to the richness of place lets me partake of it too, allowing me to shape-shift like the flocks of birds, to flow inland and out to sea, to rise and fall, to breathe. It's a vital reminder that as a human, I am heir to this complexity—that I was born, not engineered. That's why, when I worry about the estuary's diversity, I am also worrying about my own diversity—about having the best, most alive parts of myself paved over by a ruthless logic of use. When I worry about the birds, I am also worrying about watching all my possible selves go extinct. And when I worry that no one will see the value of these murky waters, it is also a worry that I will be stripped of my own unusable parts, my own mysteries, and my own depths.

I FIND THAT I'm looking at my phone less these days. It's not because I went to an expensive digital detox retreat, or because I deleted

any apps from my phone, or anything like that. I stopped looking at my phone because I was looking at something else, something so absorbing that I couldn't turn away. That's the other thing that happens when you fall in love. Friends complain that you're not present or that you have your head in the clouds; companies dealing in the attention economy might say the same thing about me, with my head lost in the trees, the birds, even the weeds growing in the sidewalk.

If I had to give you an image of how I feel about the attention economy now, as opposed to in 2017, I'd ask you to imagine a tech conference. Like so many conferences, it would be in another city, perhaps another state. The subject of this conference would be persuasive design, with talks by the likes of the Time Well Spent people, about how horrible the attention economy is and how we can design our way around it and optimize our lives for something better. Initially I'd find these talks very interesting, and I would learn a lot about how I'm being manipulated by Facebook and Twitter. I would be shocked and angry. I would spend all day thinking about it.

But then, maybe on the second or third day, you would see me get up and go outside to get some fresh air. Then I'd wander a little bit farther, to the nearest park. Then—and I know this because it happens to me often—I'd hear a bird and go looking for it. If I found it, I would want to know what it was, and in order to look that up later I'd need to know not only what it looks like, but what it was doing, how it sounded, what it looked like when it flew . . . I'd have to look at the tree it was in.

I'd look at all the trees, at all the plants, trying to notice patterns. I would look at who was in the park and who wasn't. I would want to be able to explain these patterns. I would wonder who first lived in what is now this city, and who lived here afterward before they got pushed out too. I would ask what this park almost got turned into and who stopped that from happening, who I have to thank. I would try to get a sense of the shape of the land—where am I in

relation to the hills and the bodies of water? Really, these are all forms of the same question. They are ways of asking: Where and when am I, and how do I know that?

Before long, the conference would be over, and I would have missed most of it. A lot of things would have happened there that are important and useful. For my part, I wouldn't have much to show for my "time well spent"—no pithy lines to tweet, no new connections, no new followers. I might only tell one or two other people about my observations and the things I learned. Otherwise, I'd simply store them away, like seeds that might grow some other day if I'm lucky.

Seen from the point of view of forward-pressing, productive time, this behavior would appear delinquent. I'd look like a dropout. But from the point of view of the place, I'd look like someone who was finally paying it attention. And from the point of view of myself, the person actually experiencing my life, and to whom I will ultimately answer when I die—I would know that I spent that day on Earth. In moments like this, even the question itself of the attention economy fades away. If you asked me to answer it, I might say—without lifting my eyes from the things growing and creeping along the ground—"I would prefer not to."

Conclusion

Manifest Dismantling

I have thrown away my lantern, and I can see the dark.
—WENDELL BERRY, *A NATIVE HILL*[1]

I f you become interested in the health of the place where you are, whether that's cultural or biological or both, I have a warning: you will see more destruction than progress. In "The Round River: A Parable," the conservationist Aldo Leopold writes:

> One of the penalties of an ecological education is that one lives alone in a world of wounds. Much of the damage inflicted on land is quite invisible to laymen. An ecologist must either harden his shell and make believe that the consequences of science are none of his business, or he must be the doctor who sees the marks of death in a community that believes itself well and does not want to be told otherwise.[2]

Last week I went on a walking tour of downtown Oakland led by my friend Liam O'Donoghue, an activist and historian who runs the popular podcast *East Bay Yesterday*. The tour had been a thank-you for those who had contributed to the production of his "Long Lost Oakland" map, which includes indigenous Ohlone burial sites, extinct species, now-gone historic buildings, and an ill-advised giant gas balloon that (sort of) took off from downtown in 1909. Introducing the tour next to the Jack London Tree, Liam reflected on what it meant for newcomers to be learning Oakland

history even as so many of the people and institutions who made Oakland what it was in the first place were being pushed out. In a time when monoculture threatens not only biological ecosystems, but neighborhoods, culture, and discourse, the historian, too, is in a position to see "the marks of death in a community."

On the corner of Broadway and Thirteenth, Liam took a moment to read a statement by T. L. Simons, who created the art for the "Long Lost Oakland" map. Simons described the distinct mix of love and heartbreak he experienced while spending hundreds of hours illustrating the map by hand. The process required him to meditate on a series of obliterations: of the burial sites of the Ohlone people, of the mass transit Key System that was later replaced by highways, and of the shoreline of marshes and tidal estuaries now reshaped for the demands of the global economy. "In short," he writes, "the story of this city's transformations has always been the story of human and ecological devastation." And yet his dedication came from something more than despair:

> I have chosen to illustrate this map not as a horrific depiction of the catastrophes that define our common history, but as a reflection of the resilience and magic I see in the city around me. It is a reminder that no matter how bad things get, they are always changing. I want Long Lost Oakland to ground the viewer in the place where they stand and to spark the imagination of those who will struggle for a different kind of future.[3]

Simon's attitude—one of sadness, fascination, and above all a wish to attend to the past in the name of the future—reminds me of another backward-gazing figure. In the midst of World War II, the German Jewish philosopher Walter Benjamin wrote his famous interpretation of Paul Klee's monoprint *Angelus Novus*, in which a somewhat abstract angel appears in the middle of a picture plane surrounded by dark smudges. In an essay called "On the Concept of History," Benjamin wrote:

The Angel of History must look just so. His face is turned towards the past. Where we see the appearance of a chain of events, he sees one single catastrophe, which unceasingly piles rubble on top of rubble and hurls it before his feet. He would like to pause for a moment so fair, to awaken the dead and to piece together what has been smashed. But a storm is blowing from Paradise, it has caught itself up in his wings and is so strong that the Angel can no longer close them. The storm drives him irresistibly into the future, to which his back is turned, while the rubble-heap before him grows sky-high. That which we call progress is this storm.[4]

The image of an angel that wishes to forestall progress is all the more remarkable given how often progress itself is what gets deified. One example of this is from an 1872 painting called *American Progress* by John Gast, meant to illustrate the concept of Manifest Destiny. The painting shows an enormous blond woman in diaphanous white robes striding westward into an unruly, dark landscape, trailed by all the hallmarks of Western civilization. Cultural domination is inextricable from technological progress in this image. Reading left to right, we see fleeing Native Americans, bison, a growling bear, dark clouds, and formidable mountains; those are followed closely by a covered wagon, farmers with domesticated animals, the pony express, the overland stage, railroad lines, ships, and bridges. The progress-deity herself holds a tome simply titled *School Book* and is in the middle of stringing up telegraph lines, bringing connection to the West.

In a short analysis of the painting, the historian Martha A. Sandweiss writes that when she shows the image to her students, they imagine it to be some large and grandiose oil painting. In fact, she writes, it's merely twelve and three-quarters by sixteen and three quarters inches. That's because it was commissioned and produced as a foldout by George A. Crofutt, the publisher of a series of Western travel guides.[5] In that sense, we can consider it an ad: buyers of

the Crofutt guides stood not just to see new places but to see the unfolding of a kind of divine progress (certainly something not to be missed!).

In the preface to one of his guidebooks from a year after the painting was commissioned, I found Crofutt's breathless description of "a country that only a few years ago was almost wholly unexplored and unknown to the white race":

> But since the completion of the Pacific Railroad, it has been occupied by over half a million of the most adventurous, active, honest and progressive white people that the world can produce—people that are building cities, towns and villages as though by magic; prospecting, discovering and developing the great treasure chambers of the continent; extending our grand system of railroads all over the country, like a vast net-work; or engaged in the cultivation of the inexhaustible soil, which is literally causing the wilderness to "blossom like the rose."[6]

Of course, we now know that the soil was exhaustible after all, and that "developing" actually meant quickly depleting—as in, every old-growth tree in Oakland except for Old Survivor. The phrase "as if by magic" is a chilling erasure of the waves of straight-up genocide that ravaged indigenous populations in the nineteenth century. Thinking about the Ohlone shell mounds and about how all of the extinct species on my "Long Lost Oakland" map disappeared in the nineteenth century, I can't help but read the white-robed woman in the painting as the harbinger of the cultural and ecological destruction. While the tiny beings below her run for their lives, she wears a strange and benevolent expression aimed not at them but at something else in the distance—the imagined target of progress. It's only with her gaze fixed on this target that she can trample on hundreds of species and thousands of years' worth of knowledge without ever breaking her pallid smile.

What's the opposite of Manifest Destiny? I think it would be

something like the Angel of History. It's a concept I call manifest dismantling. I imagine another painting, one where Manifest Destiny is trailed not by trains and ships but by manifest dismantling, a dark-robed woman who is busy undoing all of the damage wrought by Manifest Destiny, cleaning up her mess.

Manifest dismantling was hard at work in 2015, during the largest dam removal in California history. Just a few hours south of here on the Carmel River, the concrete San Clemente Dam had been built in 1921 by a real estate company in the Monterey Peninsula in order to provide water to a growing number of Monterey residents. But by the 1940s, it had filled up with so much sediment that another larger dam was built upstream. In the 1990s, the San Clemente Dam was declared not only useless but seismically unsafe due to its proximity to a fault line. An earthquake might have sent not only water but 2.5 million cubic yards of accumulated sediment into the towns downstream.

The dam was a problem for more than just humans. Steelhead trout, which live in the ocean but must travel upstream each year to spawn, found the dam's fish ladder impassable; even if they made it, returning to the ocean meant facing the lethal hundred-foot drop on the way back. One local fisherman compared the dam to "shutt[ing] the door on their bedroom."[7] And the effects extended downstream: the dam withheld the debris essential for creating the small pools and hidden areas that trout need to survive—either to rest while swimming upstream, or to live for the first few years before heading to the ocean for the first time. In other words, the river's loss of complexity spelled death for the steelhead. What had once been trout runs in the thousands had dwindled to 249 in 2013.[8]

The cheapest option was basically a Band-Aid solution: a $49 million plan to add more concrete to the dam to stabilize it in the event of an earthquake. Instead California American Water, which owned the dam, partnered with various state and federal agencies to carry out an $84 million plan that not only removed the dam but included habitat restoration for the trout and the California

red-legged frog, another threatened species. So much silt had accumulated behind the dam that before the agencies could remove it, they had to reroute the river around the old dam site, which would be used for sediment storage. Thus, the project involved not only tearing down a structure but building a riverbed from scratch. Drone footage of the new riverbed is surreal. The project engineers designed a series of cascading pools specifically to be trout-friendly, but without anything yet growing around the artificial banks, it looked like something from *Minecraft*.

Meanwhile, those hoping for a dramatic demolition of the dam were met with disappointment. Once the river had been successfully rerouted, six excavators and two sixteen-thousand-pound pneumatic hammers arrived and proceeded to slowly and arduously pick away at the concrete structure, turning it into dust bit by bit. In his piece on the dam removal for the *San Francisco Chronicle*, Steven Rubenstein quotes the president of the demolition company: "It's fun to knock things down . . . I spend a lot of time looking at buildings, trying to figure out the best way to get rid of them." He adds that "if you didn't wreck something, you couldn't build something else in its place." But Rubenstein notes that in this case, of course, "the idea is to replace the dam with nothing."[9]

All of this gives the project a strange forward-and-backward feeling. In time-lapse videos of the project in progress, we see people working with the industriousness of ants, set to the majestic music that you'd expect to accompany any great public works project—only this time, the structure is disappearing instead of appearing. Another part of the video features archival footage of the dam being built (just as industriously) in 1921. Over these images—originally meant to depict construction and mastery—a voice narrates the dam's destruction: "Building dams was once a triumph of humankind's ability to control nature. As our society evolves we are learning to seek balance rather than control in our relationship with our environment."[10]

Our idea of progress is so bound up with the idea of putting some-

thing new in the world that it can feel counterintuitive to equate progress with destruction, removal, and remediation. But this seeming contradiction actually points to a deeper contradiction: of destruction (e.g., of ecosystems) framed as construction (e.g., of dams). Nineteenth-century views of progress, production, and innovation relied on an image of the land as a blank slate where its current inhabitants and systems were like so many weeds in what was destined to become an American lawn. But if we sincerely recognize all that was already here, both culturally and ecologically, we start to understand that anything framed as construction was actually also destruction.

I am interested in manifest dismantling as a form of purposiveness bound up with remediation, something that requires us to give up the idea that progress can only face forward blindly. It provides a new direction for our work ethic. Remediation certainly takes the same amount of work: in this case, a dam that had taken three years to build took close to the same amount of time to remove. The word "innovation" came up a lot in coverage of the San Clemente Dam removal, since it not only required significant design and engineering, but also unprecedented cooperation and consultation among engineers, scientists, lawyers, local agencies, state agencies, nonprofits, and members of the Ohlone Esselen tribe. Seen through the lens of manifest dismantling, tearing down the dam is indeed a creative act, one that does put something new in the world, even if it's putting it back.

OF COURSE, MANIFEST dismantling not only messes with what we consider forward and backward—it also requires a kind of Copernican shift of humans away from the center of things. As Leopold put it, we must go "from conqueror of the land-community to plain member and citizen of it."[11]

In 2002, writer and environmental activist Wendell Berry wrote the introduction to an edition of the 1978 book *The One-Straw Rev-*

olution. Its author, a Japanese farmer named Masanobu Fukuoka, experienced this Copernican shift when he invented what he called "do-nothing farming." Inspired by the productivity of an abandoned lot that he saw filled with grasses and weeds, Fukuoka figured out a method of farming that made use of existing relationships in the land. Instead of flooding fields and sowing rice in the spring, he scattered the seeds directly on the ground in the fall, as they would have fallen naturally. In place of conventional fertilizer, he grew a cover of green clover, and threw the leftover stalks back on top when he was done.

Fukuoka's method required less labor, no machines, and no chemicals, but it took him decades to perfect and required extremely close attention. If everything was done at precisely the right time, the reward was unmistakable: not only was Fukuoka's farm more productive and sustainable than neighboring farms, his method was able to remediate poor soils after a few seasons, creating farmable land on rocky outcrops and other inhospitable areas.

In his book, Fukuoka writes that "[b]ecause the world is moving with such furious energy in the opposite direction, it may appear that I have fallen behind the times." Indeed, just as we associate innovation with the production of something new, we also associate an inventor with creating some new kind of design. But Fukuoka's "design" was more or less to remove the design altogether. This leads to the uncanny quality of manifest dismantling. As he writes: "That which was viewed as primitive and backward is now unexpectedly seen to be far ahead of modern science. This may seem strange at first, but I do not find it strange at all."[12]

In a chapter titled "Nothing at All," Fukuoka tells of how he arrived at the epiphany that would lead him to do-nothing farming. In his twenties, he had worked for the Yokohama Customs Headquarters in the Plant Inspection Division while studying plant pathology under a brilliant researcher. His life was basically a mix of equally intense studying and partying, and at some point, he started having fainting spells and was hospitalized for acute pneumonia. In this

hospital room, he wrote, "I found myself face to face with the fear of death," and when he was discharged, he continued to be haunted by "an agony of doubt about the nature of life and death."

When I read Fukuoka's account of what happened afterward, I was surprised to find that, like me, he had an epiphanic encounter with a night heron:

> One night as I wandered, I collapsed in exhaustion on a hill overlooking the harbor, finally dozing against the trunk of a large tree. I lay there, neither asleep nor awake, until dawn. I can still remember that it was the morning of the 15th of May. In a daze I watched the harbor grow light, seeing the sunrise and yet somehow not seeing it. As the breeze blew up from below the bluff, the morning mist suddenly disappeared. Just at that moment a night heron appeared, gave a sharp cry, and flew away into the distance. I could hear the flapping of its wings. In an instant all my doubts and the gloomy mist of my confusion vanished. Everything I had held in firm conviction, everything upon which I had ordinarily relied was swept away with the wind. I felt that I understood just one thing. Without my thinking about them, words came from my mouth: "In this world there is nothing at all . . ." I felt that I understood nothing.[13]

Fukuoka sums up the epiphany as the ultimate expression of humility, echoing Zhuang Zhou when he writes: "'Humanity knows nothing at all. There is no intrinsic value in anything, and every action is a futile, meaningless effort.'"

It was only through this humility that Fukuoka was able to arrive at a new kind of ingenuity. Do-nothing farming recognized that there was a natural intelligence at work in the land, and therefore the most intelligent thing for the farmer to do was to interfere as little as possible. Of course, that didn't mean not interfering at all. Fukuoka recalls the time he tried to let some orchard trees grow

without pruning: the trees' branches became intertwined and the orchard was attacked by insects. "This is abandonment, not 'natural farming,'" he writes. Somewhere between over-engineering and abandonment, Fukuoka found the sweet spot by patiently lis-tening and observing. His expertise lay in being a quiet and patient collaborator with the ecosystem he tended to.

Fukuoka's stance is an example of something that Jedediah Purdy suggests in his book *After Nature: A Politics for the Anthropocene*. In each subsequent chapter, Purdy shows how the different views of nature throughout history have each corresponded to a set of political beliefs about value and subjecthood, being used to justify everything from hierarchical social orders and racism ("everything in its place") to an obsession with the productivity of industry. In each case, people and their governments conceived of nature as entirely separate from the human world, whether it was the idea of "natural capital" or the pristine "backpacker's nature."

Dissolving the nature/culture distinction, Purdy suggests that in the Anthropocene, we should figure nature not as separate, but as a partner in collaboration. Like Fukuoka after his epiphany, humans might humbly take up their place as just one partner in "the necessary work of carrying on living":

> In this tradition and in modern ecology, there is potential to realize that work is not only industry, the productive action that transforms the world, but also reproduction, the work of remaking life with each year and generation. Seeing nature's work in this light would align environmental politics with the key feminist insight that much socially necessary work is ignored or devalued as "caregiving," a gendered afterthought to the real dynamos of the economy, when in reality no shared life could do without it.[14]

Purdy's recommendation echoes Mierle Ukeles when she insists in her "Manifesto for Maintenance Art:" "my work *is* the work." If

we take this to heart, it suggests that we dismantle not only structures of exploitation and destruction, but the very language with which we conceive of progress. It asks us to stop, turn around, and then get to work.

IF YOU LOOK for instances of manifest dismantling, I promise you will find them.

Peter Berg, the founder of modern bioregionalism, did a little bit of manifest dismantling in front of his San Francisco house in the 1980s. Like Fukuoka, he was inspired by weeds—in this case, the ones growing in the cracks of the sidewalk pavement. Berg got the city's permission to rip up the concrete and plant native species. Giving a tour to visitors, he said he was "secretly pleased to believe that seeds from these plants blow out and into other sidewalk cracks and are propagating more of these natives all over the place, instead of the European invaders."[5]

Here are a few more recent examples. Friends of Sausal Creek (FOSC), a group of Oakland neighbors formed in 1996 to restore Sausal Creek, daylighted a section of the creek from beneath a concrete culvert and replanted native species. A UC Berkeley class collaborated with Urban Releaf to grow seventy-two coast live oak trees to donate to neighborhoods in West and East Oakland. Ospreys arrived and began building nests on a former naval site in Richmond. Chris Carlsson, local historian extraordinaire and author of the book *Nowtopia: How Pirate Programmers, Outlaw Bicyclists, and Vacant-Lot Gardeners are Inventing the Future Today!*, continued to give bike tours of the ecological and labor histories of San Francisco. Sudo Mesh, the group responsible for the Oakland mesh network, upcycled donated laptops to youth and activists who couldn't afford them. Stanford removed the name of the Catholic priest Junípero Serra from its entrance campus buildings, citing his role in the enslavement and genocide of indigenous tribes in nineteenth-century California.

One of the best examples of manifest dismantling that I can give you comes from a local Ohlone group called Save West Berkeley Shellmound and Village Site. In 2017 I went to an event held by a group called mak-'amham, in which Ohlone tribal members share traditional food with the public. We had yerba buena tea and chanterelle mushrooms on acorn flatbread—the first thing I had ever eaten from an oak tree. Between courses, Vincent Medina, a Muwekma Ohlone tribal councilman, spoke of a current proposal to build condos at an Ohlone shellmound site in West Berkeley. Shellmounds are sacred burial sites in the Bay Area that at one point were marked by massive structures made of shellfish remains. Although the structures were demolished, the sites still contain human burials below ground level. The contested Berkeley site contains burials thousands of years old that may represent the first-ever habitation in the area; it is currently a parking lot for a fish restaurant. (In fact, I was embarrassed to learn that Shellmound Street, just south of there and which one only takes to get to IKEA, was so named for yet another ancient Ohlone shellmound site that was built over in the twentieth century. Workers on that project disturbed dozens of burials, some of which contained adults in groups, with babies, or with limbs intertwined.[16]) Building the West Berkeley condos would require excavation of the land for the foundations of ground-level parking and businesses.

The political quality of "doing nothing"—of not building at the West Berkeley site—is obvious here. But besides refusing development, what the Ohlone members have proposed is more than nothing. In 2017, Ohlone matriarchs Ruth Orta and Corrina Gould worked with a Berkeley landscape architect to create a different vision for the site: a forty-foot-high mound, echoing the shape of the original shellmound, covered in California poppies. The plan would also restore other native vegetation, create a dance arbor for Ohlone ceremonial use, and daylight a section of Strawberry Creek, which runs underground through the site. While this living monument would be of obvious importance to indigenous folks,

I consider it also an incredibly generous gesture to other East Bay residents, who stand to inhabit this place more consciously. Gould herself described the potential site as an opportunity for all of us simply to remember "our compassion, conscience and civility, to learn to be human again, together."[17]

IT'S TEMPTING TO conclude this book with a single recommendation about how to live. But I refuse to do that. That's because the pitfalls of the attention economy can't just be avoided by logging off and refusing the influence of persuasive design techniques; they also emerge at the intersection of issues of public space, environmental politics, class, and race.

Consider two things in tandem. First, people in wealthier neighborhoods almost always have more access to urban parks and to parkland, on top of the fact that such neighborhoods are often in the hills or by the water. When I spoke with Mark Rauzon, one of the original founders of FOSC, he noted that the surrounding neighborhood is well-to-do, which meant that at the get-go, FOSC had lawyers, architects, and landscape designers at its disposal— all of them landed, property-owning professionals. This is a very different situation than in West or East Oakland, where people might be working paycheck to paycheck, with no margin to spare on stewarding or even paying attention to the local watershed. In turn, people in these neighborhoods have far fewer physical spaces for rest, recreation, and conviviality—and those that do exist may be poorly looked after.

Second, consider that while seemingly every kid in a restaurant is now watching bizarre, algorithmically determined children's content on YouTube,[18] Bill Gates and Steve Jobs both severely limited their children's use of technology at home. As Paul Lewis reported for *The Guardian*, Justin Rosenstein, the Facebook engineer who created the "like" button, had a parental-control feature set up on his phone by an assistant, to keep him from downloading apps.

Loren Brichter, the engineer who invented the "pull-to-refresh" feature of Twitter feeds, regards his invention with penitence: "Pull-to-refresh is addictive. Twitter is addictive. These are not good things. When I was working on them, it was not something I was mature enough to think about."[19] In the meantime, he has "put his design work on the back burner while he focuses on building a house in New Jersey." Without personal assistants to commandeer our phones, the rest of us keep on pulling to refresh, while over-worked single parents juggling work and sanity find it necessary to stick iPads in front of their kids' faces.

In their own ways, both of these things suggest to me the frightening potential of something like gated communities of attention: privileged spaces where some (but not others) can enjoy the fruits of contemplation and the diversification of attention. One of the main points I've tried to make in this book—about how thought and dialogue rely on physical time and space—means that the politics of technology are stubbornly entangled with the politics of public space and of the environment. This knot will only come loose if we start thinking not only about the effects of the attention economy, but also about the ways in which these effects play out across other fields of inequality.

By the same token, there are many different places where manifest dismantling can begin to work. Wherever we are, and whatever privileges we may or may not enjoy, there is probably some thread we can afford to be pulling on. Sometimes boycotting the attention economy by withholding attention is the only action we can afford to take. Other times, we can actively look for ways to impact things like the addictive design of technology, but also environmental politics, labor rights, women's rights, indigenous rights, anti-racism initiatives, measures for parks and open spaces, and habitat restoration—understanding that pain comes not from one part of the body but from systemic imbalance. As in any ecology, the fruits of our efforts within any of these fields may well reach beyond to the others.

An individual body can be healed, and it can become healthy. But it can't necessarily be optimized; it's not a machine, after all. I think the same holds true for the social body. Recalling Frazier's exclamation in Walden Two that humanity is only 1 percent as productive as it could be (productive of what?), we might ask what goal manifest dismantling has to offer in place of the North Star of productivity. Beyond the vague cyclicality of what Purdy calls "going on living," can there be teleology without a telos?

For an answer, I'll return to *Feminism and Ecological Communities*, where earlier Chris Cuomo questioned movements that posit humans as "paradigmatic ethical objects." Alongside an argument for ecological models of identity, community, and ethics, she suggests a potential abandonment of teleology. But to me, it sounds less like Masanobu Fukuoka's "abandoned" orchard defeated by insects, and more like his unruly and functioning farm:

> Moral agents can decide to how to negotiate the world without hopes of reaching a predetermined, necessary state of harmony or static equilibrium, or any ultimate state. Indeed, the abandonment of such a teleology also entails abandoning hopes that our decisions and actions will result in perfect harmony or order, and such non-teleological ethics can't be motivated by a desire to actualize a pre-established end or enact given roles. We can, however, value the somewhat ordered/somewhat chaotic universe in which we inevitably dwell, and we can also decide that it is good and worthwhile to prevent significant destruction to other valuable members of the universe through the agency and choice that also seem inevitable.[20]

This is something like a goal without telos, a view toward the future that doesn't resolve in a point but rather circles back toward

itself in a constant renegotiation. The idea of an aimless aim, or a project with no goal, might sound familiar. Indeed, it sounds a bit like our old friend, the useless tree—who "achieves" nothing but witness, shelter, and unlikely endurance.

WHEN BENJAMIN LOOKED at history, he saw something other than a horizontal march toward ever greater territories. Directly opposed to the notion of technological progress, what he saw was a series of unredeemed moments of contingency, in which people struggled over and over against the ruling class. In an address to the Free Student League of Berlin in 1914, Benjamin said that "the elements of the end condition are not present as formless tendencies of progress, but instead are embedded in every present as endangered, condemned and ridiculed creations and ideas."[21] In every moment of history, something was trying to happen, like two ends of something striving to meet each other.

In this context, it was the historian's task to turn his back on the imagined course of progress and dig up each record of this impulse from the debris, to make the past live in the present, to literally do it justice. Manifest dismantling is similar. It asks us to remember—in the sense of re-membering, the opposite of dismembering. Recall that the Angel of History, beyond disinterested preservation, seeks "to awaken the dead and to piece together what has been smashed." To tear up the concrete or take down the freeway is to start to piece a community back together, though it may not (ever) look the same again.

Against the odds and the crush of techno-determinism, things keep growing that "small crack in the continuum of catastrophe." Nature and culture still abound with forms that, like Zhuang Zhou's useless tree, resist appropriation while sheltering the life beneath them. The newly planted alder trees are growing along Sausal Creek. Mak-'amham, the Ohlone food pop-up, opened a per-

manent café this year, and the line spilled out the door on opening day. The migrating birds return each year, for now anyway, and I have not yet been reduced to an algorithm.

The two ends are still trying to meet. Later, describing this movement, Benjamin would use an image that evokes the Rose Garden on another timeless day: "As flowers turn toward the sun, by dint of a secret heliotropism the past strives to turn toward the sun that is rising in the sky of history."[22]

I WROTE MOST of this book in my studio, among ceramicists, painters, and printmakers in a former industrial building near Oakland's shipping port. Today, on my way here, I took a detour through a serious gauntlet of big rigs thundering down Seventh Street to stop at Middle Harbor Shoreline Park, a surprising sliver of sand and marsh between the active cranes and the San Francisco Bay. During the nineteenth century, this site served as the western terminus of the Southern Pacific Railroad, and in World War II was a supply base for the Pacific Fleet of the US Navy. Eventually it ended up in the hands of the Port of Oakland, who turned it into one of the few parks in West Oakland.

Like most of the land edging the San Francisco Bay, this was once a wetland ecosystem, but building a port also meant dredging the shallows for ships. When the Port of Oakland took ownership of the land in 2002, it used sediment to re-create a lagoon and a beach in the hopes of supporting the local shorebird population. It also built an observation tower named after Chappell R. Hayes, an Oakland community activist and environmentalist who ran programs for at-risk youth, helped move a freeway farther away from West Oakland, rallied against the transport of spent nuclear fuel rods through the nearby port, and raised awareness of environmental racism in the boards and committees he served on.

At the dedication of the tower in 2004, former city councilwoman Nancy Nadel spoke about how Hayes, her late husband,

had helped local youth start a woodworking company that made fences for new houses in West Oakland. Noting that his nonprofit was named after "a doweling jig, a tool that helps you drill precisely perpendicularly into a piece of wood," she recalled that "[w]hen someone was stressed and uncentered, one of Chappell's favorite reminders was to stay perpendicular to the earth, don't pitch forward, don't fall back."[23]

If you remember, I started this book in the Oakland Hills. I want to end it here, at the westernmost edge of the city, where the landscape could not look or sound more different. The air today was full of the rumblings of trucks, of containers sliding across the cranes and clacking into place, of industrial vehicles beeping and backing up. A handful of people were walking or jogging on their lunch breaks. I got out my binoculars and headed toward the little re-formed beach.

In that modest stretch of mud between the hard edge of the port and an old ferry anchorage were a series of small, moving things. Upon a closer look through my binoculars, those things were avocets, sanderlings, willets, greater yellowlegs, snowy egrets, great egrets, adult and juvenile, western gulls, marbled godwits, least sandpipers, and curlews. Farther out on the rocks were black oystercatchers, cormorants, great blue herons, and even the endangered California least terns, a population actively supported by volunteers in Hayward. Some of these birds you might find at Elkhorn Slough—but this was an active shipping port, not (officially) a wildlife refuge. In other words, the beach wasn't so much a holdover from the past as a hopeful artifice, an invitation to the birds to return. And return they did.

Above all this activity soared the biggest birds of all: the brown pelicans. They, too, were once endangered, and in some senses still are. In the early twentieth century they were almost hunted out of existence, and they suffered again until the pesticide DDT was banned in the 1970s. Although brown pelicans were taken off the endangered list in 2009, their numbers have fluctuated as they con-

tinue to face habitat loss. But this year, I've been hearing people mention seeing pelicans they've never noticed before. Just before heading to the park, I'd gotten an email from the artist Gail Wight, who told me that after two years of few pelicans, around fifty had arrived near her home on the coast. Now the pelicans were flying plentifully past me, so close that I could see their faces, greeting me one at a time with their joyous six-foot-wide wingspans.

Behind them rose the skyline of San Francisco, with its new Salesforce tower and its high-rise condos. If I squinted, I could just make out the building where I used to work, where they might have been discussing "brand pillars" at this very moment. Back there, things moved so quickly that we had separate catalogs for Spring 1, Spring 2, and Spring 3. But the pelicans made all of that seem like a joke with no punch line. Based on a fossil dating from the Oligocene Epoch, the general design of the pelican appears not to have changed for 30 million years. In the winter, as they have for countless ages, the pelicans will be heading south to the Channel Islands and to Mexico to build the nests whose designs, too, have remained largely unchanged.

For now, these old survivors sheltered here—as did I—in a space formerly dedicated to the demands of war. I wasn't expecting to encounter it today, but this may be the best illustration of what manifest dismantling has to offer to those who are willing to receive it. When we pry open the cracks in the concrete, we stand to encounter life itself—nothing less and nothing more, as if there could be more.

Standing perpendicular to the earth, not pitching forward, not falling back, I asked how I could possibly express my gratitude for the unlikely spectacle of the pelicans. The answer was nothing. Just watch.

Acknowledgments

In describing the grounds of possibility from which this book grew, I will first say that I live and work on the land of the Muwekma Ohlone Tribe, and that their graciousness in sharing their culture with the public has been an inspiration to me. I'd also like to thank David Latimer and Esther Aeschbach for running 300 Jefferson Studios, a space that helps keep artists and writers like me in the Bay Area. As a writer but also just as a person, I'm indebted to the city employees and volunteers who maintain the Rose Garden, as well as the stewards of all the open spaces where I collected my thoughts. Joe Veix, my boyfriend and fellow writer, further supported this book with conversations, dinners, warmth, and unquestioning respect for my need to get away to the mountains sometimes.

The organizers of Eyeo Festival—Dave Schroeder, Jer Thorp, Wes Grubbs, and Caitlin Rae Hargarten—enabled this book early on by blindly trusting me with a talk called "How to Do Nothing," but they also deserve thanks for gathering a community whose perspective on technology is refreshingly critical and deeply human. Adam Greenfield first put the idea in my head that "How to Do Nothing" could be a book, and was instrumental in getting the ball rolling. I'm endlessly grateful to Ingrid Burrington for connecting me to Melville House, to Taylor Sperry and the rest of Melville House for taking a chance on an emerging writer, and to Ryan Harrington for being a trustworthy editor and generally keeping my spirits high.

Both of my parents are present in this book. My mother, the very picture of generosity, has ingeniously found some way to help

me with almost everything I have ever done, and her work with children influenced my emphasis on care and maintenance in this book. My father, who frequently shuttles between his electronics job and the top of a mountain, has imbued in me a certain way of looking at the world. I once asked him if he knew about augmented reality, and he said, "Augmented reality? I live there."

Lastly, I would like to thank Crow and Crowson for continuing to visit my balcony, morning after morning, directing their alien attention toward this comparatively ungainly *Homo sapiens*. May we all be so lucky to find our muses in our own neighborhoods.

Endnotes

Introduction

1. Richard Wolin, *Walter Benjamin: An Aesthetic of Redemption* (Berkeley: University of California Press, 1994), 130.
2. Robert Louis Stevenson, "An Apology for Idlers" from *"Virginibus puerisque" and other papers* (Ann Arbor: University of Michigan, 1906), 108.
3. Seneca, *Dialogues and Essays* (UK: Oxford University Press, 2007), 142.
4. Cathrin Klingsöhr-Leroy and Uta Grosenick, *Surrealism* (Cologne, Germany: Taschen, 2004), 34.
5. Zhuang Zhou, *The Complete Works of Zhuangzi*, trans. Burton Watson (New York: Columbia University Press, 2013), 31.
6. Gordon and Larry Laverty, "Leona Heights Neighborhood News," *MacArthur Metro*, March 2011: https://macarthurmetro.files.wordpress.com/2017/06/met11-03.pdf

Chapter 1

1. Gilles Deleuze, *Negotiations*, (New York: Columbia University Press, 1995), 129.
2. John Steinbeck, *Cannery Row: Centennial Edition* (New York: Penguin, 2002), 10.
3. Tanya Zimbardo, "Receipt of Delivery: Windows by Eleanor Coppola," *Open Space*, January 25, 2013: https://openspace.sfmoma.org/2013/01/receipt-of-delivery29/.
4. Pauline Oliveros, *The Roots of the Moment* (New York: Drogue Press, 1998), 3.
5. Pauline Oliveros, *Deep Listening: A Composer's Sound Practice* (New York: iUniverse, 2005), xxii.
6. Rebecca Solnit, *Wanderlust: A History of Walking* (New York: Penguin, 2001), 69.
7. John Muir, *The Writings of John Muir* (Boston, MA: Houghton Mifflin, 1916), 236.
8. Linnie Marsh Wolfe, *Son of the Wilderness: The Life of John Muir* (New York: Alfred A. Knopf, 1946), 104–105.
9. John Cleese, "Creativity in Management," lecture, Video Arts, 1991: https://www.youtube.com/watch?v=Pb5oIIPO62g.

10. Martha Mockus, *Sounding Out: Pauline Oliveros and Lesbian Musicality* (Abingdon, UK: Routledge, 2011), 76.

11. Roy Rosenzweig, *Eight Hours for What We Will: Workers and Leisure in an Industrial City, 1870–1920* (UK: Cambridge University Press, 1985), 1.

12. Samuel Gompers, "What Does Labor Want? An address before the International Labor Congress, August 28, 1893," in *The Samuel Gompers Papers, Volume 3: Unrest and Depression, 1891–94* ed. Stuart Kaufman and Peter Albert (Urbana: University of Illinois Press, 1989), 393. Gompers adds, "There is nothing too beautiful, too lofty, too ennobling, unless it is within the scope of labor's aspirations and wants. But to be more specific: The expressed demands of labor are first and foremost a reduction of the hours of daily labor to eight hours to-day, fewer to-morrow."

13. Eric Holding and Sarah Chaplin, "The post-urban: LA, Las Vegas, NY," in *The Hieroglyphics of Space: Reading and Experiencing the Modern Metropolis*, ed. Neil Leach (Abingdon, UK: Routledge, 2005), 190.

14. Franco Berardi, *After the Future* (Oakland, CA: AK Press, 2011), 66.

15. Ibid., 129.

16. Bernardi, 35.

17. Jia Tolentino, "The Gig Economy Celebrates Working Yourself to Death," *New Yorker*, March 22, 2017: https://www.newyorker.com/culture /jia-tolentino/the-gig-economy-celebrates-working-yourself-to-death.

18. Cali Ressler and Jody Thompson, *Why Work Sucks and How to Fix It: The Results-Only Revolution* (New York: Penguin, 2008), 11.

19. Berardi, 109.

20. David Abram, *Becoming Animal: An Earthly Cosmology* (New York: Vintage, 2011), 128–129.

21. David Abram, *The Spell of the Sensuous: Perception and Language in a More-Than-Human World* (New York: Vintage, 1997), x.

22. Marisa Meltzer, "Soak, Steam, Spritz: It's All Self Care," *The New York Times*, December 10, 2016: https://www.nytimes.com/2016/12/10/fashion/post -election-anxiety-self-care.html.

23. Gordon Hempton, "Welcome to One Square Inch: A Sanctuary for Silence at Olympia National Park": https://onesquareinch.org/.

24. Berardi, 68.

25. https://queensmuseum.org/2016/04/mierle-laderman-ukeles-maintenance -art, pg. 3.

26. Ibid., pg. 1.

27. City of Oakland Parks and Recreation, "64th Annual Mother of the Year Award—Call for Nominations," 2017: http://www2.oaklandnet.com /oakca1/groups/opr/documents/image/oak063029.pdf.

28. Donna J. Haraway, *Staying with the Trouble: Making Kin in the Chthulucene* (Durham, NC: Duke University Press, 2016), 83.

29. Abram, *Becoming Animal: An Earthly Cosmology*, 69.

30. Ibid., pg. 1.

Chapter 2

1. Henry Martin, *Agnes Martin: Painter, Pioneer, Icon* (Tucson, AZ: Schaffner Press, 2018), 294.

2. Michelle Magnan, "Levi Felix Interview," *AskMen*, March 4, 2014: https://www.askmen.com/entertainment/austin/levi-felix-interview.html.

3. "RIP Levi Felix," *The Reaper*, January 17, 2017: http://thereaper.rip/rip-levi-felix/.

4. Smiley Poswolsky, "The Man Who Gave Us All the Things: Celebrating the Legacy of Levi Felix, Camp Grounded Director and Digital Detox Visionary," *Medium*, January 12, 2017: https://medium.com/dear-levi/the-man-who-gave-us-all-the-things-e83ab612ce5c.

5. Digital Detox, "Digital Detox® Retreats": http://digitaldetox.org/retreats/.

6. Poswolsky.

7. Sophie Morris, "Burning Man: From far out freak-fest to corporate schmoozing event," *The Independent*, September 1, 2015: https://www.independent.co.uk/arts-entertainment/music/festivals/burning-man-from-far-out-freak-fest-to-corporate-schmoozing-event-10481946.html.

8. Digital Detox, "Corporate Offerings": http://digitaldetox.org/corporate-2/.

9. Richard W. Hibler, *Happiness Through Tranquility: The School of Epicurus* (Lanham, MD: University Press of America, 1984), 38.

10. Epicurus, "Principal Doctrines, XIV," in *The Epicurus Reader: Selected Writings and Testimonia*, trans. and ed. Brad Inwood and L. P. Gerson (Indianapolis, IN: Hackett, 1994), 33.

11. Epicurus, "Vatican Sayings, LXXXI," *Epicurus: The Extant Remains*, trans. Cyril Bailey (Oxford University Press, 1926), 119.

12. Hibler, 49.

13. Houriet, Robert, *Getting Back Together* (New York: Coward, McCann & Geoghegan, 1971), xix.

14. Ibid., xiii.

15. Peter Rabbit, *Drop City* (New York: Olympia, 1971), ii.

16. Houriet, xxxiv.

17. Ibid, 38.

18. Michael Weiss, *Living Together: A Year in the Life of a City Commune* (New York: McGraw Hill, 1974), 94.

19. Ibid.

20. Stephen Diamond, *What the Trees Said: Life on a New Age Farm* (New York: Delacorte Press, 1971), 30.

21. Weiss, 173.

22. Houriet, 14.

23. Ibid., xxxiv.

24. Weiss, 9.

25. Ibid.

26. Diamond, 17.

27. Ibid., 18.

28. Hibler, 40.

29. B. F. Skinner, *Walden Two* (New York: Macmillan, 1976), 279.

30. Ibid., 24.

31. Ibid., 262.

32. Ibid., 274.

33. Ibid., 111.

34. Ibid., 301.

35. Ibid., vii.

36. Ibid., xvi.

37. Peter Thiel, "The Education of a Libertarian," *Cato Unbound*, April 13, 2009: https://www.cato-unbound.org/2009/04/13/peter-thiel/education-libertarian.

38. Hannah Arendt, *The Human Condition* (Chicago: University of Chicago Press, 1998), 222.

39. Ibid., 227.

40. Ibid., 222.

41. Houriet, 11.

42. Ibid., 13.

43. Ibid., 24.

44. Mella Robinson, "An island nation that told a libertarian 'seasteading' group it could build a floating city has pulled out of the deal," *Business Insider*, March 14, 2018: https://www.businessinsider.com/french-polynesia-ends -agreement-with-peter-thiel-seasteading-institute-2018-3.

45. Maureen Dowd, "Peter Thiel, Trump's Tech Pal, Explains Himself," *The New York Times*, January 11, 2017: https://www.nytimes.com/2017/01/11 /fashion/peter-thiel-donald-trump-silicon-valley-technology-gawker.html.

46. Arendt, 227.

47. Susan X Day, "Walden Two at Fifty," *Michigan Quarterly Review* XXXVIII (Spring 1999), http://hdl.handle.net/2027/spo.act2080.0038.211.

48. B. F. Skinner, *The Shaping of a Behaviorist* (New York: Alfred A. Knopf, 1979), 330 (as cited in "Walden Two at Fifty").

49. Brian Dillon, "Poetry of Metal," *The Guardian*, July 24, 2009: https://www .theguardian.com/books/2009/jul/25/vladimir-tatlins-tower-st-petersburg.

50. Hans-Joachim Müller, *Harald Szeemann: Exhibition Maker* (Berlin: Hatje Cantz, 2006), 40.

51. Ibid., 83.

52. Ibid., 55.

53. Weiss, 176.

54. Ursula K. Le Guin, *The Dispossessed: An Ambiguous Utopia* (New York: Harper & Row, 1974), 78.

55. Charles Kingsley, *The Hermits* (London: Macmillan, 1913), 24.

56. Edward Rice, the Man in the Sycamore Tree: *The Good Times and Hard Life of Thomas Merton* (San Diego, CA: Harcourt, 1985), 31.

57. Ibid., 48.

58. Robert Giroux, "Thomas Merton's Durable Mountain," *The New York Times*, October 11, 1998: https://archive.nytimes.com/www.nytimes.com /books/98/10/11/bookend/bookend.html?module=inline.

59. Thomas Merton, *Conjectures of a Guilty Bystander* (Berkeley: University of California Press, 1968), 156.

60. Thomas Merton, *Contemplation in a World of Action* (Berkeley: University of California Press, 1971), 149.

61. William Deresiewicz, "Solitude and Leadership," *The American Scholar*, March 1, 2010: https://theamericanscholar.org/solitude-and-leadership/.

Chapter 3

1. Pump House Gallery, "Pilvi Takala—The Trainee": https: //pumphousegallery.org.uk/posts/the-trainee.

2. Christy Lange, "In Focus: Pilvi Takala," *Frieze*, May 1, 2012: https://frieze .com/article/focus-pilvi-takala.

3. Ibid.

4. Pumphouse Gallery, "Pilvi Takala—The Trainee."

5. Alan Duke, "New clues in planking origins mystery," *CNN*, July 14, 2011: http://www.cnn.com/2011/SHOWBIZ/celebrity.news.gossip/07/13 /planking.roots/.

6. Luis E. Navia, *Diogenes of Sinope: The Man in the Tub* (Westport, CT: Greenwood Press, 1998), 122.

7. Thomas McEvilley, "Diogenes of Sinope (c. 410–c. 320 B.C.): Selected Performance Pieces," *Artforum* 21, March 1983, 59.

8. Navia, 61.

9. McEvilley, 58.

10. Navia, 48.

11. Ibid, 23.

12. McEvilley, 58–59.

13. Navia, 110.

14. Anthony K. Jensen, "Nietzsche's Unpublished Fragments on Ancient Cynicism: The First Night of Diogenes," in *Nietzsche and Antiquity: His Reaction and Response to the Classical Tradition*, ed. Paul Bishop (Rochester, NY: Camden House, 2004), 182.

15. *The Cynics: The Cynic Movement in Antiquity and Its Legacy*, ed. R. Bracht Branham and Marie-Odile Goulet-Cazé (Berkeley: University of California Press, 2000), vii.

16. Navia, 65.

17. Herman Melville, "Bartleby, the Scrivener: A Tale of Wall Street," *Billy Budd, Sailor and Selected Tales* (UK: Oxford University Press, 2009), 28.

18. Ibid., 31.

19. Alexander Cooke, "Resistance, potentiality and the law: Deleuze and Agamben on 'Bartleby,' in *Agamben and Law*, ed. Thanos Zartaloudis (Abingdon, UK: Routledge, 2016), 319.

20. Cooke, 319.

21. Melville, 23.

22. Margaret Y. Henry, "Cicero's Treatment of the Free Will Problem," *Transactions and Proceedings of the American Philological Association* 58 (1927), 34.

23. Ibid.

24. Navia, 63.

25. Carol Becker, "Stilling the World," in *Out of Now : the Lifeworks of Tehching Hsieh*, ed. Adrian Heathfield (Cambridge, MA: The MIT Press, 2015), 367.

26. Mary Jane Jacobs and Jacquelyn Bass, *Tehching Hsieh: An Interview*, streaming video, 2012: https://www.kanopy.com/wayf/video/tehching-hsieh -interview

27. Becker, 367.

28. Henry David Thoreau, *Walden, Volume 1* (Boston: Houghton Mifflin, 1897), 143.

29. Henry David Thoreau, *On the Duty of Civil Disobedience* (London: The Simple Life Press, 1903), 19.

30. Ibid., 33.

31. Thoreau, *On the Duty of Civil Disobedience*, 12.

32. David F. Selvin, *A Terrible Anger: The 1934 Waterfront and General Strikes in San Francisco* (Detroit, MI: Wayne State University Press, 1996), 39.

33. Mike Quin, *The Big Strike* (New York: International Publishers, 1979), 39.

34. Ibid., 42.

35. Warren Hinckle, *The Big Strike: A Pictorial History of the 1943 San Francisco General Strike* (Virginia City, NV: Silver Dollar Books, 1985), 41.

36. Quin, 50.

37. Ibid., 48.

38. Selvin, 15.

39. Tillie Olsen, "The Strike," *Writing Red: An Anthology of American Women Writers, 1930–1940*, ed. Charlotte Nekola and Paula Rabinowitz (New Yoek City University of New York: The Feminist Press, 1987), 250.

40. William T. Martin Riches, *The Civil Rights Movement: Struggle and Resistance* (New York: St. Martin's Press, 1997), 43.

41. Jeanne Theoharis, *The Rebellious Life of Mrs. Rosa Parks* (Boston: Beacon Press, 2015), 155.

42. Navia, 23.

43. Eugene E. Pfaff, Jr., *Keep on Walkin', Keep on Talkin': An Oral History of the Greensboro Civil Rights Movememnt* (Greensboro, NC: Tudor, 2011), 178.

44. Ibid, 108.

45. Stu Schmill, "Policies, Principles and Protests," *MIT Admissions*, February 22, 2018: https://mitadmissions.org/blogs/entry/policies-principles-and -protests/.

46. Selvin, 21.

47. Ibid., 35.

48. Jacob S. Hacker, *The Great Risk Shift: The New Economic Insecurity and the Decline of the American Dream* (UK: Oxford University Press, 2008), 66.

49. Ibid, 66.

50. Jacob S. Hacker, "Worked Over and Overworked," *The New York Times*, April 20, 2008: https://www.nytimes.com/2008/04/20/business/20workexcerpt. html.

51. Barbara Ehrenreich, *Nickel and Dimed: On (Not) Getting by in America* (New York: Henry Holt and Company, 2001), 106.

52. Steven Greenhouse, *The Big Squeeze: Tough Times for the American Worker* (New York: Alfred A. Knopf, 2008), 13.

53. Talia Jane, Twitter post, September 16, 2018: https://twitter.com/itsa_talia /status/1041112149446348802.

54. Tiger Sun, "Duck Syndrome and a Culture of Misery," *Stanford Daily*, January 31, 2018: https://www.stanforddaily.com/2018/01/31/duck -syndrome-and-a-culture-of-misery/.

55. Paris Martineau, "The Future of College Is Facebook Meme Groups," *New York Magazine*, July 10, 2017: https://nymag.com/intelligencer/2017/07 /martin-shkreli-teens-and-college-facebook-meme-groups.html.

56. Brandon Walker, "Non CS reaccs only," Facebook post in Stanford Memes for Edgy Trees, July 2, 2018: https://www.facebook.com/groups /StanfordMemes/permalink/2299623930064291/.

57. Martin Altenburg, "Oldie but a goodie," Facebook post in Stanford Memes for Edgy Trees, August 28, 2018: https://www.facebook.com/groups /StanfordMemes/permalink/2405197476173602/.

58. Julie Liu, "when you get your summer internship and celebrate committing yourself to being yet another cog in the vast capitalist machine," Facebook post in UC Berkeley Memes for Edgy Teens, June 16, 2018: https://www .facebook.com/groups/UCBMFET/permalink/2135605103384176/.

59. Malcolm Harris, *Kids These Days: Human Capital and the Making of Millennials* (New York: Little, Brown & Company, 2017), 83.

60. Ibid., 86.

61. Laura Portwood-Stacer, "Media refusal and conspicuous non-consumption: The performative and political dimensions of the Facebook abstention," *New Media & Society* 15, no. 7 (December 2012): 1054.

62. Grafton Tanner, "Digital Detox: Big Tech's Phony Crisis of Conscience," *Los Angeles Review of Books*, August, 9. 2018: https://lareviewofbooks.org/article /digital-detox-big-techs-phony-crisis-of-conscience/#!.

63. Navia, 141.

64. Ibid., 125. Navia notes that the language for "sea of illusion" also translates to "wine-colored sea of fog," yet another image of *typhos*.

65. Jonathan Crary, *24/7: Late Capitalism and the Ends of Sleep* (London: Verso Books, 2013), 17.

66. Jacobs and Bass, *Tehching Hsieh: An Interview*.

Chapter 4

1. John Cage, "Four Statements on the Dance," in *Silence: Lectures and Writings by John Cage* (Middletown, CT: Wesleyan University Press, 2010), 93.

2. Lawrence Weschler, *True to Life: Twenty-Five Years of Conversations with David Hockney* (Berkeley: University of California Press, 2008), 6.

3. Ibid., 10.

4. Ibid.

5. David Hockney and Lawrence Weschler, *Cameraworks* (New York: Alfred Knopf, 1984), 17.

6. Weschler, 33.

7. David Hockney, *That's the Way I See It* (San Francisco: Chronicle Books, 1993), 112.

8. David Hockney and Marco Livingstone, *David Hockney: My Yorkshire* (London: Enitharmon Editions, 2011), 60.

9. Martin Buber, *I and Thou*, trans. Walter Kaufmann (New York: Touchstone, 1996), 109.

10. Ibid., 58.

11. Ibid., 58–59.

12. Emily Dickinson, "359 - A bird came down the walk," *The Poems of Emily Dickinson: Variorum Edition*, ed. R. W. Franklin (Cambridge, MA: Belknap Press, 1998), 383–384.

13. Arthur C. Danto, *Unnatural Wonders: Essays from the Gap Between Art and Life* (New York: Farrar, Straus, and Giroux, 2005), 191.

14. "A neuroscientist has just developed an app that, after repeated use, makes you see farther. Absolutely astonishing and 100% real," *The New Reddit Journal of Science*, 2014: https://www.reddit.com/r/science /comments/1y9m6w/a_neuroscientist_has_just_developed_an_app_that/.

15. Derisan, "The Dumbest," Review of ULTIMEYES in the App Store, March 24, 2017.

16. Arien Mack and Irvin Rock, *Inattentional Blindness* (UK: Oxford University Press, 1998), 66.

17. Ibid., 71.

18. Jessica Nordell, "Is This How Discrimination Ends?" *The Atlantic*, May 7, 2017: https://www.theatlantic.com/science/archive/2017/05/unconscious -bias-training/525405/.

19. William James, *Psychology* (New York: Henry Holt and Company, 1890), 227.

20. Ibid., 453.

21. Ibid.

22. James Williams, "Why It's OK to Block Ads," *Practical Ethics*, October 16, 2015: http://blog.practicalethics.ox.ac.uk/2015/10/why-its-ok-to-block-ads/.

23. Devangi Vivrekar, "Persuasive Design Techniques in the Attention Economy: User Awareness, Theory, and Ethics," master's thesis, Stanford University, 2018, 17.

24. Ibid., 68.

25. Ibid., 46.

26. Ibid., 48.

27. William James, *The Principles of Psychology, Volume 1* (New York: Dover, 1918), 403.

28. *The Biosphere and the Bioregion: Essential Writings of Peter Berg*, ed. Cheryll Glotfelty and Eve Quesnel (Abingdon, UK: Routledge, 2014), xx.

Chapter 5

1. Gary Snyder, *The Practice of the Wild* (Berkeley, CA: Counterpoint Press, 2010), 17.

2. David Foster Wallace, *This Is Water: Some Thoughts, Delivered on a Significant Occasion, about Living a Compassionate Life* (New York: Little, Brown and Company, 2009), 79.

3. Ibid., 94.

4. Louis Althusser, *Philosophy of the Encounter—Later Writings, 1978–1987*, ed. François Matheron and Oliver Corpet, trans. G. M. Goshgarian (London: Verso Books, 2006), 185.

5. Rebecca Solnit, *A Paradise Built in Hell: The Extraordinary Communities that Arise in Disaster* (New York: Penguin, 2010), 155.

6. Ibid., 32.

7. Sarah Schulman, *The Gentrification of the Mind: Witness to a Lost Imagination* (Berkeley: University of California Press, 2013), 30.

8. Alan Watts, *Ego* (Millbrae, CA: Celestial Arts, 1975), 15.

9. Michael Pollan, "My Adventures with the Trip Doctors," *The New York Times*, May 15, 2018: https://www.nytimes.com/interactive/2018/05/15/magazine/health-issue-my-adventures-with-hallucinogenic-drugs-medicine.html.

10. Francisco J. Varela, Evan Thompson, and Eleanor Rosch, *The Embodied Mind: Cognitive Science and Human Experience* (Cambridge, MA: The MIT Press, 1991), 9.

11. Robin Wall Kimmerer, *Braiding Sweetgrass: Indigenous Wisdom, Scientific Knowledge, and the Teachings of Plants* (Minneapolis, MN: Milkweed Editions, 2013), 208.

12. Ibid., 209.

13. Abram, 71.

14. *Reinventing the Enemy's Language: Contemporary Native Women's Writings of North America*, ed. Gloria Bird and Joy Harjo (New York: W. W. Norton & Company, 1997), 24.

15. Kimmerer, 162.

16. Chris J. Cuomo, *Feminism and Ecological Communities: An Ethic of Flourishing* (London: Routledge, 1998), 106.

17. Aldo Leopold, *A Sand County Almanac: Essays on Conservation from Round River* (New York: Ballantine Books, 1970), 189–90.

18. Audre Lorde, *Sister Outsider: Essays and Speeches by Audre Lorde* (Berkeley, CA: Crossing Press, 2007), 120.

19. Ibid., 111.

20. Schulman, 36.

21. Ibid., 33.

Chapter 6

1. Henry David Thoreau, "Walking," *The Atlantic*, June 1862: https://www.theatlantic.com/magazine/archive/1862/06/walking/304674/.

2. Virginia Morell, "Woodpeckers Partner with Fungi to Build Homes," *Science*, March 22, 2016: https://www.sciencemag.org/news/2016/03/woodpeckers-partner-fungi-build-homes.

3. Oliveros, *Deep Listening*, xxv.

4. Alice E. Marwick and danah boyd, "I tweet honestly, I tweet passionately: Twitter users, context collapse, and the imagined audience," *New Media and Society* 13 (1).

5. Joshua Meyrowitz, *No Sense of Place: The Impact of Electronic Media on Social Behavior* (UK: Oxford University Press, 1985), 17.

6. Ibid., 18.

7. Martin Luther King, Jr., *Stride Toward Freedom: The Montgomery Story* (Boston: Beacon Press, 2010), 32–55.

8. David Kirkpatrick, *The Facebook Effect: The Inside Story of the Company That Is Connecting the World* (New York: Simon and Schuster, 2010), 199.

9. Veronica Barassi, "Social Media, Immediacy, and the Time for Democracy," in *Critical Perspectives on Social Media and Protest: Between Control and Emancipation* (London: Rowman & Littlefield, 2015), 82.

10. Ibid., 83.

11. Ibid., 84.

12. Loving Grace Cybernetics, "From Community Memory!!!" 1972: https://people.well.com/user/szpak/cm/cmflyer.html.

13. Steve Silberman, *NeuroTribes: The Legacy of Autism and the Future of Neurodiversity* (New York: Avery Publishing, 2015), 258–259.

14. Randall Stross, "Meet Your Neighbors, If Only Online," *The New York Times*, May 12, 2012: https://www.nytimes.com/2012/05/13/business/on -nextdoorcom-social-networks-for-neighbors.html.

15. Nextdoor, "Advertising on Nextdoor": https://ads.nextdoor.com/.

16. Oliver Leistert, "The Revolution Will Not Be Liked: On the Systemic Constraints of Corporate Social Media Platforms for Protests," in *Critical Perspectives on Social Media and Protest: Between Control and Emancipation* (London: Rowman & Littlefield, 2015), 41.

17. Ian Bogost, "Meet the Nomad Who's Exploding the Internet Into Pieces," *The Atlantic*, May 22, 2017: https://www.theatlantic.com/technology /archive/2017/05/meet-the-counterantidisintermediationists/527553/.

18. Sudo Room, "Sudo Mesh": https://sudoroom.org/wiki/Mesh.

19. People's Open, "About": https://peoplesopen.net/about/.

20. Hannah Arendt, *The Human Condition* (University of Chicago Press, 1998), 201.

21. Ibid.

22. David and Lauren Hogg, *#NeverAgain: A New Generation Draws the Line* (New York: Penguin Random House, 2018), 70.

23. Donna J. Haraway, *Staying with the Trouble,* 81.

Conclusion

1. Wendell Berry, "A Native Hill," in *The Art of the Commonplace: The Agrarian Essays of Wendell Berry*, ed. Norman Wirzba (Berkeley, CA: Counterpoint Press, 2002), 27.

2. Leopold, *A Sand County Almanac*, 197.

3. T. L. Simons quoted in "Long Lost Oakland," Kickstarter, 2018: https: //www.kickstarter.com/projects/eastbayyesterday/long-lost-oakland.

4. Walter Benjamin, "Theses on the Philosophy of History," in *Illuminations*, ed. Hannah Arendt, trans. Harry Zohn (New York: Schocken, 2007), 257.

5. Martha A. Sandweiss, "John Gast, American Progress, 1872," Picturing United States History: https://picturinghistory.gc.cuny.edu/john-gast -american-progress-1872/

6. George Crofutt, *Crofutt's Trans-Continental Tourist, Containing a Full and Authentic Description of Over Five Hundred Cities, Towns, Villages, Stations, Government Forts and Camps, Mountains, Lakes, Rivers; Sulphur Soda, and Hot Springs; Scenery, Watering Places, Summer Resorts* (New York: Geo. A. Crofutt, 1874), 1.

7. Teresa L. Carey, "With San Clemente Dam gone, are steelhead trout about to make comeback on the Carmel River?" *The Mercury News*, July 7, 2017: https://www.mercurynews.com/2017/07/07/with-san-clemente-dam-gone -are-steelhead-trout-about-to-make-comeback-on-the-carmel-river/.

8. Lindsey Hoshaw, "Biologists Watch Steelhead Return After Historic

Dam Removal," *KQED*, September 7, 2017: https://www.kqed.org
/science/1860284/biologists-watch-steelhead-return-after-historic-dam
-removal.

9. Steve Rubenstein, "How a dam's destruction is changing environmental
 landscape," *The San Francisco Chronicle*, August 6, 2015: https://www
 .sfchronicle.com/bayarea/article/How-a-dam-s-destruction-is
 -changing-6430111.php.

10. California American Water, "San Clemente Dam Removal Update—Year 3,"
 February 9, 2016: https://www.youtube.com/watch?v=hNANijh-7sU#t=26.

11. Leopold, 240.

12. Masanobu Fukuoka, *One Straw Revolution: An Introduction to Natural Farming*
 (New York: New York Review Books, 2009), 19.

13. Ibid., 8.

14. Jedediah Purdy, *After Nature: A Politics for the Anthropocene* (Cambridge, MA:
 Harvard University Press, 2015), 200.

15. Peter Berg, "A San Francisco Native Plant Sidewalk Garden," in *The Essential
 Writings of Peter Berg*, ed. Cheryll Glotfelty and Eve Quesnel (London:
 Routledge, 2015), 107.

16. Cecily Burt, "Film traces destruction of Emeryville shellmound," *East Bay
 Times*, August 17, 2016: https://www.eastbaytimes.com/2005/06/03/film
 -traces-destruction-of-emeryville-shellmound/.

17. Coalition to Save the West Berkeley Shellmound & Village Site, "An Ohlone
 Vision for the Land," Shellmound—Ohlone Heritage Site and Sacred
 Grounds: https://shellmound.org/learn-more/ohlone-vision/.

18. James Bridle, "Something is wrong on the internet," *Medium*, November 6,
 2017: https://medium.com/@jamesbridle/something-is-wrong-on-the
 -internet-c39c471271d2.

19. Paul Lewis, "'Our minds can be hijacked': the tech insiders who fear a
 smartphone dystopia," *The Guardian*, October 6, 2017: https://www
 .theguardian.com/technology/2017/oct/05/smartphone-addiction-silicon
 -valley-dystopia.

20. Cuomo, *Feminism and Ecological Communities*, 109.

21. Wolin, *Walter Benjamin*, 49.

22. Benjamin, 255.

23. Nancy Nadel, speech at the dedication of the Chappell R. Hayes
 Observation Tower, January 14, 2004: http://www.kimgerly.com
 /nancynadel/docs/chappell_011404.pdf.

Index